HYECHO'S JOURNEY

The World of Buddhism

THE UNIVERSITY OF CHICAGO PRESS

CHICAGO AND LONDON

The University of Chicago Press, Chicago 60637
The University of Chicago Press, Ltd., London
© 2017 by The University of Chicago. All rights reserved.
Published 2017
Printed in China

26 25 24 23 22 21 20 19 2 3 4 5

ISBN-13: 978-0-226-51790-2 (cloth)
ISBN-13: 978-0-226-51806-0 (e-book)
DOI: 10.7208/chicago/9780226518060.001.0001

The University of Chicago Press gratefully acknowledges the gener-
ous support of the University of Michigan toward the publication of
this book.

Library of Congress Cataloging-in-Publication Data
Names: Lopez, Donald S., Jr., 1952– author. | Bloom, Rebecca | Carr,
 Kevin Gray, 1974– | Chan, Chun Wa. | Jun, Ha Nul. | Sinopoli,
 Carla M. | Yokota, Keiko.
Title: Hyecho's journey : the world of Buddhism / Donald S. Lopez
 Jr. With Rebecca Bloom, Kevin Carr, Chun Wa Chan, Ha Nul Jun,
 Carla Sinopoli, and Keiko Yokota-Carter.
Description: Chicago ; London : The University of Chicago Press,
 2017. | Includes bibliographical references and index.
Identifiers: LCCN 2017013158 | ISBN 9780226517902 (cloth : alk. paper)
 | ISBN 9780226518060 (e-book)
Subjects: LCSH: Buddhism. | Hyech'o, active 8th century—Travel. |
 Buddhist pilgrims and pilgrimages. | Buddhism—History. | Bud-
 dhist legends. | Buddhism in art.
Classification: LCC BQ4022 .L67 2017 | DDC 294.3—dc23 LC record
 available at https://lccn.loc.gov/2017013158

♾ This paper meets the requirements of ANSI/NISO Z39.48-1992
(Permanence of Paper).

You bemoan the distance to the frontier in the west.
I lament the long road east.
Rugged roads cross colossal snowy ridges,
Dangerous ravines where bandits wander.
Even birds in flight fear the soaring cliffs.
Travelers struggle over tilting bridges.
I have never cried once in my life.
Today I shed a torrent of tears.

HYECHO

CONTENTS

· ILLUSTRATIONS ·

MAPS

FIGURES

Thus historians can write only by combining within their practice the
"other" that moves and misleads them and the real that they can repre-
sent only through fiction.

MICHEL DE CERTEAU, *THE WRITING OF HISTORY*

This is a different kind of book about Buddhism: in its scope, in its content,
in its method, and in how it was made. Most works that seek to represent
the Buddhist world follow a chronological approach, beginning with the
historical Buddha—who was born around 500 BCE—and his mythological
and historical antecedents, moving through the developments in his native
India in the centuries after his death, tracing the movements of Buddhism
to the various regions of Asia, describing its various forms with geograph-
ical names like Chinese Buddhism, Japanese Buddhism, and Tibetan Bud-
dhism or generic names like Theravāda, Tantra, or Zen, eventually reaching
the present day with figures like the Fourteenth Dalai Lama and modern
manifestations like mindfulness in America. The reader will find a very dif-
ferent approach in the pages that follow.

Two challenges face any presentation of the Buddhist tradition: the
problem of time and the problem of space. The problem of time is not simply
the twenty-five-hundred-year sweep of the tradition; it is difficult, if not im-
possible, to provide a coherent narrative of the development of Buddhism

by following a single chronology. As much as we would like to trace Buddhism north from India to China to Korea and to Japan, and as much as we would like to trace Buddhism south from India to Sri Lanka to Burma to Thailand and to Cambodia, it simply did not happen that way. Highly significant developments occurred in India long after Buddhism was established and flourishing in China. Buddhism was already well established in Japan before it ever spread to Tibet, despite Tibet's long border with India and Nepal. And numerous Mahāyāna and tantric elements flourished in Southeast Asia before what is known today as Theravāda Buddhism became the state orthodoxy in various kingdoms of the region. It is therefore not possible to draw a time line that moves directly from A to B. Instead, the line has all manner of branches, twists, spirals, and vanishing points.

The problem of space is another challenge. We must recall that the terms we use so often today in course titles, advertisements for academic positions, and museum galleries do not appear in the Buddhist world before the twentieth century, terms like "Chinese Buddhism," "Thai Buddhism," "Korean Buddhism," "Tibetan Buddhism," and even "Theravāda Buddhism." What we find instead is *fojiao* in Chinese, *bukkyō* in Japanese, *nang pa sangs rgyas pa'i chos* in Tibetan, *buddhadharma* in Sanskrit, *sāsana* in Pāli. We note that not one of these terms has any geographical designation. And we note that it is common to translate all of these terms, rather roughly, with a single English word: Buddhism.

With the expansion of studies of Buddhism over the past thirty years into historical periods, into geographical regions, and into languages that were not previously studied, some scholars have argued that it is more accurate to refer to what we study as "Buddhisms," in the plural, rather than Buddhism. However, that expansion of our knowledge can also lead to the opposite conclusion: that the doctrines, the practices, the institutions, the allusions, the conventions, the stories, the rhetorical forms, and the obsessions found across the dynasties, across the regions, and across the languages justify the use of the term "Buddhism," in the singular and without an adjective. The question is how to convey this.

One approach would be to make use of an ancient Buddhist practice, a practice that is arguably more important and more pervasive than meditation. This project centers not on the philosophical doctrines of no self and mind-only, on the deep meditative states of the concentrations and absorptions, on the visualization of tantric deities in their maṇḍalas. All of these were the domains of Buddhist elites. Instead, it considers a far more ubiquitous form of Buddhist practice: pilgrimage. It focuses not on the masterpieces of Buddhist literature by the famous masters of the tradition, but

on a fragmentary travelogue by a young and, apparently, undistinguished monk. His name is Hyecho. Korean by birth, he set out around 724 by sea from China to India and returned to China by land three years later. During those three years, he traveled farther than any other Buddhist pilgrim of the premodern period.

The story of Buddhism has always been told as a historical narrative that begins with the Buddha and then branches out from this single source, with each step in its development, both in space and in time, representing a movement away from the point of origin in ancient India and toward an ever-distant periphery, a process that encompasses more than twenty-five centuries. Our story is different, presenting Buddhism as an international tradition during one of its most vibrant periods, seen through the eyes of a single monk. Instead of following a vertical trajectory, from past to present, it offers a horizontal perspective, surveying the Buddhist world at a single moment—the eighth century—from horizon to horizon, from Korea in the east to Arabia in the west. Buddhism is portrayed as a single physical and conceptual world, a network of interlocking traditions that cross national and cultural boundaries, a system without a single center but with many interconnected hubs. The scope of this book is therefore different from that of other presentations of Buddhism. Instead of covering twenty-five hundred years, it focuses on three: 724–727 CE. The book's scope is thus both chronologically limited and geographically expansive. It seeks to describe a single Buddhist tradition as it existed across a vast geographical range at a single historical moment.

And so this book imagines a Buddhist world, a world that was defined not simply by oceans and mountains but by a shared Buddhist imagination, one with its own map and its own population; one that included not only present persons but also their past and future lives; one that included all manner of superhuman beings, both sinister and divine; one in which the landscape was saturated with stories of events that occurred at seemingly ordinary sites in an extraordinary past.

This book also differs from other books on Buddhism in its content. As we discuss in the introduction, the fact that Hyecho did not stay anywhere long enough to master a local language meant that his encounter with the people and places of his travels did not take place through speech and scripture. He relied instead on his eyes and his memory. Hyecho journeyed so far over such a brief period of time that his encounter with Buddhism in the many regions of the Buddhist world was largely visual: he encountered Buddhism through art, architecture, and ethnography. Buddhism was a world that he saw in situ rather than read in sūtras.

Yet, like so many travelers over the centuries—one thinks of Freud's reflections on his first trip to Rome—Hyecho knew India long before he arrived there. He knew the story of the Buddha's birth at Lumbinī, the story of his death at Kuśinagara. He knew the sūtras that the Buddha had spoken on Vulture Peak, the miracles he had performed at Śrāvastī. He knew the story of King Śibi carving off his own flesh to save the life of a dove, long ago in his kingdom in Gandhāra. At so many places that Hyecho visited, his arrival would trigger a memory, an association. Unlike so many Chinese and Korean pilgrims who preceded him, he did not stay to study; he did not copy sūtras and pack them on his back. He seemed to travel light, his vision sparking memories of sacred sites, not as they were but as they had been.

In an effort to capture this within the pages of a small book, we have for the most part avoided historical narrative and instead focused on two elements so central to how the Buddhist tradition has been conveyed and how it has been practiced over its long history: story and art. The title of each chapter is a place that Hyecho visited on his journey. Each chapter tells a story that Hyecho would have known about that place. Each chapter includes reproductions of works of Buddhist art associated with that place and its stories. Throughout, we follow Hyecho's lead, retracing his route as preserved in his travel journal; we describe the places he visited in the order that he visited them, even when doing so violates the chronology of the life of the Buddha. Hyecho visited the place of the Buddha's death before he visited the place of the Buddha's birth.

Hyecho's account of his journey survives only in fragments; he went to many more places than those described in the extant manuscript of his travel journal. The beginning and the end of his journal, both of which may have been substantial, are entirely missing. That fact is reflected in the contents of this book. Rather than seeking to represent all the places he visited—both those named in the text and those that likely appeared in the lost sections of his journal—we have chosen twelve places from along his route, some described by him, some mentioned only in passing. Hyecho says he went to India to see "the eight great stūpas." Our twelve chapters include six of these, plus six more places along his way, including the place of his birth—the kingdom of Silla in ancient Korea—and the place of his death—the sacred mountains of Wutaishan in China.

Hyecho's journal describes a Buddhist pilgrimage, but his comments about the places in many cases are little more than notes. Indeed, some scholars speculate that the surviving text is merely a set of notes for a more expansive work that was never written, or which has not survived. Despite what we have to assume was a spiritual motivation to make the perilous sea

passage to India, what he reports is largely mundane. With a few notable exceptions, we learn little of the Buddhist life in the many regions through which he passed, apart from whether or not the local king and his subjects revere the three jewels, whether there are monasteries in the region, and whether those monasteries are Hīnayāna or Mahāyāna. Indeed, his concerns seem instead to be largely ethnographic, describing the local animal husbandry and the local dress and diet, especially whether the people eat meat, onions, and scallions. We learn, for example, that Tibetans like to eat lice. In all regards, Hyecho's account is of much less historical use than that of the far more famous pilgrim Xuanzang, for example, although it is certainly unfair to compare the work of a twenty-year-old monk to that of one of the giants in the history of Buddhism.

Yet what Hyecho lacks in history, he offers in imagination. But this imagination is not a flight of fancy. In five of the twelve places along the route (Bodh Gayā, Kapilavastu, Kuśinagara, Sāṃkāśya, and Gandhāra), Hyecho's comments clearly suggest that he knew the texts and tales that we reference. In the case of Gandhāra, for example, we recount the *jātaka* tale that he specifically names. These cases, and other hints throughout the journal, provide strong evidence that Hyecho knew the stories that we tell. He says just enough about some places to allow us to imagine what he might have said about others.

One might argue that Hyecho's life is too insignificant and his travel journal too insubstantial to warrant their use as the fulcrum for the book. However, Hyecho was chosen precisely because so little is known about him and because his journal is so fragmentary. When the standard maps of Chinese pilgrims to Asia are produced, using different kinds of lines to mark the routes of different pilgrims, we often find the journeys of Faxian, Xuanzang, Yijing, and Hyecho included. The first three are towering figures in the history of Chinese Buddhism in their own right, and their three travel journals provide much of what we know of medieval Indian Buddhism. The fourth route, that of Hyecho, extends much farther geographically than the other three and was completed far more quickly. For this reason alone, Hyecho deserves to be the subject of a book. That he was an insignificant Korean adolescent monk at the time of his journey makes him all the more intriguing.

ABOUT THE ART

This book was composed as a freestanding study, but it was also intended as a complement to a groundbreaking three-year exhibition of Buddhist art at the Freer and Sackler Galleries in Washington, DC, the Smithsonian's

museums of Asian art. The exhibition, which opened in October 2017, is entitled "Encountering the Buddha: Art and Practice Across Asia." As the name suggests, the exhibition sought to represent Buddhist artworks as both products and objects of Buddhist practice across the Buddhist world of Asia. One of the practices presented in the exhibition is pilgrimage, represented by the journey made by Hyecho.

Each of the twenty-four works of art presented in this volume is drawn from the Freer and Sackler collections; many were on display during the exhibition. The decision to link this book so closely to the exhibition has many advantages, allowing us to select works from one of the world's great collections of Asian art, housed in a single institution, works that readers of the book are able to see together in person in a single place. The exhibition reciprocally benefited from having Hyecho—the archetypal pilgrim, a real-life practitioner—anchor Buddhist art and practice in a concrete historical moment, in a world revealed to the visitor. He functioned as an avatar through which visitors could understand more intimately an essential Buddhist practice as well as the centrality of art and architecture to its endeavor.

The decision to connect this book to this exhibition and the collections of the Freer and Sackler also carries with it certain constraints. It means, for example, that not all of the works of art in the pages of this book date from the eighth century, that is, from Hyecho's lifetime. It also means that not all of the works of art discussed here came from places that Hyecho visited. However, the works were not chosen randomly. As we mention repeatedly in the pages that follow, the present volume began as a carefully controlled exercise in imagination. The works chosen, therefore, are meant to evoke the places that Hyecho visited. A painting produced in Tibet, for example, is used in the chapter on Sāṃkāśya, the city in India where the Buddha is said to have descended to earth on a jeweled staircase. To show the ways that places of pilgrimage in India radiated throughout the Buddhist world, we have chosen this painting for our cover.

Because we recognize that Buddhist images and imagery rebound across centuries (and in Buddhist terms, across aeons), these anachronisms are entirely intentional. Buddhist images not only rebound through time; they reverberate through space and across regions, uniting Buddhist Asia. The ancient region of Gandhāra (in modern Pakistan and Afghanistan) is one of the points of origin of Buddhist art, where statues were carved in a Hellenistic style using the grey schist rock common to that region. Yet the influence of this art is visible across the Buddhist world. Indeed, all works of Buddhist art are composed of many different cultural elements, the location of their physical production marking but one site of their genesis.

It was not only the imagery of Buddhism that traveled across Asia but images themselves. Among the treasures that Buddhist pilgrims brought back from their travels were not only texts but objects as well. In the catalog of the treasures that the Chinese monk Xuanzang brought back from India, we find not only the titles of Sanskrit treatises, but lists that include "one sandalwood image of the Buddha two feet nine inches high including the seat and halo, an imitation of the image of the Tathāgatha descending by a precious stairway from the heavenly palace to earth in the country of Kapitha." To convey the important point that works of art also went on pilgrimage, we have included a number of portable paintings and sculptures, the kinds of works pilgrims took with them for blessing and protection or brought back to their birthplace, bringing the Buddha to his new home.

To use only Chinese works for Chinese sites, only Indian works for Indian sites would accord with traditional Buddhist historiography and would confirm the connections between art history and nationalism. However, Hyecho's journey led him to go against the standard chronology and geographic path, traveling from east to west and, in a sense, back in time, from a Korean present to an Indian past. His pilgrimage allows us to offer a more complex and, we feel, more compelling picture of the Buddhist world. We have chosen these works of art in order to paint that world.

Hyecho visited or mentions all of the countries where the works of art in this volume originated, with one important exception: Japan. Japanese works are included in our book for several reasons. First, it is impossible to represent the Buddhist world of the eighth century without including Japan. This was the time of the great efflorescence of Buddhist philosophy and material culture of the Nara period, which ended in 794 with the advent of the Heian, an era associated with the esoteric Buddhism of Kūkai (774–835), a tradition that Hyecho practiced in the last decades of his life. Second, the recent centuries of contention and conflict between Korea and Japan mask a very different relationship in the more ancient past. During the seventh century, and extending into the eighth, the distinction between the cultures of Japan and Korea, especially among the elite who patronized Buddhism, is difficult to maintain. Finally, we have included Japanese works because they are among the most stunning in the Freer and Sackler collections.

ABOUT THE AUTHORS

The reader may have noticed the consistent use of the plural pronoun "we" in these pages. This is not an affectation but an accurate representation of authorship. In an effort to change the paradigm, or at least the stereotype,

of the humanities scholar as the shivering figure toiling alone by candlelight in the bowels of a musty archive, in 2015 the University of Michigan announced the Humanities Collaboratory, a program to bring together a team of scholars—faculty, staff, and students—to work on a single project. The current volume is the first product of that program. Our team, which has come to be known on campus as Team Hyecho, consists of Donald Lopez as principal investigator and (in alphabetical order), art historian of South Asia and Tibet Rebecca Bloom, art historian of Japan Kevin Carr, art historian of East Asian Buddhism Chun Wa Chan, scholar of Korean Buddhism Ha Nul Jun, archaeologist of South Asia Carla Sinopoli, and Asia librarian Keiko Yokota-Carter. Each member of the team comes from a different discipline, studies a different language, works on a different region, or focuses on a different historical period. We have found these multiple perspectives, each from a different acute angle, to be essential to the project.

In the Asian humanities, textual scholars rarely work with images and art historians rarely work with texts; it is only in recent generations that scholars of Asian art have been expected to be able to read the languages of the cultures they study. It is only in recent generations that textual scholars have done more than read inscriptions on the base of a statue or on the back of a painting. This project—involving the entire geographical range of the Buddhist world; primary texts and secondary scholarship in Chinese, Japanese, and Korean; and works of art from numerous regions and periods—could not have been undertaken by a single scholar. It required the work of a team whose members bring together a range of training and expertise. Because Hyecho's travel journal is so fragmented, a project like this also requires many imaginations. This book is therefore not only the product of collaborative scholarship; it is also a work of collaborative imagination, the result of the expertise, the effort, and the creativity of all members of the team working closely together over an uninterrupted period of seven months. Donald Lopez, whose name appears on the cover, served simply, as Hyecho did more than a millennium ago, as the scribe (*bishou*).

Over the course of its long history, Buddhism has extolled the saint and the scholar—in the language of the tradition, the *arhat*, the *bodhisattva*, the *mahāsiddha*, the *paṇḍita*. Chinese Buddhism has a genre of works devoted to the "lives of eminent monks." This focus on mastery is reflected in the academic study of Buddhism, where scholarship has produced editions and translations of the most influential texts of the canon, the masterpieces of Buddhist art, and the lives and works of various masters of a given tradition. Scholars of Buddhism have generally not made the kind of historical

turn steered in the 1980s by authors like Natalie Davis and Carlo Ginzburg, where the ordinary, the common, and the quotidian became the focus of scholarship. Historians of Buddhism have rarely recorded the lives of ordinary people, even ordinary monks and nuns. This project makes a tentative turn in this direction with its selection of Hyecho as its hero and its touchstone, a single simple monk, a figure of relative obscurity, remembered for the journey that he undertook for reasons that can only be imagined. Yet all we have is Hyecho's fragment, which begins long after his journey has begun and ends before his journey would end. It has been the task of Team Hyecho to imagine him and the people and places he encountered. Hyecho provides a map for our—both writers' and readers'—dreaming. One of our inspirations is Italo Calvino's *Invisible Cities*.

HOW TO READ THIS BOOK

For all these reasons, this is not a conventional scholarly monograph. It is an unconventional, even experimental work. It is not a continuous narrative, and readers may read it in many different ways. For those who wish to know everything we know about Hyecho, his life, his sectarian affiliations, the route of his travels, and the mystery of his final days, the introduction seeks to gather what is available from the few original sources that survive, drawing on the impressive work of Korean, Japanese, and Chinese scholars.

The introduction describes his route from Korea, to China, to India, to Central Asia, and back to China. It also provides some background for the Buddhist doctrines that he would have known. However, readers can skip the introduction without particular peril. Each of the twelve chapters is devoted to one of the places along the route of Hyecho's journey, which are presented in the order in which he visited them. Each chapter has three parts. It begins with a story, drawn from the vast store of Buddhist lore, about the place, a story that in almost every case Hyecho would have known. After the story is a commentary, which attempts to see the story as a scholar of Buddhism would see it, noting the underlying themes and sometimes hidden agendas. Next, two works of art are described, each connected somehow to the place that Hyecho visited. Here, the insights of both Buddhist studies and art history help the reader to see things that are not always immediately visible. The two works are reproduced at the end of each chapter.

Each chapter was written to be a self-contained piece. No chapter assumes knowledge of anything that appears in another chapter (occasional

redundancies among the chapters fill in needed background), although references to other chapters are provided for those who wish to draw connections. And so, while the chapters follow the sequence of Hyecho's route, beginning in Korea and ending in China, they do not need to be read in that order, or in any order. Each is meant to be its own stop along the journey. We invite the reader to begin.

Three maps are presented here. Map 1 shows Hyecho's route from his native Korea, across the sea to India, on to Central Asia and Arabia, and back to China. Maps 2 and 3 are details of this larger map. The maps are topographic, representing mountain ranges and major rivers. Modern national names and borders are provided in light type to orient the reader.

The main map, map 1, contains two insets, which appear in expanded form as map 2 and map 3. Map 2, "The Cradle of Buddhism," shows the major pilgrimage sites that Hyecho visited in India that are associated with the life of the Buddha. Map 3, "Hyecho's Route Through Central Asia," depicts his often circuitous route through the region.

The portions of Hyecho's route that are described in his travel journal are represented on the maps by a solid line. Portions that have been reconstructed from other sources are represented by a broken line.

Two types of locations appear in the maps. The places that Hyecho says he visited are marked by purple dots. The places that he mentions but likely did not visit are marked by green dots. The locations of these places were determined using current scholarship on Hyecho as well as GPS calculations. The names of locations given in black type, such as "South India" and "Arabia," are those that appear in Hyecho's text where he locates them, not at their actual geographic locations. Some points on the map, such as "Byzantine Empire" and "Territory of the Turks," are regions rather than specific sites.

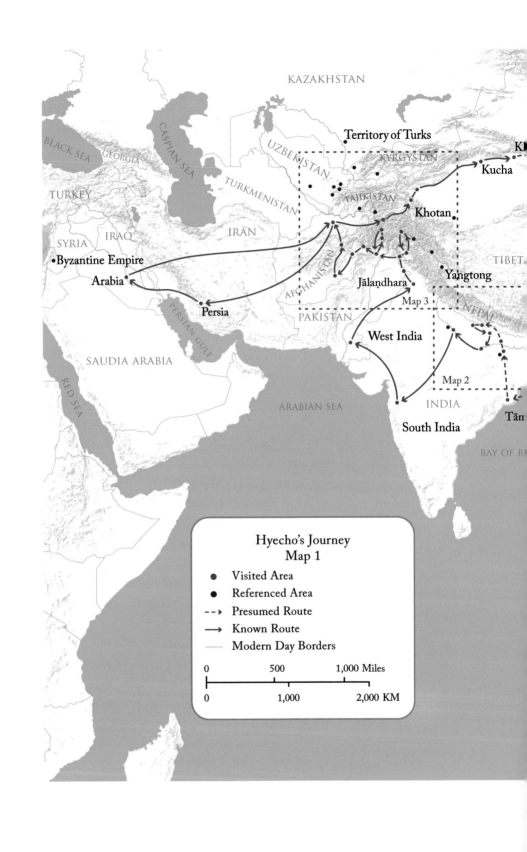

KAZAKHSTAN

BLACK SEA
GEORGIA

CASPIAN SEA

TURKEY

UZBEKISTAN

KYRGYSTAN

Territory of Turks

KI

Kucha

TURKMENISTAN

TAJIKISTAN

Khotan

SYRIA IRAQ

IRAN

•Byzantine Empire

Arabia•

Persia

AFGHANISTAN

Jālandhara

Yangtong

TIBET

Map 3

NEPAL

PAKISTAN

PERSIAN GULF

West India

SAUDIA ARABIA

Map 2

RED SEA

ARABIAN SEA

INDIA

South India

Tān

BAY OF BE

Hyecho's Journey
Map 1

● Visited Area

● Referenced Area

--→ Presumed Route

—→ Known Route

— Modern Day Borders

0 500 1,000 Miles

0 1,000 2,000 KM

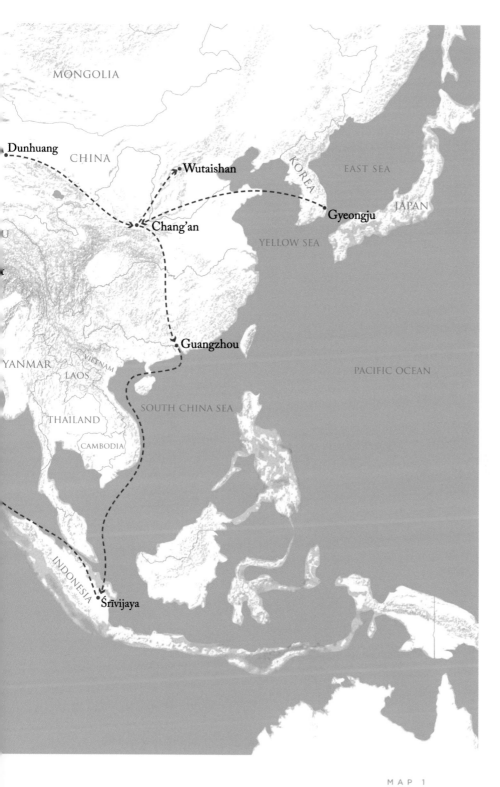

MAP 1

Hyecho's Journey, 724–727 CE.

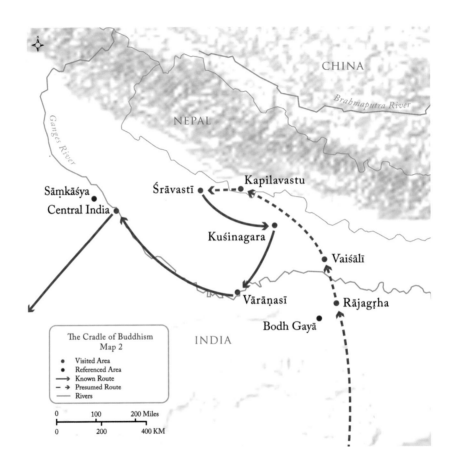

MAP 2

The Cradle of Buddhism.

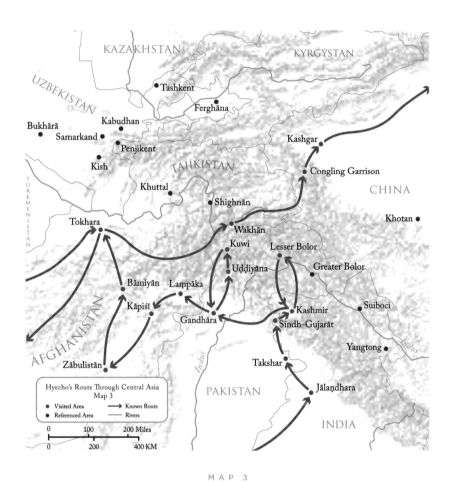

MAP 3

Hyecho's Route Through Central Asia.

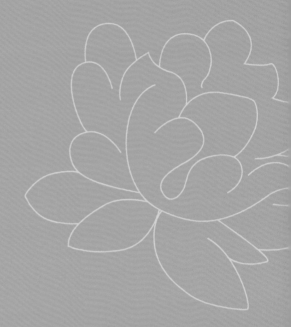

INTRODUCTION

Tracing Hyecho's Route

. . .

As the Buddha, eighty years old, lay on his deathbed, ready to pass into nir-vāṇa, his devoted attendant, his cousin Ānanda, asked him a series of questions, his last chance to receive advice from the enlightened one. One of the questions was how the monks and nuns and the laymen and laywomen should honor the Buddha after he is gone. Ānanda recalls that over the years, after the annual rains retreat—that is, after the three-month period of the monsoon, during which monks were required to remain in one place—the monks would all go to see the Buddha and to meet the other monks who had come to honor him. The monks have found great benefit in this practice. Ānanda laments that after the Buddha is gone, the monks will never be able to see him again. The Buddha replies, suggesting a substitute:

There are four places, Ānanda, that a pious person should visit and look upon with feelings of reverence. What are the four? "Here the Tathāgata was born." This, Ānanda, is a place that a pious person should visit and look upon with feelings of reverence. "Here the Tathāgata became fully enlightened in unsurpassed, supreme enlightenment." This, Ānanda, is a place that a pious person should visit and look upon with feelings of reverence. "Here the Tathāgata set rolling the unexcelled wheel of the dharma." This, Ānanda, is a place that a pious person should visit and look upon with feelings of reverence. "Here the Tathāgata passed away into the state of nirvāṇa in which no element of clinging remains." This, Ānanda, is a place that a pious person should visit and look upon with feelings of reverence.

These, Ānanda, are the four places that a pious person should visit and look upon with feelings of reverence. And truly there will come to these places, Ānanda, pious monks and nuns, laymen and laywomen, reflecting: "Here the Tathāgata was born. Here the Tathāgata became fully enlightened in unsurpassed, supreme enlightenment. Here the Tathāgata set rolling the unexcelled wheel of the dharma. Here the Tathāgata passed away into the state of nirvāṇa in which no element of clinging remains."

And whoever, Ānanda, should die on such a pilgrimage with his heart established in faith, at the breaking up of the body, after death, will be reborn in a realm of heavenly happiness.[1]

The term translated as "pilgrimage" here is *cetiyacārika* in the original Pāli, meaning "wandering to shrines." The word often translated as "shrine" is *caitya* in Sanskrit (*cetiya* in Pāli). It is related to *citi* and *cayana*, words used in the Hindu Vedas to refer to piling bricks to make fire altars. A related

term, relevant in the case of the Buddha, is *citā*, which refers to piling wood for a funeral pyre. Thus, the term translated as "shrine" and, by extension, the word translated as "pilgrimage," derive from the ancient Indian practice of making mounds as funerary monuments.

The Buddha lists the sites of the four defining events of his long life—his birth in Lumbinī Garden; his enlightenment under the Bodhi Tree in Bodh Gayā; his first sermon, when he set forth the middle way, the four noble truths, and the eightfold path to the "group of five" in the Deer Park in Sarnath, near Vārāṇasī; and the event that was about to occur, his passage into nirvāṇa at Kuśinagara. In keeping with the Buddha's deathbed instructions, Buddhists visited these and other places associated with his life. The practice of pilgrimage was thus recommended by the Buddha himself, and he promised the reward of rebirth in heaven to those who might die along the way.

Scholars have speculated that the Buddha may not have said this, that the passage about pilgrimage may have been interpolated into the account of the Buddha's last days long after his death, when the four places of pilgrimage had already been established, in an effort to encourage the pious to visit them. We know, for example, that by the time of the emperor Aśoka, who ruled much of what is today India, Pakistan, and Afghanistan about one hundred fifty years after the death of the Buddha (his reign is placed c. 268–232 BCE), the four places of pilgrimage were sufficiently famous that he had monuments built there. According to later legends, the emperor went in person to worship at each of these places, guided by the aged monk Upagupta.

What is certain is that this passage inspired many to set out on the journey, not just those living in India, but, as Buddhism spread across Asia, people from many other Buddhist lands. This book is the story of one such pilgrim. His name is Hyecho. He was not the first monk to make the journey from China to India. He was not the last. He was not the most famous. In fact, he was among the most obscure of those whose names are known. Many more have been forgotten.

Hyecho (Huichao in Chinese) is not as famous as Faxian, the first of the great Chinese pilgrims, who set off from China in 399, returning in 413 with the texts he had collected. His *Record of the Buddhist Kingdoms* (*Foguo ji*) was among the first Buddhist texts to be translated into a European language, into French in 1836. He is not as famous as Xuanzang, who departed from China in 627 and returned in 645 with more than six hundred Buddhist manuscripts and devoted the rest of his life to their translation. Hyecho is not as famous as Yijing, who set out from China in 671 and returned in 695. Yijing spent several years in Sumatra, translating the massive monastic

code into Chinese, and then returned briefly to China in 689 to obtain more paper and ink.

Why, then, have we chosen Hyecho as the hero of our story? He was not a great scholar who composed famous treatises. All that we have is a fragment of a travel journal, entitled *Memoir of a Pilgrimage to the Five Kingdoms of India* (*Wang wu Tianzhuguo zhuan* in Chinese, *Wang o Cheonchukgukjeon* in Korean). It is not the work of a sophisticated writer. Somewhat colloquial in both vocabulary and grammar, the journal is marked by odd word order and consistent misuse of certain verb forms, as would be typical of someone who could speak Chinese but had not learned to write well.[2] The five poems that appear in Hyecho's travel journal are of higher quality, in most cases conforming to the conventions of regulated verse that were used during the Tang Dynasty.

Hyecho is not remembered as a translator. Although he seems to have been involved in the translation of tantric texts, he is listed only as the *bishou* or "recorder of the translation." We do not know why he went to India, we do not know with certainty when he went or the route he took to get there, and we know little of his long life after he returned. The most common motivation for Chinese monks to make the pilgrimage to India was to retrieve Sanskrit texts. Indeed, the Chinese term *qujing* (literally "fetching scriptures") became another term for "pilgrimage." A standard feature of the travel accounts of Chinese monks is the titles of the texts that they brought back from India.

Xuanzang's pilgrimage was a feat of such fame that almost a thousand years later it was fictionalized as *Journey to the West* (*Xiyou ji*), one of the most beloved works in Chinese literature. Xuanzang is the model for one of the protagonists, the virtuous but rather timid monk Sanzang, who is rescued from one colorful catastrophe after another by the monkey Sun Wukong. Even here, a list of the scriptures that Sanzang and his motley disciples receive from the Buddha is provided. Yet Hyecho seems to have returned with empty hands.

The great center of Buddhist learning in India at the time was the monastery of Nālandā, not far from Vulture Peak, a place that Hyecho visited. Both Xuanzang and Yijing, as well as several Korean monks, studied there for years. Hyecho does not mention it. Over the course of his life, he saw more of the Buddhist world than perhaps any other monk in the history of the tradition. And yet he left no mark upon it. His very obscurity—the fact that he was not a famous translator, a great scholar, or a royal preceptor, the fact that he was not an "eminent monk"—is the source of a certain fascination.

Some time around 721, this eighteen-year-old Buddhist monk left his native Korea (unified under the rule of the Silla state at the time) for China. He later set out by sea from Guangzhou in southern China, stopping for some time on the island of Sumatra in modern Indonesia, arriving in India in 724. His pilgrimage took him to many Buddhist sacred sites, perhaps continuing as far west as Arabia. Turning east, he traveled along the Silk Road, arriving back in Chinese territory in 727. For the rest of his life, Hyecho remained in China, assisting in the translation of esoteric Buddhist scriptures and performing rituals for the court. Among the more than fifty Chinese and Korean pilgrims to journey to India during the Tang Dynasty, his travels were by far the most extensive. Yet we know him only from a fragment of his travel journal, discovered by the French Orientalist Paul Pelliot in 1908 among tens of thousands of documents in the "Library Cave" at Dunhuang (fig. 1).

Starting in China, Hyecho continued to Vietnam, Indonesia, and perhaps to Myanmar (using today's names). He then arrived in India, visiting the cradle of Buddhism, where the Buddha lived and died. Turning to the south, he saw great cave temples, carved into solid rock. Leaving India, he traveled extensively through what are today the countries of Pakistan, Afghanistan, and Iran, where, prior to the rise of Islam, Buddhism was a powerful presence. And he witnessed some of the first Muslim incursions into northwestern India. Hyecho returned to China along the Silk Road, stopping at the great cave temple complex of Dunhuang.

Hyecho saw parts of the Buddhist world of India and Central Asia at their cultural peak. He saw other regions of the Buddhist world at the cusp of great transformations. He saw others that were in decline; some had been abandoned. Buddhism had been introduced at the Tibetan court in the seventh century, but the first monastery would not be founded until 797. A Buddhist renaissance was about to begin in Bengal, with the founding of the Pāla Dynasty around 750 and the building of the great monastery of Vikramaśīla around 800. In Java, Borobudur, perhaps the greatest Buddhist monument in the world, was being built under the patronage of the Śailendra Dynasty. In Vietnam, Mahāyāna Buddhism was establishing its roots.

Hyecho witnessed Buddhism in India during an age in which the great philosophical schools of both the mainstream (that is, non-Mahāyāna) schools and the Mahāyāna were thriving, the great monastic universities, like Nālandā, were flourishing, and something new was occurring: the rise of Buddhist tantra, which went largely unnoticed by the Chinese pilgrims.

Before turning in earnest to Hyecho's journey, we will briefly describe the travels of three of the most famous monks who went on the perilous

pilgrimage to the land of the Buddha's birth. Hyecho and his *Memoir of a Pilgrimage to the Five Kingdoms of India* are dwarfed by three renowned Chinese pilgrims and their accounts of their travels: Faxian, Xuanzang, and Yijing, each of whom preceded him to India. Faxian (337–422) was the first, leaving China in 399 and returning in 413. The account of his journey, *Record of the Buddhist Kingdoms* (*Foguo ji*, also known as the *Faxian zhuan* or *Record of Faxian*) is a relatively brief work, recounting his visits to many important pilgrimage sites in India. Traveling overland from China to India and then returning by sea, he not only describes the places that he visits but recounts the Buddhist stories associated with them. Hyecho, writing more than three centuries later, makes only occasional allusions to the stories and events associated with Buddhist sites, perhaps assuming that they would already be known to his readers.

The most eminent of the Chinese pilgrims to India was Xuanzang (600–664). His sojourn in South Asia—setting out in 627 and returning in 645—was among the most consequential in Buddhist history, in part because of the hundreds of texts he brought back for translation and in part because of his detailed record of his travels, entitled the *Great Tang Record of the Western Regions* (*Da Tang xiyu ji*).

Xuanzang, traveling to India and back by land, visited many of the places that Hyecho later visited; the two accounts offer an important comparison of the same sites a century apart. Xuanzang, however, provides far more detail. He seems to have had substantive interactions with many people, both commoners and kings, whom he met in his travels. He includes detailed information on geography, language, climate, and local customs, while also offering careful accounts of the state of Buddhism in each region. Sometimes he finds it flourishing, sometimes in a serious state of decline.

Hyecho's third predecessor was the monk and translator Yijing (635–713). He set out for India by sea in 671 and returned by sea in 695. His account of his travels is called *Tales of Returning from the South Seas with the Inner Dharma* (*Nanhai jigui neifa zhuan*). Far less interested in ethnography than Xuanzang, Yijing focused especially on observing and recording the proper performance of the rules and rituals of monastic life in the places he visited. He remained abroad long enough to learn a great deal, spending ten years at Nālandā and another ten years in Sumatra, which he describes as a thriving center of Buddhism. It was in Sumatra that he undertook his translation of the lengthy Mūlasarvāstivāda vinaya, one of the major monastic codes of Buddhism. Yijing not only recorded his own travels to India, but he also compiled biographies of monks who had made the journey, in a work called

Great Tang Biographies of Eminent Monks Who Sought the Dharma in the Western Regions (*Da Tang xiyu qiufa gaoseng zhuan*). Fifty-six monks are described there, forty-nine Chinese and seven Koreans.[3]

Hyecho's journal pales in comparison to these works. Unlike theirs, it survives only in fragments; it is impossible to know how his full work would have compared in size. Apart from the length, Hyecho's account is far less concerned with Buddhism; when he describes a place, he tends to focus on the customs of the local people (especially dress, diet, and whether capital punishment is practiced), often offering a perfunctory and rather formulaic description of any Buddhist presence, noting whether or not the king and his subjects revere the three jewels and whether the monks are Hīnayāna or Mahāyāna.

Hyecho uses the terms "Hīnayāna" and "Mahāyāna" often in his travel journal to describe the affiliations of the monks and monasteries he encountered along the way. It is noteworthy that he does not use the word "tantra" or any of its several synonyms. Before traversing Hyecho's world in the physical sense, let us briefly consider these terms, so important to his conceptual world, and hence to our understanding of him.

HYECHO'S BUDDHISM

As just noted, standard elements of Hyecho's descriptions of the places he visits include whether Buddhism is practiced there and, if so, what kind. In these usually brief notes, he does not use the term "Buddhism." He says instead some version of "The kings, chiefs, and common people revere the three jewels." The three jewels are the Buddha, the dharma, and the saṃgha. The standard profession of faith in Buddhism is to say, "I go for refuge to the Buddha. I go for refuge to the dharma. I go for refuge to the saṃgha." Like the professions of faith in other religions, these three simple sentences are the subjects of complex commentary. However, in brief, the notion of refuge refers to a place of protection from suffering, especially the sufferings in the next life. It is the Buddhist contention that only the three jewels provide such protection, not any deity or demigod (although in practice Buddhists continue to propitiate local deities for their assistance in less ethereal concerns than rebirth and liberation from it). Exactly what the Buddha, dharma, and saṃgha are is also the subject of extensive commentary, especially in light of the doctrine of the three bodies of the Buddha. However, it is generally said that the Buddha is a place of refuge because he is the only teacher who has abandoned all faults and acquired all virtues.

The dharma in this context generally means the Buddha's teaching but is sometimes specified as nirvāṇa itself, the ultimate refuge from suffering. The term "saṃgha" simply means "community" in Sanskrit, and in common parlance it refers to the community of ordained monks and nuns (and in the patois of modern Buddhism, the congregation of a Buddhist church or "dharma center"). However, in the context of the refuge formula, it also has a specific meaning, referring only to the community of the enlightened, that is, those who have attained one of the four levels of the path. The Buddha, the dharma, and the saṃgha are called "jewels," it is said, because, like jewels, they are difficult to find and, when found, are of great value. Thus, when Hyecho says that the people of a given region revere the three jewels, he means that they are Buddhists, which, at most times and places, means that they support the community of monks and nuns through their offerings and that they pay homage to Buddhist sacred objects, such as images and stūpas.

In those regions where the people revere the three jewels, Hyecho often provides some further description, with phrases like "Both Mahāyāna and Hīnayāna are practiced there." These terms, both often misunderstood, require some explanation. The term "Mahāyāna," which, notably, Hyecho always mentions first in the sequence, is in some ways the easier of the two terms. It means "great vehicle" and was originally a term of self-appellation used by those in India who were adherents of one or more of the new scriptures that began to appear about four hundred years after the Buddha's passage into nirvāṇa, the so-called Mahāyāna sūtras. These texts offered a number of innovations, or revisions of Buddhist doctrine, particularly around the person of the Buddha and the path to buddhahood. It should be said, however, that the deviations from the previous tradition are in many cases less acute than often represented. By the time Hyecho made his journey, the famous Mahāyāna sūtras—works like the *Lotus Sūtra*, the *Diamond Sūtra*, the *Flower Garland Sūtra*, the *Vimalakīrti Sūtra*, and the *Perfection of Wisdom in Eight Thousand Stanzas*—had been composed, and exegetical schools had developed that derived doctrinal systems from their disparate pronouncements. The two major schools called themselves Yogācāra ("practitioners of yoga," also known as Cittamātra, "mind only") and Madhyamaka ("followers of the middle way").

One of the challenges for adherents of what came to be called the Mahāyāna (a term that was coined long after the Buddha's death) was how to refer to the various traditions of Buddhism that preceded it. This challenge remains to the present day. The authors of the Mahāyāna sūtras had to justify their existence, defending their claim that their scriptures were the

word of the Buddha; their opponents argued that those sūtras were spurious. As is so often the case in religious polemics, the followers of the Mahāyāna sought to belittle their critics, coining a pejorative term to describe them (one thinks of terms like "Quaker" and "Shaker" in English). That word was "Hīnayāna." This term is often rendered in English as "lesser vehicle" or even "individual vehicle," but this is to bowdlerize the original. When one looks up *hīna* in the Sanskrit dictionary, the definitions include "deficient," "defective," "poor," "vile," and "base." It is obviously not a term that those who rejected the Mahāyāna ever used to describe themselves, and the fact that Hyecho uses it marks him as a proponent of the Mahāyāna.

Over the centuries, scholars, both Buddhist monks and European academics, have filled many pages attempting to explain exactly what the Mahāyāna is and how it differs from the Hīnayāna. Yet one of the clearest explanations is also one of the most succinct. It comes from Yijing (mentioned above), who wrote, "Those who worship bodhisattvas and read Mahāyāna sūtras are called Mahāyāna, while those who do not are called Hīnayāna."

What then to call the traditions of Buddhism that predated the rise of the Mahāyāna and their adherents who never accepted the Mahāyāna sūtras as the authentic words of the Buddha? In the language of modern Buddhism, such Buddhists are often called Theravāda, the "way of the elders," referring to the Buddhist tradition of Sri Lanka and the Buddhist countries of Southeast Asia: Myanmar, Thailand, Cambodia, Laos, and parts of Vietnam. However, the term "Theravāda" is not appropriate for describing Buddhism during Hyecho's time; coined by a British convert, it was not used to refer to an autonomous branch of Buddhism until the twentieth century. Sometimes the pre-Mahāyāna schools are called "Nikāya Buddhism," because there were many schools (called *nikāya*, or "group"). Here, we will refer to those many Buddhist schools that did not accept the Mahāyāna sūtra as the word of the Buddha as "mainstream schools."

In the centuries following the Buddha's death, a number of such schools developed, some along regional lines. Although there were some differences among them on points of doctrine, they differed primarily on the constituents of the monastic code (vinaya), over points that strike the modern reader as rather minor, such as whether a monk's sitting mat can have fringe and whether the monk's daily meal, which must be completed by noon, could instead be completed when the sundial was two fingerbreadths past noon. These various schools—of which eighteen were included in a traditional list, but in fact there were more—tended to accept the same canon of sacred scriptures. The word "canon," however, is misleading in this context, since

for several centuries after the Buddha's death, his teachings were primarily preserved orally, with different groups of monks within a monastery responsible for the memorization and recitation of different sections of the canon.

A number of these schools survived throughout the long history of Buddhism in India, including during Hyecho's time. They continued to uphold the early canon and to reject the claim that the Mahāyāna sūtras are the word of the Buddha. Evidence of their persistent resistance is found in some of the Mahāyāna sūtras themselves. In the *Lotus Sūtra*, for example, the Buddha (as portrayed by the authors of the sūtra) repeatedly extols those who accept the *Lotus Sūtra* as his word, describing the wonders that await them, and condemns those who reject it, describing the horrors of hell to which they are doomed. The great masters of the Mahāyāna, beginning with Nāgārjuna and continuing to the demise of Buddhism in India more than a millennium later, often include in their treatises a defense of the Mahāyāna as the word of the Buddha.

The ambiguous fate of the Mahāyāna in its native India—where it likely remained a minority movement and, like the rest of Buddhism, eventually disappeared—was not reflected in the movement of Buddhism beyond. As a result of a series of historical factors, the Mahāyāna became the dominant form of Buddhism in China, Korea, Japan, Tibet, and Mongolia, with the "Hīnayāna" becoming little more than a scholastic category, a school without teachers and students. It was only in the south, first in Sri Lanka and later in Southeast Asia, that a remnant of the early schools survived and later flourished, in what is today called the Theravāda (the "way of the elders"), a term of very recent provenance.

With minor variations by region, the one thing that all monks shared, regardless of whether they accepted the Mahāyāna sūtras, was the monastic code. This is what made it possible for both "Hīnayāna" and Mahāyāna monks to live together in the same monastery, as Hyecho observed, likely to his amazement, since the Mahāyāna is the only Buddhism he would have known in his native Korea or in China.

As noted above, there is one more category of Buddhism that requires discussion, a category that has been used traditionally and by modern scholars, the category of tantra. Prior to his departure for India, Hyecho went to Guangzhou in southern China, where, in 719, he may have met Vajrabodhi and Amoghavajra, who had arrived by sea from India and were making their way to Chang'an, the capital of Tang China. Together with the Indian scholar-monk Śubhakarasiṃha, who had arrived in Chang'an by the Central Asian land route in 716, they have long been regarded as the central

figures in introducing Buddhist tantra or "esoteric Buddhism" to China and hence to East Asia. This raises the vexed question, What is Buddhist tantra? This is a question that scholars of Indian Buddhism continue to debate, a question that gains a further layer of complexity in China.

Tantric practice in Buddhism is often centered on rituals intended to bring specific benefits, often "worldly" benefits, through invoking various deities (which can include buddhas and bodhisattvas) through the drawing of maṇḍalas and through the recitation of mantras, as well as longer incantations called *dhāraṇī*. The sexual imagery so often associated with tantra in the West is certainly present, but it represents only one domain of a larger tradition, a domain that was never as important in China as it became, for example, in Tibet. Indeed, the representation of tantric practice in late Indian Buddhism (and hence in Tibetan Buddhism) as constituting a separate vehicle, the Vajrayāna, and the formation of a separate school in Japan, the Shingon, which saw itself as the special domain of esoteric teachings (*mikkyō*), may obscure the less autonomous status of Buddhist tantra in India and China during Hyecho's lifetime.

A number of scholars have argued that much of what is deemed Buddhist tantra is largely the amalgamation and ritualization of elements long present in Buddhism. The various spells called "mantra" and *dhāraṇī*, generally regarded as defining elements of Buddhist tantra, appear throughout the Buddhist canon. In the Pāli scriptures, there are numerous works called *paritta* ("protection"), which the Buddha prescribes for protection from snakes, scorpions, evil spirits, and various illnesses. A chapter of *dhāraṇī* was a standard section of many Mahāyāna sūtras, including such famous works as the *Lotus Sūtra*.

It is thus not the case that all texts that carry the word "sūtra" or "tantra" in their titles are concerned with the liberation from rebirth and the achievement of buddhahood. Tantric works offer practices for attaining *siddhi*, that is, "accomplishments" or "powers," and tantric exegetes distinguish between "mundane accomplishments" (which include all manner of magical powers) and the single "supramundane accomplishment" of buddhahood. The majority of texts classified as "tantric" are concerned with the former.

If tantra is not, then, a fundamentally separate tradition in Buddhism, what is it? The works that masters such as Vajrabodhi and Amoghavajra brought to China dealt with such topics as astrology, divination, the prevention of natural disasters, the subjugation of demons, the protection of the state, and the longevity of the monarch. The newly arrived Indian masters translated these texts into Chinese, performed initiations, built elaborate altars for the performance of elaborate rituals, provided initiations to the

royal family, and trained Chinese monks to perform those rituals themselves. Their ceremonies were apparently potent, because their services were sought throughout their years in China. They themselves seem not to have represented their Buddhism as anything new or as an independent school, lineage, or vehicle. Nor does it appear that their Chinese hosts saw them that way; mantra, *dhāraṇī*, and all manner of apotropaic rituals had been part of Chinese Buddhist practice long before the arrival of the Indian masters. Indeed, their success at the Tang court likely derived not from the fact that their magic was different but from the fact that their magic was better. The services that they provided had been provided to Chinese emperors by Daoist priests for centuries.[4]

Thus, whether or not Hyecho met Vajrabodhi and Amoghavajra in Guangzhou prior to setting sail for India, the absence of anything that might be deemed "tantric" in his travel journal can be read in a number of ways. One of those ways would be to conclude that, like the teachings of the Indian masters with whom he would study upon his return, what he encountered in India was, to him, simply Buddhism.

HYECHO

We know very little about Hyecho. He is not mentioned in any of the several compilations of "lives of eminent monks," a genre that began in the sixth century with the famous text by Huijiao (497–554) and continued for several centuries. The version by the monk Zanning (919–1001), *Song Biographies of Eminent Monks* (*Song gaoseng zhuan*), contains biographies of more than five hundred monks. Hyecho is not included. Even though, after his return from India, he seems to have been involved in translation projects under the direction of the renowned Indian tantric master Amoghavajra, he is not listed among the thousands of authors, translators, and editors of the thousands of texts that constitute the Chinese Buddhist canon.

Hyecho was probably born between 700 and 704; he is thought to have died around 780. His motivations for undertaking his remarkable journey are unknown. It was not uncommon for Korean monks to study in China during the Sui and Tang dynasties, and many spent their entire lives there. At the same time, the number was not large; Hyecho was one of forty-one Korean monks known to have gone to China in the eighth century, from the large monastic population in Silla.[5] Thus, the fact that he traveled from Korea to China is merely noteworthy. His journey to India, especially at such a young age, is remarkable, however. Between 500 and 800 CE, fourteen Korean monks set out for India. Of these, only two returned to Silla.[6]

Because Hyecho appears to have been a disciple of the Indian tantric master Vajrabodhi when he returned from India, some scholars have speculated that he became his disciple before he left for India. According to one account, Vajrabodhi and Amoghavajra, arriving by the sea route from India (stopping along the way in Śrīvijaya), stopped in Guangzhou in 719 as they proceeded to the capital. Some speculate that Hyecho met them there and, either on their instruction or inspired by their example, set out for India via the same route, either to study tantric Buddhism or to retrieve tantric scriptures. Yet the fragments that remain of Hyecho's travel journal make no mention of tantric Buddhism, and, unlike so many Chinese pilgrims to India, he seems not to have brought back any scriptures of this or any other Buddhist tradition.

The date of Hyecho's arrival in India and the length of time he spent there is also subject to speculation. He states that he arrived in the Anxi Protectorate in Kucha, the far western outpost of the Tang Empire, in the twelfth lunar month of 727. Because he often provides his travel time from one place to the next, it can be calculated that he arrived in Kuśinagara—the site of the Buddha's passage into nirvāṇa and the first place described in full in the surviving fragment—sometime in 724.

Apart from the terms from his journal that appear in a pronunciation glossary called *Pronunciations and Meanings of All the Scriptures* (*Yiqiejing yinyi*) by the monk Huilin (discussed in chapter 1), we find no reference to Hyecho's journeys elsewhere in the vast literature of Chinese Buddhism.

HYECHO'S MOTIVATIONS

We do not know exactly when Hyecho was born. We do not know when he entered the Buddhist order. We do not know why he went to China. And we know very little about Hyecho's motivations for undertaking his journey to India or how he chose his route. The five poems that appear in the surviving fragments of the journal express sadness and homesickness, common emotions in Chinese poems penned by those traveling—either by choice, by necessity, or by imperial order—far from home. Only one poem contains Buddhist allusions and thus offers some insight into what may have motivated the young monk to set out on his journey:

> Undaunted by the distance to buddhahood,
> Why should I think the Deer Park far?
> I am only daunted by the dangers of rugged mountain paths;
> I give no thought to the gusts of karmic winds.

The eight stūpas are difficult to truly see.
They have all passed through the cosmic fires.
How can my own vow be fulfilled?
Yet I saw them with my own eyes this very day.[7]

The first four lines contrast Hyecho's spiritual and physical journeys. The term translated as "buddhahood" in the first line is *puti* in Chinese, *bodhi* in Sanskrit. Often translated as "enlightenment," here it refers to the enlightenment of a buddha that Hyecho, a Mahāyāna monk, has vowed to attain. The path of the bodhisattva, one who aspires to buddhahood, is long, encompassing billions of lifetimes and several aeons. If Hyecho has vowed to achieve buddhahood and traverse the long path to enlightenment, why should he be worried about walking from Bodh Gayā to the Deer Park in Sarnath—the site of the Buddha's first sermon—a mere 160 miles away? His journal suggests that he had already made the journey, that he had already traveled from Sarnath to Bodh Gayā. Again contrasting the spiritual and the physical in the next two lines, he says that he is not concerned about the karmic headwinds—the consequences of his own past negative deeds—that will impede his progress to enlightenment. His concerns are more immediate: the many dangers that lurk along the mountain paths he must traverse to travel from one sacred site to the next.

It is difficult to imagine what confronted a young Korean monk, perhaps twenty years old, arriving on the northeastern coast of India around 724. Was he alone, or with other pilgrims? He does not say. Did he have a map? If not, how did he make his way from sacred site to sacred site? There must have been an established route for Buddhist pilgrims, but how did he find it? Where did he stay, and what did he eat? And how did he come to stray so far from the Buddhist holy land, ending up in Arabia before finally turning east to return to China? He does not say.

It is clear, however, that the world that Hyecho traveled through was not simply a Buddhist world. It was a world of many, and unfamiliar, kings, peoples, languages, cuisines, and material things. During the short duration of his travels through India, Hyecho would have been unaware of the depth of the political and military conflicts that defined the region in the eighth century. He was not unobservant, however. In his brief observations, he made note of abandoned cities near important centers of pilgrimage, the desolate remains of earlier centers of power and of the powerful city of Kanauj (Kānyakubja) to the west, which had supplanted them. He recorded the size of armies (in elephants) and the strength of kings, as well as economic staples and systems of taxation.

In addition to traveling through lands of many kings, Hyecho's pilgrimage to the "eight great stūpas" in the Buddha's life also took him through lands whose inhabitants adhered to—and whose rulers sponsored—diverse religious traditions and practices, worshipping Hindu deities and local gods and goddesses, as well as the Buddha. This was a complex world in a dynamic time.

One of the constant themes in the accounts of Buddhist pilgrims to India, whether they were from China, Korea, or Tibet, is the danger of travel there. Of the many who set out, many never returned. The Chinese monk Yijing recommended that pilgrims stop in Sumatra to study Sanskrit before continuing on to India. It is likely that Hyecho's ship would have stopped there, but it is unclear how long he might have stayed and how much Sanskrit, if any, he might have learned during what was likely a brief stay. Regardless, a knowledge of Sanskrit would have been of little use to him when he arrived in Bengal, knowing none of the several vernaculars of the India of his day. Pilgrims from China and from elsewhere in Asia were confronted with languages they could not understand, foods they did not recognize, a climate with seasons they had not encountered, and local peoples who were sometimes hostile. Most dangerous of all, there were all manner of snakes, insects, and diseases that claimed the lives of many.

The pilgrims were also easy prey for bandits who would take their possessions—including the gold that many carried as offerings to the monasteries where they sought to study—and sometimes their lives. Yijing reports that he once became separated from his group and was stopped by bandits with drawn bows who stripped him of all of his clothes. Relieved to be left with his life, he rolled in the mud, covered his private parts with leaves, and proceeded on his way.[8] Hyecho himself wrote, "Though there are many bandits on the roads, when travellers simply relinquish their belongings, they are just left alone and not [injured or] killed. However, if travellers hold too dearly to their possessions, they are likely to meet injury."[9] Thus, because of the great distance and the dangers encountered along the way, "The eight stūpas are difficult to truly see." And it is difficult for the scholar to identify what he meant by this term.

As noted earlier, at the time of his death, the Buddha instructed his followers to visit the sites of the four major events of his life: his birth, his enlightenment, his first sermon, and his death. However, he told his followers to entomb his remains in a single stūpa. After his death, a dispute arose over who should take possession of his remains. A compromise was reached when the relics were divided into eight and given to various groups, each of

whom constructed a stūpa. Hyecho, however, does not seem to be alluding to these eight.

At two different points in his journal, Hyecho lists "four great stūpas." Neither list conforms to the four sites recommended by the Buddha at the time of his death. First, in his description of Vārāṇasī and nearby Sarnath, he lists the Deer Park at Sarnath, where the Buddha gave his first sermon; Kuśinagara, where he passed into nirvāṇa; the city of Rājagṛha, where he often visited and where, on nearby Vulture Peak, he gave many discourses; and the Mahābodhi, where the Buddha was enlightened. Later in the text, he lists the four stūpas in central India: Kapilavastu, the Buddha's home city, near the site of his birth in Lumbinī Garden; Sāṃkāśya, where the Buddha returned to earth after teaching the dharma to his mother in the Heaven of the Thirty-Three on the summit of Mount Sumeru; the Āmrapālī Grove in Vaiśālī, a gift to the Buddha from a disciple, the wealthy courtesan Āmrapālī, and where he gave a number of famous discourses; and the Jetavana Grove in Śrāvastī, the gift of the Buddha's wealthy disciple the merchant Anāthapiṇḍada and where he performed a famous miracle. Taken together, Hyecho's two lists represent the so-called eight "great sites" (Sanskrit *mahāsthāna*, Chinese *lingdi*) where Śrāvastī is mentioned, because it was there that the Buddha performed the famous twin miracle (see chapter 8); Rājagṛha is included not for its proximity to Vulture Peak but because there the Buddha tamed the wild elephant Nālāgiri; and Vaiśālī is included because there the Buddha accepted a gift of honey from a monkey.[10]

The first half of Hyecho's poem is about space and place, the distance to enlightenment, the distance to the Deer Park. The second half of the poem is about time:

> The eight stūpas are difficult to truly see.
> They have all passed through the cosmic fires.
> How can my own vow be fulfilled?
> Yet I saw them with my own eyes this very day.

According to Buddhist cosmology, a world passes through four stages, each called a "great aeon" (*mahākalpa*). The first is the aeon of nothingness, empty space. This is followed by the aeon of creation, in which the physical universe slowly comes into existence. This is followed by the aeon of duration, in which the world is fully formed and inhabited by various beings. This is followed by the aeon of dissolution, when the entire world is incinerated by seven suns that rise in the sky. The term "cosmic fires" in Hyecho's

poem—literally "fires at the end of each age" in the Chinese—alludes to this final conflagration. Yet Hyecho says that the eight stūpas have passed through the cosmic fires. He is likely referring to the declaration that certain sacred sites in the Buddhist world are indestructible, able even to survive the fires of the aeon of dissolution. For example, speaking of Vulture Peak, the Buddha says in the *Lotus Sūtra*, "When sentient beings see themselves amidst a conflagration at the end of a *kalpa*, it is in fact my tranquil land always full of devas [gods] and humans."[11]

Still, the doctrine of impermanence is the hallmark of Buddhist thought, and disintegration is a constant theme, across measures of time both long and short. Hyecho was visiting India more than a thousand years after the Buddha had passed into nirvāṇa. According to Buddhist theories of time, the death of the Buddha begins a period of inexorable decline. As the Buddha and then his own disciples pass away, it becomes more and more difficult to practice the dharma, more and more difficult to follow the path to enlightenment. Although this process is sometimes referred to as "the decline of the dharma," it is not so much the dharma that declines but the capacity of human beings to put it into practice. With the passage of time, humans increasingly lack the intelligence, the diligence, and the morality to follow the Buddhist path to its conclusion. Five specific degenerations are sometimes listed: (1) degeneration of the life span, because human life spans are decreasing; (2) degeneration of views, because wrong views prevail; (3) degeneration of afflictions because negative states of mind are increasing in strength; (4) degeneration of sentient beings, because the inhabitants of saṃsāra are mentally and physically inferior to those who preceded them; and (5) degeneration of the age, because the world and the environment are in decline.

If the eight great sites endure horrific holocausts, and the capacity to practice the dharma dwindles, Hyecho asks, "How can my own vow be fulfilled?" This may be his vow to visit the eight sites, or, perhaps more likely, it is his vow to achieve buddhahood, a vow that must survive many aeons and pass through many cosmic fires. As he stands before the Mahābodhi, the place of the Buddha's enlightenment, this leads him to conclude, with a sense of wonder, "Yet I saw them with my own eyes this very day."

We have little idea of the state of the Mahābodhi at the time of Hyecho's visit; when Xuanzang visited a century before, it was still an active place of pilgrimage; many shrines marked the momentous events of the Buddha's enlightenment and the seven weeks that followed. Hyecho's journal mentions none of this, although there is a lacuna in the text at this point.

Despite the intimation of joy that ends Hyecho's poem, the Buddhist pilgrim to India must have arrived at the sites with feelings of both elation and despair. He was elated to have finally arrived at the places where the Buddha had been born, had been enlightened, had taught the dharma, and had passed into nirvāṇa. Each of these had its own potency, but none more than Bodh Gayā, the site of the enlightenment of the Buddha and all one thousand buddhas of the Fortunate Age (*bhadrakalpa*). And yet, there was despair, for the pilgrim had arrived too late. The Buddha's attendant, Ānanda, had failed to ask the Buddha to live for an aeon, or until the end of the aeon, and so he had passed into nirvāṇa long ago. Since the cycle of rebirth has no beginning, Buddhists lament not only that they were born too late, but that they were born at the wrong place when the Buddha was alive, that, as a result of their past deeds, they were elsewhere in saṃsāra when the Buddha was in India. When Xuanzang finally reached the Bodhi Tree, he threw himself on the ground and wept, saying, "At the time when the Buddha perfected himself in wisdom, I know not in what condition I was, in the troublous whirl of birth and death; but now, in this latter time of image [worship], having come to this spot and reflecting on the depth and weight of the body of my evil deeds, I am grieved at heart, and my eyes filled with tears."[12]

Hyecho found even such famous places as the birthplace of the Buddha largely deserted, increasingly engulfed by the surrounding forest, a forest filled with thieves. Monasteries and stūpas were in disrepair. Indeed, it is primarily through the reports of Chinese pilgrims that scholars have come to understand that in many parts of South and Central Asia, Buddhist institutions were in various states of serious decline long before the arrival of Muslim armies, who have long been blamed for the virtual disappearance of Buddhism from the Indian subcontinent by the thirteenth century. The fact that the eight great stūpas passed through the cosmic fires does not suggest that they survived unscathed.

HYECHO'S ROUTE

Hyecho is considered unique among the Chinese and the Korean pilgrims to India both for the extent of his travels and for his route; he was the only monk known to have traveled from China to India by sea and return to China by land.

As noted, it is not known when Hyecho left his native kingdom of Silla, located in the southeastern corner of the Korean Peninsula, and set out

for China. It is also not known whether he traveled to China by land or by sea; Korean monks traveled by both routes. If he traveled by sea, he may have made his way north to the port of Dangseong on the western coast, near the modern city of Hwaseong. From there, it was a relatively short trip across the Yellow Sea to the Shandong Peninsula. It is unclear how long he spent in China or where he went before departing by sea for India. By that time, probably in 723 or 724, a sea route had been established between India and China, with Guangzhou the main port of embarkation. Place names that appear in Huilin's *Pronunciations and Meanings of All the Scriptures*—discussed in chapter 1—suggest that his ship may have sailed down the coast to Khmer, in modern Cambodia.

The monk Yijing, who had returned to China in 695, had spent several years in the kingdom of Śrīvijaya (in the region of Palembang in modern Sumatra) on his way to and from India. He was impressed by the commitment of the monks there to the code of discipline (vinaya) and had recommended that Chinese monks on the way to India stop there, both to acclimate themselves to the South Asian climate and to study Sanskrit. Hyecho therefore likely stopped in Sumatra, but he probably did not stay long. Again, place names in Huilin's *Pronunciations and Meanings of All the Scriptures* suggest that as the ship sailed west toward India, it stopped in the Nicobar Islands before proceeding across the Bay of Bengal, finally landing at the port of Tāmralipti at the mouth of the Hooghly River, south of modern-day Calcutta. This was a major port and trade center, with roads leading to the sacred Buddhist sites and urban centers in the north. Yijing had both disembarked there when he arrived in India and embarked from there when he left, and Xuanzang reports a significant Buddhist presence, with more than a thousand monks in some ten monasteries in the vicinity.

From Bengal, Hyecho proceeded northwest toward the major Buddhist pilgrimage sites: the places of the Buddha's birth, enlightenment, first sermon, and death—which the Buddha himself had recommended at the time of his passing—as well as Vulture Peak, Śrāvastī, Vaiśālī, and Sāṃkāśya, where the Buddha had given teachings and performed miracles. There would have been well-worn pilgrim routes to these places by the time of his arrival in the early eighth century, but Hyecho's precise route is unclear. The extant manuscript begins with the final sentences of what is a description of either Śrāvastī or Vaiśālī before moving to the first full description of a site, Kuśinagara, the place where the Buddha passed into nirvāṇa. Hyecho arrived there, he says, after a month's journey; from where is not clear. He finds it, one of the four sacred sites of Buddhism, largely deserted, tended by a single monk.

He then traveled south to the vicinity of Vārāṇasī, describing what is clearly Sarnath, located about eight miles northeast of the modern city, the site of the Deer Park, where, after his enlightenment, the Buddha met the "group of five"—the five mendicants with whom he had practiced various forms of asceticism for six years—and set forth the four noble truths. Hyecho describes the lion-capital pillar erected by the emperor Aśoka and the stūpa there. He says that the monastery is filled with statues, that there is a huge gilt dharma wheel, and that the images were provided by the king Śīlāditya. Scholars assume that this king, whom Xuanzang knew and called by the same name, was Harṣavardhana, who ruled much of northern India from 606 to 647.

Hyecho then says, "Here [presumably, in the kingdom of Magadha] there are four great stūpas: the Deer Park, Kuśinagara, Rājagṛha, and the Mahābodhi." This statement provides clues about his route but also raises questions. He has already described Kuśinagara and the Deer Park, and next he describes the Mahābodhi, the site of the Buddha's enlightenment. He does not describe Rājagṛha, but the fact that he lists it among "the four great stūpas" suggests that he went there. Rājagṛha, literally, "the king's house," was the capital of the kingdom of Magadha at the time of the Buddha, ruled by his friend and patron King Bimbisāra, who was murdered and usurped by his son Ajātaśatru, who became the Buddha's disciple. Located outside of Rajāgṛha is Vulture Peak (see chapter 5), where the Buddha taught many sūtras, including the *Lotus Sūtra*, a text of great fame and influence in East Asia. Rajāgṛha is located to the south and east of Vārāṇasī; traveling from Tāmralipti, Hyecho would have reached it first. Its absence from his description may result from the fact that the section describing India prior to his arrival in Kuśinagara is lost. However, Bodh Gayā, called "Mahābodhi" by Hyecho, the site of the Buddha's enlightenment, is only forty miles southwest of Rājagṛha. There was a major road between Tāmralipti and Campā, from which Hyecho could have easily traveled west to either Bodh Gayā or Rājagṛha. Hyecho says that he saw the Mahābodhi with his own eyes and suggests that he went there from the Deer Park in Sarnath. Did he not visit Rājagṛha, the site of Vulture Peak, or is his description also lost?

Just nine miles outside the city of Rājagṛha was the great monastic complex of Nālandā, the greatest center of Buddhist learning in the world at that time and the treasured destination of many monks who made the long journey from China; both Xuanzang and Yijing had spent years there studying and acquiring texts; Xuanzang returned to China with twenty packhorses loaded with 657 texts. Indeed, in the decades prior to Hyecho's journey, a

number of Korean monks had made their way to India, spending long periods at Nālandā. The eighth-century monk Chonnyun stayed long enough to acquire a Sanskrit name, Āryavarman. A student of the vinaya, he died at Nālandā at the age of seventy. During the same period, the Korean monk Hyeeop arrived at Nālandā; he also died there, around the age of sixty. Yijing reports that during his own time at Nālandā, he saw a work by Hyeeop, composed in Sanskrit. The Korean monk Hyonjo made two trips to India. On the first, he studied for three years in Bodh Gayā and three years in Nālandā. On his second journey, he returned to Nālandā, before continuing to Amarāvatī in the southeast, where he died.[13] The descriptions of these Korean monks share a pattern. When they arrive in India, they make a pilgrimage to the sacred sites (Bodh Gayā is commonly mentioned), and then they go to Nālandā to study. Hyonjo also studied in Bodh Gayā, which was not simply a place of pilgrimage but a center of learning. Most of the Korean monks who went to India died there, not always of fever, sometimes of old age.

All of this makes Hyecho all the more anomalous. He provides no description of Bodh Gayā (the Mahābodhi), saying only that he saw it with his own eyes. The name Nālandā appears nowhere in his text. How could he have made the long journey to India and then somehow missed, or avoided, the primary destination of the Chinese and Korean monks who had preceded him? At any point in his travels, did he acquire Sanskrit texts to take back to China for translation, as his predecessors had? He mentions none. The absence of Nālandā from his account is thus yet another of the many mysteries about Hyecho's journal. One possibility is that, as Huilin's *Pronunciations and Meanings of All the Scriptures* suggests, there was another, longer, version, since lost, that contained a fuller description and that the extant text is a kind of draft or summary. That longer text may have included an account of his studies at Nālandā. However, such a suggestion is belied by the brevity of his journey. Scholars calculate that the period from his arrival in India to his return to China was three years, during which time he traveled more widely than any other Buddhist pilgrim of his age. The most famous pilgrim to precede him to India was Yijing, who spent ten years studying at Nālandā. This suggests that Hyecho's motivations may have been different from those of other monks who made the perilous journey to the "Western Regions."

Hyecho next states that he traveled west from Vārāṇasī for two months, to Kānyakubja, a city on the Ganges some 250 miles west of Vārāṇasī. Again, it seems improbable, and certainly inefficient, for him to walk the 150 miles from Vārāṇasī to Bodh Gayā and then retrace his steps before continuing on to Kānyakubja. However, this is what the text suggests. After a lengthy

description of the region, he says, "There are four great stūpas in this territory": at Jetavana in the city of Śrāvastī (see chapter 8), which he says has a temple and some monks; at Āmrapālī in the city of Vaiśālī, which he says is in ruins; at Kapilavastu (see chapter 7), the birthplace of the Buddha, which he says is deserted; and at Sāṃkāśya (see chapter 9), which he says is located seven days west of Kānyakubja. Again, this list raises questions about his route. Sāṃkāśya is close to Kānyakubja, and thus it makes sense that he would have described it in this section of the journal. However, the other three cities, Śrāvastī, Āmrapālī, and Kapilavastu, are far to the west in Magadha and are places that Hyecho would likely have visited when he was in that region.

At this point in his itinerary, Hyecho departs from what must have been a fairly standard pilgrimage route in the region sometimes called "the cradle of Buddhism." From Kānyakubja, he heads south. On the way, he composes this poem:

Gazing at the road home on this moonlit night,
Floating clouds return with the rustling wind.
I humbly entrust my letter to them,
Yet the wind blows too swiftly to heed me and return.
My country is north of the heavenly cliffs.
I am bound for lands at the edge of the world to the west.
There are no wild geese here in the far south.
Who will carry my message to the forests of my home?

We must pause to wonder what Hyecho might have been thinking. In some ways, the purpose of his pilgrimage had been fulfilled. He seems to have visited the "eight great stūpas" associated with the life of the Buddha, all within a relatively circumscribed region in north central India; each a part of what must have been by then a fairly standard pilgrimage route for Buddhist pilgrims, both Indian and foreign, with fellow travelers, established places to rest and to eat, and the occasional encounter with a compatriot. Now, however, for reasons that are unclear, he was deviating from the beaten Buddhist path to travel far to the south. He may never return. How would the news of his death ever reach his family in the faraway north? There are no geese to carry it.

And as he turns south, Hyecho's route becomes even more murky; he simply says that he walked south for more than three months to the city where the king resided. This king and his kingdom are a subject of

speculation. There are a number of possibilities. The most likely is the Cālukya kingdom, which ruled much of southern India during the time of Hyecho's journey. He describes a large monastery cut out of the mountainside, not by humans but by a *yakṣa* (a kind of demigod) by order of Nāgārjuna, the great Mahāyāna master and founder of the Madhyamaka school of Buddhist philosophy. Scholars date Nāgārjuna to the second century of the Common Era, although according to traditional accounts, he lived for six hundred years, or seven hundred years, as Hyecho himself says. Nāgārjuna is indeed associated with southern India, and he wrote two of his most famous works—the *Jeweled Garland* (*Ratnāvalī*) and the *Letter to a Friend* (*Suhṛllekha*)—for his patron, King Gautamīputra of the Śatavahana Dynasty, who ruled southern India from c. 103 to 127 CE.

Hyecho describes this rock-cut monastery in some detail, saying that it is three stories high and three hundred paces in circumference and that it housed three thousand monks in Nāgārjuna's day. By the time of Hyecho's visit, it was in ruins. Again, exactly which of the many rock-cut temples in the region (none of which are traditionally associated with Nāgārjuna) it is is difficult to identify with any certainty. There are at least three options. The first is the famous Buddhist cave complex at Ajanta. The earliest caves there were built under the patronage of the Śatavahana kings, thus providing at least an oblique connection to Nāgārjuna. According to the chronology of art historian Walter Spink, construction there ended around 480, and the caves would have been abandoned by the time of Hyecho's visit. However, there is no obvious candidate in that area for the three-story edifice he describes.

A second possibility is the Pandavleni caves near the city of Nasik, which, according to some scholars, served as the capital of the Cālukya kingdom during Hyecho's time. The Buddhist caves there were carved between the third century BCE and the second century CE, some under the patronage of Gautamīputra himself. These also would likely have been abandoned when Hyecho visited. Again, however, it is not immediately clear where among the caves Hyecho's three-story edifice would be.

The third possibility is the Ellora Caves, again, situated in the Cālukya realm. There, Cave 11 and Cave 12 seem likely candidates. They are three-story Buddhist monasteries, with pillars cut out of the rock face, just as Hyecho describes. There are also freestanding temples nearby cut entirely out of stone, possibly providing the circumference that Hyecho describes. However, these caves are dated between 650 and 730 CE, long after Nāgārjuna (unless he lived for seven hundred years) and were being completed around the time that Hyecho would have visited them, far too recently for them to have fallen into ruin.

The title of Hyecho's journal is *Memoir of a Pilgrimage to the Five Kingdoms of India.* The term "five kingdoms of India" was common in Chinese works about India and referred simply to the northern, southern, eastern, western, and central regions. Hyecho uses these terms to describe his destinations; their general vagueness and his failure in many cases to provide local place names are sources of much of the uncertainty about his route. Thus, leaving "South India" he walks north for two months to the place where the king of "West India" lives. He is presumably referring to the Sindh region; today it is the southernmost province of Pakistan, but it was considerably larger in Hyecho's time. He says that both the king and the commoners have faith in the three jewels and that there are many monasteries, where the monks practice both Hīnayāna and Mahāyāna; Xuanzang found Buddhism there, with hundreds of monasteries and more than ten thousand monks. Hyecho says little about the Buddhism of the region and instead focuses on the local diet. He reserves special praise for the singing voices of the people of West India, which he says are better than the voices of the inhabitants of the other four regions of India. The only verifiable fact in his description is the statement, "Currently, half the country is destroyed, crushed by the invasions of the Arabs." Indeed, in 711, the Sindh capital of Aror (modern Rohri) fell to Muslim troops under the command of Muhammad ibn Qasim of the Umayyad Caliphate. This is Hyecho's first reference to Muslim conquest. He will mention it again and again as he travels north and west.

He left West India and traveled north for more than three months to "North India." Here, Hyecho helpfully provides a place name: Jālandhara, an ancient city in what is now the Punjab state of India. It is located along what the British called the Great Trunk Road, a route dating back at least to the Mauryan Dynasty (fourth to second century BCE) that eventually linked Chittagong in modern Bangladesh in the east with Kabul in modern Afghanistan in the west. Hyecho next briefly describes the mysterious land of Suvarṇagotra, literally "Golden Race" in Sanskrit. He has little to say about it, except that it is ruled by the Tibetans and is very cold. He makes no mention of the fact that it is apparently ruled by women and is also known as Sthrīrājya ("ruled by women"), as Xuanzang (who apparently did not go there) reports in the account of his travels. Next, Hyecho traveled west to Takshar, located today in Punjab Province in Pakistan. He says there are many monasteries there, with both Mahāyāna and Hīnayāna monks.

Hyecho reports that he next walked west for a month to "Xintou Guluo," which scholars have reconstructed as "Sindh-Gujarat." On the modern map, Sindh is the southern province of Pakistan, bordering the Indian state of Gujarat at its southern border. If this is Hyecho's reference, he would have had

to travel both west and south to reach it, a journey that likely would have taken more than a month. In addition, he had already been to Sindh; it is unlikely that he would have returned. The location of Hyecho's "Sindh-Gujarat" is therefore difficult to determine with any certainty. In his discussion of the region, however, he provides more Buddhist content than his stock statement about the presence of monks and monasteries (which he does also provide). He states, for example, that it is the homeland of Saṃghabhadra, the important fifth-century Indian master of the Vaibhāṣika school. He is famous for his treatise entitled *Nyāyānusāra* (*Conformity with Correct Principle*), a work written in Sanskrit but preserved only in Chinese. It is his refutation of the *Abhidharmakośa* by Vasubandhu. In it, Saṃghabhadra defends the Vaibhāṣika school against Vasubandhu's critique. Hyecho's mention of Saṃghabhadra is noteworthy here. In his travel journal, he mentions few Buddhist figures apart from the Buddha himself, causing one to wonder about his level of familiarity with the scholastic canon. As noted above, in his description of South India, he mentions Nāgārjuna, but Nāgārjuna was a legendary figure. That he mentions Saṃghabhadra, the author of a technical treatise (a work that Hyecho mentions by name), here suggests that the young monk had received training in Buddhist philosophy. According to traditional accounts, Saṃghabhadra was born in Kashmir, suggesting that Hyecho's "Sindh-Gujarat" was quite far from the region generally designated by the term.

In this section of his account, Hyecho also mentions the famous monastery of Tamasāvana, visited by Xuanzang. It was near the town of Cīnābhukti, identified with the town of Patli, west of the Beas River in northern Punjab, near the modern Pakistani border. He reports that the Buddha had taught the dharma there and that a nearby stūpa contains hair and a fingernail of the Buddha. Like Xuanzang, he reports that the monastery had three hundred monks, and he goes on to say that there were seven or eight large monasteries in the area. Because Hyecho does not mention the direction or distance from Sindh-Gujarat, as he typically does elsewhere in his account, it is not clear that he visited these monasteries himself.

Xuanzang, according to his biography, spent four months at the nearby monastery of Nagardhana, studying the great Sarvāstivāda compendium of doctrine, the *Mahāvibhāṣa* (*Great Exegesis*). Hyecho also mentions the monastery, not because Xuanzang had studied there but because he was told that another Chinese monk, who is not named, had studied there. Just as he was preparing to return home, that monk became ill and died. Hyecho, out of empathy for his unknown compatriot, and perhaps fearing a similar fate, was moved to compose a poem about him:

There is no one to tend the lamp in your hometown.
In another land, the jeweled tree is destroyed.
Where has your numinous spirit gone?
Your jade countenance has turned to ashes.
I recall sad thoughts and deep feeling,
And grieve that you cannot fulfill your vow.
Who knows the way to your homeland?
I stare blankly at the white clouds returning home.

From the northern Punjab, Hyecho walked north for fifteen days to reach Kashmir. He reports that the king and his subjects are devout Buddhists and that there are many monks and monasteries, both Hīnayāna and Mahāyāna. He mentions the vast Wular Lake, saying that the *naga*, or water deity, who inhabits it has long made daily offerings to a thousand arhats. Although these arhats never appear, bread and rice can be seen rising to the surface of the lake.

In this section Hyecho offers an interesting observation about the economics of Buddhism in India more generally, noting that monasteries were not established by the state (as was the case in China and Korea). Individual monasteries were established by individual members of the nobility, both male and female, to generate merit for themselves. Such donors also often established or supported Jain and Hindu temples and monasteries, as well as *brahmadeyas*—lands dedicated to the support of brahmins. To establish a monastery, however, was more than a construction project; the monasteries had to be maintained. According to the monastic code, Buddhist monks are prohibited from tilling the soil. Their food must be provided to them; the literal translation of the term generally translated as "monk" (*bhikṣu*) is "beggar." Therefore, Hyecho explains, when a monastery was founded, the patron would donate the surrounding villages, as well as their villagers, to "the three jewels." This meant in effect that the land and the labor to cultivate it became the property of the monastery, with the food produced used to feed the monks. Hyecho says that (apparently in contrast to China and Korea) there were no slaves in India, in the sense of a person who is bought and sold, but the products of the villagers' labor were provided to the monks of the monastery.

From Kashmir, Hyecho continued north and east for fifteen days to places that he calls Greater Bolor, Yangtong, and Suoboci, all of which, he says, are under the control of Tibet. Today, these regions encompass Balistan in Pakistan and western Ladakh in India. He finds monasteries and monks there. It is at this point in the text that Hyecho makes his first mention of

Tibet (which he did not visit), noting, "There are no Buddhist monasteries whatsoever and the *buddhadharma* is unknown." According to traditional Tibetan accounts, he was right about the first and wrong about the second.

During the first half of the seventh century, Tibet was ruled by King Songtsen Gampo (c. 605–650), who defeated his enemies to establish control over much of the Tibetan Plateau. Traditional Tibetan accounts count him as the first of three "dharma kings" (*chos rgyal*) who established Buddhism in Tibet, and consider him an incarnation of Avalokiteśvara, the bodhisattva of compassion. The historical record, such as it exists, is a good deal more mundane. According to the Tibetan legends, the king had two foreign wives, both Buddhists, who converted their warrior husband to the dharma. The first was the Nepalese princess Bhṛkutī, and the second was the Chinese princess Wencheng. Each brought with her a statue of Śākyamuni Buddha, those statues becoming the central images in two temples founded by Songtsen Gampo in his new capital, Lhasa: the Jokhang and the Ramoche. However, Nepalese chronicles make no mention of the Nepalese princess; the Chinese princess, although a historical figure, seems to have arrived in Tibet shortly before the king's death and had no influence at court. But a number of Buddhist temples in Songtsen Gampo's domain seem to date from the seventh century, including the foundation of the Jokhang, the renowned "Cathedral of Lhasa." The first monastery in Tibet, called Samye, was not constructed until the late eighth century (perhaps between 775 and 779), and then only with the help of the Indian tantric master Padmasambhava, who was called in to subdue the local spirits obstructing the introduction of the new religion. Thus, at the time of Hyecho's writing, there were no Buddhist monasteries in Tibet, but something of the dharma was known, at least at court. Hyecho seems more interested, however, in the strange culinary habits of the Tibetans, reporting that they loved to eat the lice that infested the furs they wore. Whether or not Tibetans ate lice then, they did not do so after their conversion to Buddhism, out of compassion for all sentient beings.

From Greater Bolor, Hyecho traveled north and west for seven days to Lesser Bolor, the Gilgit region of modern Pakistan. Although this had been a great center of Buddhism (the source of the famed Gilgit manuscripts), he makes no mention of any Buddhist presence there, noting that the region was under Chinese control. Hyecho is much more expansive in his description of the next stop in his journey. Continuing to the northwest from Kashmir, he reaches Gandhāra.

Gandhāra was an important kingdom of ancient India, mentioned often in both Hindu and Buddhist sources. The region encompasses a section of

northwestern Pakistan and northeastern Afghanistan. It was a major center of Buddhism for centuries, with important developments in doctrine, art, and architecture taking place there. Beginning with Alexander the Great's conquest of its capital, Takṣaśilā, in 326 BCE, there was a strong Hellenistic presence, and sometimes rule, for centuries, a presence strongly reflected in the sculptures of buddhas and bodhisattvas produced in the region. There has long been a debate among art historians over whether the first icons of the Buddha were made under Greek influence, a position championed by the French art historian Alfred Foucher (1865–1952) (see chapter 6). In the second century of the Common Era, the region was ruled by the Kushan king Kaniṣka I from his capital Puruṣapura (modern Peshawar). Kaniṣka I was remembered as second only to Aśoka as a royal patron of Buddhism in ancient India. What is known as the Fourth Buddhist Council was held during his reign.

Several important *jātaka* stories, the tales of the Buddha's former lives, are set in Gandhāra (see chapter 10). It was the main center for the Sarvāstivāda, one of the most important of the mainstream (what Hyecho would call Hīnayāna) schools of India, together with several other mainstream schools. It was a center for the study of the *abhidharma*, the third component of the Buddhist canon or *tripiṭaka*, together with the sūtras or discourses of the Buddha, and the vinaya or code of monastic discipline. The *abhidharma* consists of technical treatises on psychology, epistemology, cosmology, and the structure of the Buddhist path. The most important *abhidharma* text, the *Mahāvibhāṣa*, was compiled there. Gandhāra, and the city of Puruṣapura, is also said to have been the birthplace of two of the most important figures in the history of Buddhist thought, the brothers (or half-brothers) Asaṅga and Vasubandhu.

Hyecho describes the region as ruled by Turks (Tujue), likely referring to the Kabul Shahi Dynasty, which controlled the region under a succession of Hindu and Buddhist kings. The region came under Muslim rule after the Battle of Peshawar in 1001. Hyecho reports that twice a year, the king, who was a devout Buddhist, would perform what he calls "the great festival." He is referring here to a strange Buddhist rite, called in Sanskrit the *pañcavārṣika pariṣad* or "quinquennial festival," obviously practiced in Gandhāra more often than every five years. The practice is said to go back to the emperor Aśoka himself, who, in an extravagant display of the Buddhist virtue of *dāna* or giving, gave away all of his possessions, his wealth, his personal belongings, and his robes, to the monastic community, after which his ministers bought it all back. In Hyecho's account, the devout Turkic king gives away everything, including his wife, twice a year.

Walking for three days to the west, Hyecho arrived at a monastery that he calls Kaniṣka; this is presumably the great monastery built by the Kushan king in Puruṣapura, his capital. Hyecho correctly identifies the city as the birthplace of Asaṅga and Vasubandhu and describes a stūpa that constantly glows. Demonstrating his knowledge of the *jātaka* tales, he names four stories said to have taken place in the Gandhāra region.

Going north from Gandhāra, Hyecho reached Uḍḍiyāna (also spelled Oḍḍiyāna and Udyāna), a region that included the Swat River Valley of modern Pakistan. In subsequent centuries, it was closely associated with the practice of tantric Buddhism. Xuanzang, visiting in the seventh century, said that the inhabitants "enjoy learning but do not make profound studies, and they take the recitation of spells [mantras] as their profession."[14] Hyecho, despite his later association with esoteric Buddhism, makes no mention of this, saying simply that the people practice the Mahāyāna.

Hyecho reports that he next traveled fifteen days to the northeast, to a place he calls Kuwi, and then back to Gandhāra. He continued on to Lampāka, likely in the vicinity of Kabul in Afghanistan. Traveling west for eight days, he reached the region of Kāpiśī; today, Kapisa is a province in northeastern Afghanistan. Xuanzang found a flourishing Buddhist community there, with more than a hundred monasteries and more than six thousand monks, most following the Mahāyāna. The king, who was a devout Buddhist, had an eighteen-foot silver statue of the Buddha made each year and held the quinquennial festival. Hyecho found the common people to be generous supporters of the monastic community. A monastery called Śāhis had hair and bone relics of the Buddha. Unlike Xuanzang, however, Hyecho describes the monks as Hīnayāna.

Continuing west for seven days, Hyecho reached Zābulistān, likely the state of Zabol in modern Afghanistan, southwest of Kabul. Here again, the nobility, whom he calls Turks, revere the three jewels, and there are many Mahāyāna monasteries. From there he traveled north to Bāmiyān, site of the colossal statues destroyed by the Taliban in 2001. Although Xuanzang describes the statues, Hyecho, oddly, makes no mention of them, providing again his stock phrase, "The king, chiefs, and commoners all greatly revere the three jewels. There are many monasteries and monks and both Mahāyāna and Hīnayāna are practiced."

Hyecho next traveled north for twenty days to Tokhara, a region, called Bactria in Greek sources, that encompasses regions of the Tarim Basin in modern Afghanistan, Tajikistan, and Uzbekistan. In ancient Indian sources, including the *Mahābhārata*, its peoples are described as *mleccha* or barbarians, beyond the border of Indian civilization. In the first centuries of the

Common Era, Buddhism was a powerful presence there, especially during the Kushan Dynasty, with Buddhist texts produced in local languages that scholars call Tocharian A and Tocharian B. Hyecho describes the king and the commoners as devout Buddhists, supporting many Hīnayāna monasteries and monks. However, at that time, Tokhara was under the control of the Arab army, and the king had fled to the east. Indeed, in 663 troops of the Umayyad Caliphate had invaded Tokhara and taken the capital city of Balkh (called Bactra by Hyecho).

Tokhara appears to be the last place that Hyecho found Buddhism as he continued his travels west. He reports that he made his way west for one month, reaching Persia; a journey of that length may indeed have brought him to what is today northeastern Iran. Describing the Persian Empire, he explains, "A long time ago, the king of this country ruled over the Arabs. The Arabs raised camels for the king. Now, the entire country has been taken over by the Arabs." Arab troops had invaded the Sasanian Empire in 642 and had brought it under their control by 651. Of the local religion, Hyecho writes, "The people here like to hunt, serve Heaven, and know nothing of the *buddhadharma*." Scholars speculate that the term "serve Heaven" refers to Zoroastrianism, a religion of ancient Persia.

Hyecho's track seems to go cold here. He reports that he walked north for ten days in the mountains to arrive in Arabia. Since the Arabian Peninsula is to the south of Persia, his destination is difficult to identify; he may simply have been referring to another region under Arab control. He says nothing that would provide geographical specificity, noting instead the dress and culinary habits of the people. This section is followed by a paragraph on the Byzantine Empire, which he reports has thus far successfully repelled Arab invaders.

The Byzantine Empire is the westernmost reference in Hyecho's journal. He next turned east, with a series of brief entries, largely ethnographic in nature. He begins with six "Hu nations." In its early usages, the Chinese term *hu* seems to have been a generic term for non-Han peoples living beyond the western borders of China. By Hyecho's time, it had taken on a more specific meaning of the general region of Sogdia, including much of modern Uzbekistan. The six places he mentions are Bukhārā, Kabūdhan, Kish, Tashkent, Penjikent, and Samarkand. He only indicates that he visited Samarkand, where he found one monastery that housed one monk who knew nothing about Buddhism. He notes that all six regions are all under Arab rule but that the people practice Zoroastrianism (what he calls "the fire religion").

Next he describes Ferghāna, east of Samarkand; there is a Ferghana Province in modern Uzbekistan. He says that Buddhism is absent there. Yet,

moving east to Khuttal, in modern Tajikistan, he reports that, despite being under Arab rule, the king and the commoners are Buddhists and that there are Hīnayāna monks and monasteries. He next describes the "Turks," who occupy a vast region north of six Hu nations, bordered by the north sea to the north, the west sea to the west, and China to the east. He may be describing the region of modern Kazakhstan, with the Caspian Sea to the west, but it is unclear what the north sea might be. He describes the inhabitants of this region as a nomadic people who know nothing about Buddhism.

Not since his puzzling statement that he walked north ten days from Persia to arrive in Arabia has Hyecho made any reference to his own travel in his journal, suggesting that he may not have personally visited all the places he describes after that. He returns to his old pattern, however, with the next section, where he describes Wakhān, seven days east of Tokhara. This is likely the Wakhān Darya Valley in northeastern Afghanistan, although it is located far more than a seven-day walk from Tokhara. The region was under Arab rule, but the king and the commoners had not converted to Islam and remained devout Buddhists, supporting Hīnayāna monks.

It is in his description of Wakhān that we find one of the rare moments of human interaction in Hyecho's account of his far-flung travels. He says that in Wakhān he met a Chinese envoy traveling in the other direction, "on his way to a foreign land." His compatriot seems to have complained about the difficulties of the long road, likely not knowing that this would elicit little sympathy from Hyecho. Indeed, Hyecho was moved to write a poem about his encounter with one of the rare people with whom he could converse:

> You bemoan the distance to the frontier in the west.
> I lament the long road east.
> Rugged roads cross colossal snowy ridges,
> Dangerous ravines where bandits wander.
> Even birds in flight fear the soaring cliffs.
> Travelers struggle over tilting bridges.
> I have never cried once in my life.
> Today I shed a torrent of tears.
>
> Frigid snow turns into ice,
> Cold winds crack the earth.
> A vast frozen sea flat as an altar,
> Rivers and streams erode icy cliffs.
> Even the falls of the Dragon Gate are frozen;
> Ice in the wells coils like a snake.

Carrying fire, I climb into the wilds and sing.
Will I ever be able to cross the Pamirs?

Hyecho had traveled to India by sea and seems to have survived the heat of India without particular complaint. But somehow finding himself as far west as Persia, he now has to make his way back to China across some of the most desolate and difficult terrain in the world. Hyecho was clearly ready to return to familiar lands.

Next he describes, without indicating that he went there, the "nine Shighnān countries," each ruled by its own king with his own army. The region appears to be the Pamir Plateau in modern Tajikistan. Again he notes that the people know nothing of Buddhism.

From this point in his journal, Hyecho finally returns to Chinese territory. Traveling east from Wakhān, after two weeks he crosses the Pamir River and arrives at the Congling Garrison, in the modern Chinese province of Xinjiang, where Chinese troops guard the western borderlands of the Tang Empire. From there, he continues east for a month to the oasis city of Kashgar, long a major stop on the Silk Road. Xuanzang found several hundred monasteries and more than ten thousand monks in the region, all of the Sarvāstivāda school. He notes that their practice involved the recitation of the scriptures rather than their study, and that they could recite the *tripiṭaka* as well as the *Mahāvibhāṣa*, the major compendium of doctrine of the school. Hyecho merely notes the presence of Hīnayāna monasteries and monks. Traveling east for a month, he arrives in Kucha, still in modern Xinjiang, where many Sanskrit Buddhist manuscripts have been found. Here, he reports a mixed Buddhist community, with local monks practicing Hīnayāna and the Chinese monks practicing Mahāyāna. At the time of Hyecho's arrival, the Grand Protectorate General to Pacify the West (Daduhufu), a Tang Dynasty outpost to control the Tarim Basin region, had its headquarters in Kucha, so Hyecho found a significant Chinese presence there. He next provides a brief note on Khotan, a kingdom located in southwestern Xinjiang on the southern edge of the Taklamakan Desert, which he apparently did not visit. It was a major center of Buddhism until the eleventh century, notable for its strong adherence to the Mahāyāna among the largely Sarvāstivāda monastic communities elsewhere in Central Asia. Here, Hyecho seems to conclude that he is finally back in China and has no further need to report on the places and peoples he encounters. "From here eastward, all the land is Tang territory. Everyone knows this situation and nothing more needs to be said about it."

In the penultimate entry in the manuscript, however, Hyecho pauses to describe the practice of Buddhism at the four garrisons of the Grand Protectorate General to Pacify the West: Kucha, Khotan, Kashgar, and Karashahr. For the first time in many thousands of miles, Hyecho mentions monasteries and monastic officials by name, praising them for their leadership. All were born in China except for the abbot of Longxing monastery, who is "just like a native Chinese in terms of his scholarship and his manners." More importantly for the purposes of tracing his travels, it is at this point in the text (and the only point in the text), that Hyecho provides a date. He reports that he reached Anxi at the beginning of the eleventh lunar month of 727.

Hyecho continued east to Karashahr, another outpost of the Grand Protectorate General to Pacify the West, where he finds many Hīnayāna monasteries and monks. Despite having said that there is nothing more to be said, he begins to describe the dress of the local people, when the text ends in midsentence.

IN CHINA

Although the fragment of the manuscript of *Memoir of a Pilgrimage to the Five Kingdoms of India* ends here, in 727, Hyecho's life did not. He seems to have lived for at least another fifty years. As was the case with his youth, very little is known about his later life.

From the western borders of the Tang Empire, where his journal ends, he continued eastward, eventually reaching the Tang capital of Chang'an (modern Xi'an). There he joined the circle of disciples of the two Indian masters who (together with their predecessor Śubhakarasiṃha) are credited with introducing tantric Buddhism to East Asia: Vajrabodhi and his disciple Amoghavajra. According to most accounts, Vajrabodhi (671–741) was a brahmin from South India, the son of a royal priest in Kanchipuram in modern Tamil Nadu. At a young age, he was ordained as a Buddhist monk and traveled north to the monastery of Nālandā, where he studied the vinaya as well as the doctrines of the mainstream and Mahāyāna schools. It was at Nālandā that he first learned of the yoga tantras. Around 701, he is said to have returned to southern India and then to Sri Lanka, where he received tantric initiation from a master named Nāgabodhi or Nāgajñāna. From Sri Lanka, he eventually departed by sea for Śrīvijaya in modern Sumatra. From there, likely along the route that Hyecho would later follow in the opposite direction, he sailed to China, accompanied by his disciple Amoghavajra, whom he had met somewhere in this travels, perhaps as late as 718. They arrived in Guangzhou in 719, making their way to Chang'an in

721. His ability to make rain and cure diseases won him favor at court, and over the next twenty years he performed all manner of rituals and initiations, largely for worldly goals of protection, prosperity, and longevity, rather than more ethereal attainments. He also translated tantric texts (mostly of the yoga tantra class) from Sanskrit into Chinese and composed ritual manuals.[15]

In all of this, he was assisted by his disciple Amoghavajra (705–774), who is perhaps the most important figure in the history of East Asian esoteric Buddhism. There is uncertainty about his origins, with some sources saying he was born in Samarkand and others saying that he was born in Sri Lanka. If the former, he would have met Vajrabodhi upon the master's arrival in China. However, according to another account, they arrived in China by sea together. One of the biographies of Vajrabodhi explains that when he was in South India, the bodhisattva Avalokiteśvara appeared to him and instructed him to go to Sri Lanka and venerate the tooth relic of the Buddha (at Kandy) as well as the Buddha's footprint (on Adam's Peak), and then proceed to China to pay homage to Mañjuśrī (presumably at Wutaishan). Sailing on a "Persian ship" from Sri Lanka, Vajrabodhi arrived in Śrīvijaya, where, according to some sources, he is supposed to have first met Amoghavajra, who was fourteen years old.[16]

In 740 there was an imperial edict expelling all foreign monks from China. Vajrabodhi is said to have protested that he was not a "barbarian monk" (*huseng*) but instead an "Indian monk" (*fanseng*), so the edict did not apply to him. According to one account, the emperor granted him an exemption. He died in 741 in Luoyang. It is possible that he had in fact not been granted an exemption and that he and Amoghavajra were making their way to the coast on their way back to India at the time of his death.[17] Amoghavajra apparently used the opportunity to go to Sri Lanka to acquire tantric texts, traveling by sea, as Hyecho did, again stopping in Sumatra. In Sri Lanka, he is said to have met Vajrabodhi's teacher.

Amoghavajra returned to China five years later, bringing with him hundreds of texts. Until his death in 774, he played an active role in the turbulent politics of the times, being called upon to perform rituals (apparently successfully) to protect the Tang capital from foreign invaders. He is also credited with dozens of translations of Indian works, most importantly, the first section of the tantric text the *Tattvasaṃgraha* (*Compendium of Principles*). Many more independent works are ascribed to him. He was an ardent devotee of Mañjuśrī, the bodhisattva of wisdom, and, with imperial support, he had the Jingesi Temple constructed at Wutaishan. Completed in 767, it was believed to be the bodhisattva's abode.

Hyecho was clearly a member of Vajrabodhi and Amoghavajra's circle, but his precise role over a period of some five decades is not well understood, because the sources are few, and all are from very late in his life. The first and most substantial source is the preface to the translation of a tantric text. It is a work in ten fascicles, with an extravagant title, even by the standards of Mahāyāna Buddhism. It might be rendered as the *Sūtra of the Natural Ocean of the Mahāyāna Yoga Vajra, the Great Royal Tantra of the Many Thousand Arm and Thousand Bowl Mañjuśrī* (*Dasheng yujia jingang xinghai Manshushili qianbi qianbo dajiaowangjing*). The preface may have been written by Hyecho himself or by someone else; it may have been attached, or reattached, to the translation much later. Here is the preface in its entirety:

Preface: In the twenty-first day year of the Kaiyuan era [733] of the Great Tang, in the tenth year of the sexagenary cycle, in the hour of the dragon [between 7 and 9 a.m.], on the first day of the first month, inside the practice hall of Jianfusi, the *tripiṭaka* [master] Vajra[bodhi] bestowed upon the monk Hyecho the dharma teachings of the *samādhi* of the secret enlightenment teachings of the *Mahāyāna Yoga Vajra of the Five Peaks and Five Wisdoms, the Glorious Bodhisattva Mañjuśrī [with] a Thousand Arms, Thousand Hands, and Thousand Bowls [with a] Thousand Śākyamuni Buddhas*. After he had taken on the dharma, [Hyecho] never left the *tripiṭaka* master's side, serving him for eight years. Then on the fifteenth day of the fourth month of the twenty-eighth year of the Kaiyuan era [740], the seventeenth year of the sexagenary cycle, [Xuanzong,] the Holy Kaiyuan Emperor made his way to the practice hall of Jianfusi. On the fifth day of the fifth month, he ordered that this sūtra be translated. At the hour of the rabbit [5–7 a.m.], [they] burned incense and began the translation. The *tripiṭaka* master read the Sanskrit text and Hyecho wrote down [the translation] of the sūtra of the dharma teaching of the *Mahāyāna Yoga Thousand Arm Thousand Bowl Mañjuśrī*. The translation was completed on the fifteenth day of the twelfth month [of that year]. On the nineteenth day of the second month of the first year of the Tianbao era [742], the *tripiṭaka* [master] [Amogha]vajra[18] took the Sanskrit text and letters of the *ācārya* of the five regions of India and gave all of them to the Indian monk Mokṣanandabhaga to take to [Vajrabodhi's] teacher, the *ācārya* Ratnabodhi, who lives in the Country of Lions in the south of the five regions of India. [The sūtra was not] returned.

Thereafter, in the tenth month of the ninth year of the Dali era [774] of the Tang [Dynasty], the great teacher of vast wisdom, the *tripiṭaka* monk [Amoghavajra] came to Daxingshansi. He further exhorted and encouraged [Hyecho] to select the great teachings of the *Yoga of the Dharma Gate of the Secret Heart Ground* and later the text of the *Sūtra of the Thousand Arm Mañjuśrī*. [This translation work lasted] until the fifteenth day of the fourth month of the first year of the Jianzhong era [780] of the Tang. [Next, Hyecho] went to the Qianyuansi on Mount Wutai, where he hoped to obtain the text of the old translation of the sūtra in Chinese that was at the temple. On the fifth day of the fifth month [of that year] the *śramaṇa* Hyecho began to record [the translation] again. He wrote out the *Royal Sūtra of the Great Teaching of All Tathāgatas, Yoga Secret Vajra Samādhi*, and the *Dharma Gate of the Glorious Teaching of the Three Secrets*, noting the secret meanings of the texts.[19]

To restate this in somewhat clearer terms, Hyecho became Vajrabodhi's disciple in 733, six years after his return to China, at Jianfu Monastery in the Tang capital of Chang'an, receiving instruction (and presumably initiation) in the *Sūtra of the Thousand Arm Mañjuśrī*. Hyecho remained with Vajrabodhi for the next eight years. In 740 the Tang emperor Xuanzong (685–762) came to the monastery and ordered that the sūtra be translated into Chinese. The translation began the following month, with Vajrabodhi reading the Sanskrit and, presumably, translating it into Chinese and Hyecho serving as scribe (*bishou*). The translation was completed seven months later. Early in 742, Vajrabodhi instructed his disciple Amoghavajra to take the Sanskrit text of the sūtra back to India. He did so, giving it to an Indian monk to give to one Ratnabodhi, in the "Country of the Lions," presumably Sri Lanka.

The story then fast-forwards thirty-two years to 774, when Amoghavajra, now back in China, worked with Hyecho on the translation of two texts, including the *Sūtra of the Thousand Arm Mañjuśrī*. This project apparently lasted six years, until 780. At that point, Hyecho went to Wutaishan to retrieve the original translation that had been made by Vajrabodhi, and he copied that translation as well as that of two other esoteric works.

There are a host of problems raised by the preface, beginning with problems with the chronology. Vajrabodhi died in the autumn of 741 and thus could not have given instructions in 742 for the Sanskrit manuscript of the sūtra to be returned to India. However, this is a discrepancy of only a few months. A more serious discrepancy is the statement that Amoghavajra and

Hyecho began working on the translation of the sūtra in 774 and continued until 780. Amoghavajra died in 774. It is also unclear whether the translation of the sūtra by Vajrabodhi was of the complete text or whether only a portion was translated prior to his death. If it was of the complete text, it would not have made sense for Amoghavajra to begin a new translation. If Vajrabodhi's translation was incomplete, it is unlikely that he would have sent the Sanskrit manuscript back to India. There is also the question of who composed the preface. If it was Hyecho himself, as some believe, why would he make such significant errors regarding the dates of his own activities and those of his teacher? The preface does, however, establish Hyecho's association with Vajrabodhi some six years after his return from India and his association with Amoghavajra about four decades later. What he did during the intervening decades remains a mystery; one scholar speculates that he went back to India.[20]

The mysteries of the preface, and of Hyecho's role in the story that it tells, multiply when one looks at the text to which it is appended, the *Sūtra of the Thousand Arm Mañjuśrī*. The text is far too long to translate here, but we can provide a summary.

The sūtra (or tantra) opens in the Palace of Maheśvara, located in the Akaniṣṭha Heaven, the highest heaven of the Realm of Form. In a number of Mahāyāna texts, it is identified as the abode of the buddha Vairocana, and indeed, as the sūtra opens, Vairocana and Śākyamuni are seated in the palace, preaching to sixteen bodhisattvas. They describe Mañjuśrī as abiding in a world called the Ocean of the Lotus Treasury World of the Diamond Realm. He has a thousand arms, each hand holding a begging bowl. Inside each bowl are a thousand Śākyamuni Buddhas, who further manifest ten trillion Śākyamuni Buddhas. Vairocana explains that Mañjuśrī was his teacher in the distant past, instructing him to teach sentient beings how to visualize the letters of the alphabet, beginning with the letter *a* and ending with the letter *ḍha*. This is not the standard Sanskrit alphabet, but a syllabary called the *arapacana* (after its first five letters). Its final letter is *ḍha*. The syllabary appears in many Mahāyāna sūtras and tantras, with the recitation of the syllabary serving often as a *dhāraṇī*, each letter having a symbolic meaning. The syllabary is associated particularly with Mañjuśrī, so much so that *arapacana* is one of his names and constitutes his name mantra: *oṃ arapacana dhīḥ*.

Mañjuśrī next vows to purify the sins of ten classes of beings, not only those who follow his teachings, but those who slander him and even doubt his existence; not only those who make offerings to him and make images of

him, but those who steal from temples; not only the virtuous, but fishermen and murderers; not only bodhisattvas, but those doomed to Avīci, the worst of all the hells. After Mañjuśrī makes these ten vows, the earth quakes and flowers fall from the sky.

At this point, Śākyamuni descends from the Palace of Maheśvara to his more familiar abode in Jetavana in the city of Śrāvastī, where he preaches the dharma to an audience of seven million. He expounds what are called the "ten laws of the diamond *samādhi*." (A *samādhi* is a deep state of concentration, often accompanied by visions.) The Buddha explains that even if the entire world were engulfed in a conflagration, he would be untouched by the flames, enjoying a cool breeze amid rivers and streams in a fragrant forest, with lotuses blossoming in ponds. A giant lotus would rise from the waters of Lake Anavatapta, assisting all beings to become bodhisattvas.

Next, Śākyamuni instructs Mañjuśrī, the teacher of all bodhisattvas, to perform an esoteric ritual to initiate sixteen bodhisattvas of the Diamond Realm. They include such famous bodhisattvas as Avalokiteśvara, Samantabhadra, Amoghapāśa, and, strangely, Mañjuśrī himself, together with figures associated with the esoteric tradition, such as Karmapāramitā and Vajrabhairava. Śākyamuni then instructs Mañjuśrī on the ten gates of faith and insight, which the text lists as the mind of renunciation, the mind of ethics, the mind of patience, the mind of effort, the mind of concentration, the mind of wisdom, the mind of aspiration, the mind of protection, the mind of joy, and the uppermost mind. He then provides three *dhāraṇī* before enumerating the ten merits of practicing esoteric meditation and instructs bodhisattvas to expound on the ten gates of meditation.

When a bodhisattva notices that Mañjuśrī is not present in the assembly, Śākyamuni explains that Mañjuśrī is inseparable from the nature of reality (*dharmatā*) and that he is the protector of the famous *śūraṃgamasamādhi* (literally, the concentration of "going like a hero" or perhaps "heroic progress"). This *samādhi* is one of the more famous in Mahāyāna Buddhism, the subject of an eponymous sūtra that sets forth a *samādhi* that allows bodhisattvas to proceed quickly to buddhahood and allows enlightened beings to appear in any form. Mañjuśrī, having reappeared, then asks who will follow him in fulfilling his vows, and five buddhas volunteer: Vairocana, Akṣobhya, Ratnasambhava, Avalokiteśvara (instead of the more standard Amitābha), and Amoghasiddhi.

Next, Śākyamuni describes the ten bodhisattvas who assist sentient beings in reaching the ten gates of liberation. The sets of ten continue with his instructions on the ten inclinations and the ten well-nourished minds.

Vairocana then expounds on the ten well-nourished minds as well as the ten diamond minds of the bodhisattva. Amoghasiddhi then speaks, setting forth the ten gates of liberation.

As the sūtra concludes, Śākyamuni reappears, descending again from the Palace of Maheśvara in the Realm of Form to the city of Śrāvastī in Jambudvīpa. He predicts that in the future the influence of the three jewels will decline and the world will be filled with ghosts and demons. During this period of chaos, it will be important for beings to acquire the divine eye (*divyacakṣus*), a magical vision that allows one to see into the heavens and hells and to see sentient beings rise and fall according to their deeds. He cautions the assembly against following the six heterodox teachers; this is the standard list of five that appears in many Buddhist texts, with the Jain teacher, Nirgrantha Jñātīputra, listed twice. He warns that those who follow them will be reborn in hell, and he goes on to enumerate a long list of grisly punishments.

The sūtra concludes with Śākyamuni expounding on one of the most basic of Buddhist doctrines—the ten virtuous deeds—and promising to assist Mañjuśrī in bringing enlightenment to all sentient beings in the coming degenerate age.

As this summary suggests, the *Sūtra of the Thousand Arm Mañjuśrī* is a somewhat disjointed text, jumping from point to point, often without transition. This is not uncommon in the Mahāyāna sūtras, where texts were sometimes compilations of shorter works or included interpolations into an earlier work. However, there are several signs to indicate that the *Sūtra of the Thousand Arm Mañjuśrī*, despite what the preface suggests, is not a work of Indian origin and is instead apocryphal.

Given the gap of several centuries between the death of the Buddha and the earliest attempts to record his teachings in a written form, scholars of Buddhism have struggled, with little success, to identify the original teachings of the Buddha. There is consensus that the Mahāyāna sūtras, works like the *Lotus Sūtra* and the *Diamond Sūtra*, were composed long after his death and were not taught by the historical Buddha. However, scholars of Buddhism reserve the designation "apocryphal" for those works composed outside of India that purport to be Indian works. In China, these include such famous texts as the *Awakening of Faith* (*Dasheng qixin lun*), the *Sūtra for Humane Kings* (*Renwang jing*), and the "pure land" text, *Sūtra on the Visualization of the Buddha of Infinite Life* (*Guan wuliangshou jing*). In the case of Chinese Buddhism, in order for a text to be considered authentic, there needed to be evidence that the text had been brought from outside China.

A manuscript in Sanskrit (or another Indic language) was important proof. Colophons or prefaces provided the name of the translator and the time and place of the translation, descriptions such as those found in the preface to the *Sūtra of the Thousand Arm Mañjuśrī*.

Sanskrit originals of Indian scriptures were highly prized in China; as we shall see in chapter 12, an emperor was willing to pay an Indian monk a high price for his text, even after it had been translated. This makes the story of Vajrabodhi instructing a disciple to transport the *Sūtra of the Thousand Arm Mañjuśrī* back to India rather strange. It is unlikely that the only copy of a Sanskrit text that was translated by order of the emperor himself would have been taken back to India. Next, the translation is sent from the capital to distant Mount Wutai, without a copy of this important text being made and kept in Chang'an. Then, some thirty years later, Amoghavajra decides he wants to translate the text again. But how could the text be translated if the original had been sent back to India?

The *Sūtra of the Thousand ArmMañjuśrī* was discovered in one of the temples at Wutaishan in 938, some one hundred and fifty years after Hyecho's death. At the time of its discovery, it lacked the preface; the first references to the preface do not appear until the Yuan Dynasty (1271–1368), more than three hundred years later. Earlier catalogs list the text, with Amoghavajra as translator, but those references appear to be insertions. Thus, although the text is often associated with Amoghavajra, a well-known devotee of Mañjuśrī, it is difficult to conclude that the preface to the *Sūtra of the Thousand Arm Mañjuśrī* provides reliable information about its source and about its translation.

One piece of evidence that would suggest that it is apocryphal is the list of the "ten gates of faith and insight" that figure so prominently in the sūtra. This particular list is unknown in Indic texts. However, it appears in the *Brahmā's Net Sūtra* (*Fanwang jing*), one of the most famous, and important, of the Chinese apocrypha. There, one finds a list of fifty-two stages of the bodhisattva. The second group of ten in that list corresponds to the ten in the *Sūtra of the Thousand Arm Mañjuśrī*, although they have another name. The particular title of this list—"ten gates of faith and insight"—occurs only in the *Sūtra of the Thousand Arm Mañjuśrī*. This is further evidence that the text is not of Indian origin but rather was composed in China, perhaps by Amoghavajra himself, who could have easily given it a Sanskrit title to provide an air of authenticity.

This is not to diminish the significance of the text, or of Hyecho's devotion to it. As we shall see in chapter 12, Mañjuśrī was of great importance in

China, and among his many forms, the thousand-bowl form of the bodhisattva was well known. Caves at Dunhuang are adorned with his image, and a beautiful silk painting of the Thousand Arm Mañjuśrī, now in the Hermitage, was discovered in the Library Cave at Dunhuang, the place where Paul Pelliot found Hyecho's journal.

And so, like the years of his travels across the Buddhist world as a youth, the latter decades of Hyecho's life remain shrouded in obscurity. There is one piece of evidence to indicate that he served at the Palace Shrine (Neidaochang) in the Tang capital.[21] In that capacity, he would have performed various rituals on behalf of the state. According to a report that he sent to the throne, in 774 he was dispatched to Xianyousi Monastery, some fifty miles west of the capital, where he successfully performed a rain ritual. By that time, he was at least seventy years old. Had he served as a ritual specialist since Vajrabodhi's death in 741?

Amoghavajra, prior to his death, instructed twenty-one of his disciples to perform a ritual for the welfare of the empire. Hyecho's name is second on the list.[22] Amoghavajra died on the twenty-eighth day of the seventh month of 774. That Hyecho was one of his close disciples by the end of the tantric master's life is clear from his last testament, in which he says that he had eight students who were well trained in the five sections of the canon, six of whom are still living. He lists the six, one of whom is Hyecho of Silla.

We find no further reference to Hyecho after the statement that he went to Wutaishan in 780 to continue the work on the *Sūtra of the Thousand Arm Mañjuśrī*, a work that he had begun to study in 733. He was almost eighty years old by then. We assume that he died there, in the sacred abode of the bodhisattva of wisdom.

CONCLUSION

So many questions remain. Why would a teenage Buddhist monk leave his native Korea and travel to China, then board a ship for a perilous voyage into the tropics, to arrive finally in India? As we have noted, he did not seem to go for the same reasons as the Chinese and Korean monks who had preceded him: to study the dharma and to retrieve texts. Hyecho seems to have done neither. Having made what must have been by then the standard pilgrimage circuit of "the eight great stūpas," why did he then go south? Returning from the south, what took him on his tortured route through what is today Pakistan, Afghanistan, and Central Asia, westward all the way to Persia and perhaps Arabia?

One tentative explanation may be found not in the spiritual but in the mundane. Despite its reputation for nonattachment and austerity, Buddhism has long had an essential association with wealth and commerce. When the Buddha is not with his monks, he is often with his patrons: kings, queens, wealthy merchants, and wealthy courtesans. When he is with his monks, he is often living in groves donated by his patrons. Although the term translated as "monk" literally means "beggar" in Sanskrit, it seems that those beggars could be choosers.

It is clear that Buddhism spread, both within India and beyond, along trade routes; there are many stories of Buddhist monks traveling in the company of merchants, either along a road or aboard a ship. The presence of Buddhism in a given location at a given moment in history is almost always dependent on either the generous patronage of an emperor or king or proximity to an active trade route. This is one reason why such vibrant Buddhist communities were to be found along the network of east-west routes known collectively as the Silk Road, and why those communities so often fell into decline when those routes shifted.

Hyecho never mentions a companion in the account of his travels. However, it is unlikely that he always traveled alone and still lived to tell the tale. It may be that his pilgrimage took him not where he wanted to go but where merchants were going, preferring the safety of numbers over the most direct route home. And so he traveled far, seeing more of the world than any other Buddhist pilgrim.

In the pages that follow, we will follow his route, beginning in his native Korea, which he left, never to see again, when he was not yet twenty years old, and ending at Wutaishan, the sacred mountain of Mañjuśrī, where he died some sixty years later. As we have noted, Hyecho says very little about the places he visited. We know where he went, but we often do not know why. The pages that follow are thus, in many ways, exercises in imagination, navigating between retracing his terrestrial route and flights of fancy. We know the places on Hyecho's pilgrimage, we know the Buddhist stories associated with those places, and we know the artworks that those places inspired, some of which Hyecho would have seen with his own eyes. Our exercise in imagination is thus an attempt to imagine Hyecho's mind, the things he would have seen, the thoughts he would have had, as he walked, unknown and unnoticed, through the Buddhist world.

· ONE ·

DUNHUANG

The Discovery of the
Pilgrim's Account

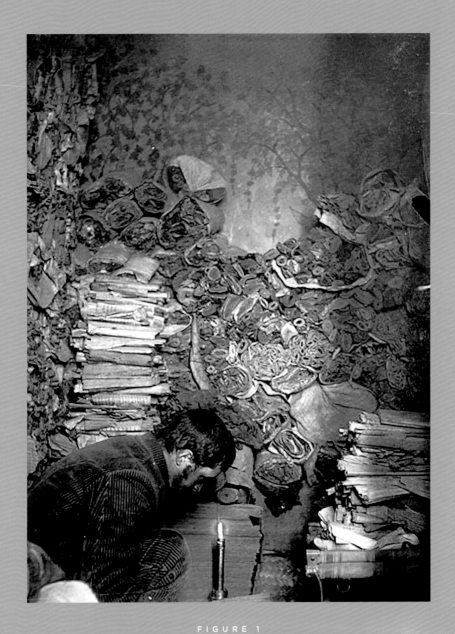

In April 1908, the French scholar Paul Pelliot, age twenty-nine, sat crouched in a cave temple in far western China, surrounded by tens of thousands of texts, piled all around him, ten feet high. This came to be known as Cave 17, the "Library Cave" in the Mogao cave-temple complex near the town of Dunhuang, one of the last stops on the Silk Road for those leaving Han China, one of the first stops for those entering. Pelliot was not the first European scholar to examine the texts.

By 1900, the Mogao Caves, known as the Caves of a Thousand Buddhas, were sparsely populated and largely abandoned. Their caretaker and self-appointed "abbot" was a Daoist priest named Wang Yuanlu. On June 25, 1900, he was removing sand that had accumulated in Cave 16, in preparation for restoring the shrine there, when he discovered a sealed vestibule on the right side of the passageway into the cave. Opening it, he found it filled from wall to wall, from floor to ceiling, with all manner of bundles of scrolls, texts, paintings, and banners, as many as fifty thousand pieces. The cave seems to have been sealed in the earlier decades of the eleventh century; scholars continue to debate why the texts were kept there and why the cave was sealed.

Wang reported his discovery to the governor of Gansu Province, who ordered the cave to be resealed. A door was built into the wall, and only Wang had the keys. In 1907, Aurel Stein, a Hungarian archaeologist and a naturalized British subject, arrived in Dunhuang, having heard about the remarkable rock-cut caves from a member of a Hungarian expedition to northwestern China who had visited the site in 1879. Convincing Wang that he was something of a latter-day Xuanzang, the Tang Dynasty monk who had made the famous "journey to the west" to gather Buddhist scriptures, Stein persuaded Wang to give him several thousand texts and hundreds of paintings to return to India, in exchange for a contribution of the equivalent of £130 for the restoration of Cave 16. Stein's Chinese, however, was not good, and he took only those texts that Wang gave him, which included hundreds of duplicates of the same texts, especially the *Lotus Sūtra* and the *Diamond Sūtra*. Returning to London, Stein was knighted. Most of the works that he acquired (he made a second trip in 1915 and took even more documents) are found today in London. More than forty-five thousand manuscripts and printed documents on paper, wood, and other materials in many languages are now in the British Library, and almost four hundred paintings from Dunhuang are preserved in the British Museum.

Pelliot, arriving the next year, also gained the trust of Wang, largely because of his fluency in Chinese. Working by candlelight over a period of two weeks, he went through thousands of texts, many of them just fragments, placing those that he wanted in two piles: one pile for works that he considered important treasures and one pile for works he considered valuable but less essential. He found works in Chinese, Tibetan, Sanskrit, and a number of ancient Central Asian languages, such as Sogdian. Although the works were predominantly Buddhist, there were many Daoist and Confucian texts, as well as Nestorian Christian texts and an abundance of secular works and administrative documents.

In 1911, the Japanese nobleman Count Ōtani Kōzui (1876–1948) led an expedition to Dunhuang, returning to Kyoto with more than four hundred manuscripts. The Russian scholar Sergei Oldenburg (1863–1934) arrived in 1914, taking 365 scrolls and some eighteen thousand fragments back to St. Petersburg. Not to be outdone, the American archaeologist Langdon Warner (1881–1955) did something that the previous visitors had not. He removed twenty-six paintings from the walls of four caves and took them to the Fogg Museum in Boston. Thus, apart from the texts, artifacts, and art that remained in China, the treasures of Dunhuang are to be found in London, Paris, Kyoto, St. Petersburg, and Cambridge.

Among the more than ten thousand documents and paintings that Paul Pelliot chose and took back to Paris was a fragment without a title. We do not know which of his two piles he had placed it in.

THE COMMENTARY

The text Pelliot found was a single handwritten scroll of 227 columns, each with some thirty characters per column. The scroll was made from nine sheets of paper, each about eleven inches high and sixteen and a half inches wide. Based on the type of paper and the calligraphic style, scholars date the manuscript to the eighth century. This suggests that Hyecho stopped in Dunhuang as he made his way back to China; the manuscript may be a copy of a draft that he left there. If this is the case, then the text that survives represents Hyecho's account of his travels as his journey drew to a close; it is not a record of memories written years later.

Paul Pelliot could not have known this, his task made all the more difficult by the fact that the scroll he discovered was a fragment. The beginning of the text, which would have included the title and the author's name, was missing. The end of the text, which would have included a colophon where the author and title would again be named, was also missing. Through a

piece of brilliant detective work, Pelliot established that some of the terms that appeared in the manuscript also appeared in a pronunciation glossary called *Pronunciations and Meanings of All the Scriptures* (*Yiqiejing yinyi*).

Much of what we can infer about Hyecho's journey comes not from Hyecho's journal but from this glossary. With the introduction of Buddhism into China, translators were confronted with a vast vocabulary that included not only technical terms but also personal and place names. In order to render these into Chinese, a huge number of neologisms were required, with many terms transcribed phonetically rather than being translated. In the seventh century, scholars and translators sought to standardize these terms and their pronunciations, producing glossaries called "pronunciations and meanings" (*yinyi*) that compiled unusual terms gathered from various texts and provided their correct pronunciation; the terms include personal names and place names, as well as names of various foods and objects. The most comprehensive of these texts was produced by Huilin (733–817). Compiled between 783 and 807, it includes terms from more than thirteen hundred scriptures. Huilin was from Kashgar, an important oasis city on the Silk Road and one of Hyecho's stops on his long journey back to China. Although Huilin was somewhat younger than Hyecho, they likely knew each other. Like Hyecho, Huilin was a disciple of Amoghavajra, perhaps a more prominent disciple, renowned for his vast learning as well as for his knowledge of Indian philology. Unlike Hyecho, Huilin receives a detailed entry in *Biographies of Eminent Monks of the Song Dynasty*. Huilin thus might have known of Hyecho's otherwise obscure travel journal because he knew its author.

Huilin's volume not only provides a list of terms; he helpfully supplies their source and the chapter or section in which they occur in that source. Pelliot could therefore conclude that the title of the work was *Memoir of a Pilgrimage to the Five Kingdoms of India* and that the author was Hyecho (Huichao in Chinese).

A total of eighty-five terms from Hyecho's journal appear in Huilin's glossary, but the majority of those terms are missing from the extant manuscript of Hyecho's text. *Pronunciations and Meanings of All the Scriptures* suggests that the full version of Hyecho's text was in three parts. The first part described his journey from China to India. Huilin lists thirty-nine terms from this section, none of which appear in the surviving manuscript of Hyecho's journal. The second part describes his travels in India. Here, of the eighteen terms in *Pronunciations and Meanings of All the Scriptures*, only four appear in Hyecho, suggesting that the full version was much more detailed than the version that survives. The third part describes his return to China. Here, fourteen of the twenty-eight terms that appear in Huilin's

work are found in Hyecho's. All of this implies that Hyecho's journal was originally a much longer and more detailed text; what survives appears to be the second half of the second part and the first half of the third part. To further complicate things, the terms listed in *Pronunciations and Meanings of All the Scriptures* do not always match those in Hyecho's text. Scholars have therefore speculated that the fragment of Hyecho's journal that survives is not simply a fragment of the larger text but is instead a fragment of a draft or of an abbreviated version. In that case, the full version that was read by Huilin is no longer extant.

Pronunciations and Meanings of All the Scriptures is nonetheless helpful in a number of ways, including in the reconstruction of Hyecho's route. For example, it provides place names that do not appear in the surviving fragment, including the Chinese names for Champa (Linyi) in modern Vietnam and the Nicobar Islands (Luoxingguo or "Land of the Naked" in Chinese), suggesting that Hyecho's ship stopped at these places on the way to India.

THE ART

At the beginning of the introduction to this book, we cited a famous passage from the *Great Discourse on the Final Nirvāṇa* (*Mahāparinibbāna Sutta*), the account of the Buddha's final days, in which he instructs his followers to visit four places after his death: the places of his birth, enlightenment, first sermon, and death. The quotation is from the Pāli version of the text. In most cases of texts in the Pāli canon, a Sanskrit version is known (often preserved only in Chinese), which provides a similar, but not always identical, version of the same text. Thus, there is a Sanskrit text with the same title (*Mahāparinirvāṇa Sūtra*). However, this text, usually called simply the *Nirvāṇa Sūtra*, is a very different work. This is likely the version of the Buddha's final days that Hyecho would have known. The first artwork presented in this chapter (fig. 2) is a page from the Chinese translation of that sūtra, discovered in the Library Cave at Dunhuang.

There are several versions of the text, in varying lengths. One version was brought back to China by the famous pilgrim Faxian; he completed his translation in 418. The page presented here is from the more famous and longer version, whose translation into Chinese was completed by the monk Dharmakṣema in 423. This passage is from the fortieth chapter of the text. It reads:

[The Buddha said: "O good man! To illustrate: a father and mother couple have three sons. One is obedient, respects his parents, is sharp and

intelligent, and knows well of the world.] The second son does not respect his parents, does not have a faithful mind, is sharp and intelligent, and knows well of the world. The third son does not respect his parents, and has no faith. He is dull-witted and has no intelligence. When the parents wish to impart a teaching, who should be the first to be taught, who is to be loved, to whom do the parents need to teach the things of the world?"

The bodhisattva Kāśyapa said: "First must be taught the one who is obedient, who respects his parents, who is sharp and intelligent, and who knows what obtains in the world. Next, the second and then the third [son]. And although the second son is not obedient, for the sake of loving-kindness this son should be taught next."

"O good man! It is also the same with the Tathāgata. Of the three sons, the first may be likened to the bodhisattva, the second to the *śrāvaka*, and the third to the *icchantika*."[23]

This passage makes it clear that the *Nirvāṇa Sūtra* is a Mahāyāna sūtra, extolling the bodhisattva over the *śrāvaka*, the stereotypical Hīnayāna disciple of the Buddha, and mentioning the *icchantika*, a strange figure in the Buddhist cast of characters; these are beings who are so incorrigible that they reject the Buddha's teachings and thus are doomed forever to saṃsāra, with no hope of liberation. The Chinese monk Daosheng believed that such a teaching was contrary to the Buddha's compassionate declaration that all beings will one day become enlightened. Yet Faxian's version of the *Nirvāṇa Sūtra* contained no such promise. When Dharmakṣema translated a longer version of the sūtra, it contained a passage in which the Buddha declared that all beings are endowed with the Buddha nature, including *icchantikas*.

The page from the sūtra here appears to come from a copy made in the early seventh century. The calligraphy is that of a professional scribe, rendered in a clear and balanced hand, with the standard seventeen characters per line. It likely comes from a version found in a large collection of sūtras. To protect the text from insects, the paper was dyed with a yellow liquid made from the bark of the Amur cork tree. This text may be, in both content and form, like the copy of the *Nirvāṇa Sūtra* from which Hyecho learned of the powers of pilgrimage.

The second piece (fig. 3) is a beautiful painting from Dunhuang that conveys many of the meanings and motivations of Buddhist art. The central figure is the bodhisattva Kṣitigarbha, rare among the bodhisattvas of the Mahāyāna for appearing not in the raiment and jewelry of an Indian prince (like Mañjuśrī in chapter 12) but in the guise of a shave-pate monk.

He is shown in his abode on the sacred mountain called Jiuhuashan in An-hui Province in China, a place strongly associated with the Korean monk Jijang (also known as Kim Kyogak, 696–794), a contemporary of Hyecho. "Jijang" is the Korean pronunciation of Dizang, the Chinese name of Kṣiti-garbha. Born into the royal family of Silla, he became a Buddhist monk and, like Hyecho, made his way to China. He took up residence on Jiuhuashan in southeastern China, where he devoted himself to meditation, winning the adoration of the local laity and of Korean pilgrims. So great was his piety that after his death he was considered to be a human manifestation of the bodhisattva. Jiuhuashan, in fact a chain of nine peaks, whose name means "Nine Flower Mountain," came to be regarded as the abode of Kṣitigarbha and as one of the four sacred Buddhist mountains of China. Kṣitigarbha is especially beloved not only for his simple mien but for his willingness to descend into hell to rescue sentient beings who have been reborn there; he was even depicted as the Lord of Hell. Indeed, in our painting, the figure to his left is one of the ten kings of hell.[24]

The several purposes of the painting, which dates from the late tenth or early eleventh century, are clarified by the Chinese characters in the col-ored cartouches. The green one at the top reads, "Homage to the bodhisat-tva Kṣitigarbha, painted and donated on a memorial day," indicating that the painting was made on behalf of a deceased family member and donated on the anniversary of the person's death. The red cartouche on the right reads "General of the Five Paths." This is an epithet of King Zhuanlan, lord of the tenth of the ten courts of hell. In the cosmology of Chinese Buddhism (not reflected in Indian sources), hell has ten courts, each presided over by its own king. The damned must pass through each of these to be tried and judged for the misdeeds they have done. These trials occur at specific in-tervals after death. Over the course of the first seven weeks (according to standard Buddhist cosmology, the longest period of time between death and rebirth), the dead appear before the first seven kings, one each week, beginning on the seventh day after death. The court of the eighth king is reached on the hundredth day after death, the ninth court on the first anni-versary, and the tenth and final court on the third anniversary. As the last opportunity for absolution, Kṣitigarbha was particularly propitiated on the third anniversary, entreated one last time to descend into hell and intercede on behalf of the deceased. Hence, the king to the left of the bodhisattva is the king of the tenth court of hell. Kṣitigarbha has two accoutrements, a wish-granting jewel (which he holds in his left hand) and a monk's staff (*khakkhara*), held here by the tenth king of hell.

The red cartouche to the left reads "Daoming heshang," the name of the monk who stands to Kṣitigarbha's right. According to a story, a monk named Daoming was summoned to hell by Yama, king of the underworld. When he learned that he had been summoned by mistake, he was able to return to the land of the living when he saw a monk descending into hell with a lion. The monk was Kṣitigarbha, and the lion was the mount of the bodhisattva Mañjuśrī (see chapter 12). Kṣitigarbha instructed Daoming to return to earth and paint what he had seen; the more canine than feline creature at the bodhisattva's feet is presumably the lion.

The upper area of the painting thus brings together a range of sacred associations with the bodhisattva Kṣitigarbha: his abode on Jiuhuashan, his depiction by the monk Daoming, his association with the dead and their trials before the ten kings of hell. The lower panel of the painting provides clues about its worldly origins. The green cartouche at the bottom of the painting, which may or may not represent a memorial tablet, reads, "Offered by the former princess of the Li clan from Khotan, the kingdom of gold and jade." The princess, dressed in red, is depicted in the bottom right corner, in a posture of piety; she appears to hold two lotuses (a blossom and a bud) in her right hand and an incense burner in her left. Khotan was an ancient Buddhist kingdom, located in what is today the southwestern region of Xinjiang Province in China. The princess may be the daughter of the Khotanese king Li Shengtian, who reigned from 912 until his death in 966. She was married to Cao Yanlu, the ruler of Dunhuang from 976 to 1002. Her husband or another family member commissioned this painting to assure the beneficial rebirth of the princess on the third anniversary of her death, placing it in the sacred precincts of a cave temple in their kingdom of Dunhuang.

In the center of the lower panel is an empty peach-colored box. This space would often be used for a more substantial dedicatory inscription than that which appears at the top. The space may have been left empty for an inscription that was never added, or the original inscription may have been erased by a later owner of the work. The figure in the bottom left corner is not identified with an inscription. It appears to be the buddha Vajrasattva, holding a vajra and a bell. His presence indicates some connection of the work to tantric Buddhism, which had its own rituals for the deliverance of the dead.

The two works that illustrate this chapter, a text and a painting, suggest many of the themes that will recur in the pages that follow. The *Nirvāṇa Sūtra*, the text in which the Buddha prescribes pilgrimage, is a work that exists in multiple versions, with more and more passages added in an attempt

to contain innovations in Buddhist doctrine within the mouth of the Buddha. In the text, the Buddha is about to die but does not die. Whether his lifespan was limitless, as the *Lotus Sūtra* (see chapter 5) and the *Nirvāṇa Sūtra* proclaim, or whether he somehow lives on inside his stūpas, India remains a sacred site for Buddhists as the place where the Buddha's presence persists, thus inspiring monks from distant Korea to set out on a long and arduous pilgrimage. The painting of Kṣitigarbha introduces a host of themes about the Buddhism of Hyecho's day. To mention one, that a Korean monk could travel to China and come to be so respected by the Chinese living in the vicinity of Nine Flower Mountain that he would be considered the human incarnation of the beloved bodhisattva Kṣitigarbha, suggests a less bounded Buddhist world than one might imagine today.

Although he was never deified, as his compatriot Jijang came to be, Hyecho also found his way to the Chinese mountain-abode of a bodhisattva: Wutaishan of Mañjuśrī, regarded as an auspicious and sacred place, perfect for translation and practice. Such stories of steadfast travel across long distances, and of the immense piety performed at sanctified sites, link the many places of the Buddhist world and the pilgrims who traversed it. This cosmopolitan quality of the Buddhist world is also suggested by Dunhuang, and long before it was pillaged by a series of foreigners in the early decades of twentieth century. As one of the last Chinese outposts for those leaving China and one of the first Chinese outposts for those entering China, Dunhuang was in many ways not Chinese; even its famous cave paintings are known above all for their Central Asian (that is, not Han) elements. That the Library Cave contained works in so many different languages from such faraway regions is further evidence of its importance as a cultural crossroad. Hyecho, who likely stopped in Dunhuang, where his travel journal would one day be found, saw so many of those regions with his own eyes.

FURTHER READING

Neville Agnew, Marcia Reed, and Tevvy Ball, eds., *Cave Temples of Dunhuang: Buddhist Art on China's Silk Road* (Los Angeles: Getty Conservation Institute, 2016).

Valerie Hansen, *The Silk Road: A New History* (Oxford: Oxford University Press, 2012).

Roderick Whitfield, Susan Whitfield, and Neville Agnew, *Cave Temples of Mogao at Dunhuang: Art History on the Silk Road*, 2nd ed. (Los Angeles: Getty Conservation Institute, 2015).

迦葉菩薩品

大般涅槃經迦葉菩薩品第十二

迦葉菩薩白佛言世尊如来憐愍一切衆生
不調能調不淨能淨无歸依者能作歸依未
解脱者能令解脱得八自在為大醫師作大
藥王善星比丘是佛菩薩時子出家之後受
持讀誦分別解說十二部經壞欲界結獲得
四禪云何如来記說善星是一闡提斯下之
人地獄劫住不可治人如来何故不先為其
廣說正法後為菩薩如来世尊若不能救善
星比丘云何得名有大慈愍有大方便佛言
善男子譬如父母唯有三子其一子者有信
順心恭敬父母利根智慧於世間事能憲了
知其第二子不敬父母无信順心利根智慧
於世間事能憲了知其第三子不敬父母无
有信心鈍根无智父母若欲教吉之時應先
教誰先親愛誰當先教誰知世間事迦葉菩
薩曰佛言世尊應先教授有信順心恭敬父
母利根智慧知世事者其次第二乃及第三
而彼二子雖无信心恭敬之心為憲念故次
復教之善男子如来亦尒其三子者初喻菩

FIGURE 2

A Page from the Great Discourse on the Final Nirvāṇa, Sui
Dynasty, Dunhuang, China (581–618). Ink on paper, 8 ¼ ×
149 ¾ in. Purchase—Charles Lang Freer Endowment, Freer
Gallery of Art (F1982.2).

The Bodhisattva Kṣitigarbha, Northern Song Dynasty (late
tenth to early eleventh century). Ink, color, and gold on silk,
41 ¹⁵/₁₆ × 22 ⁷/₈ in. Purchase—Charles Lang Freer Endow-
ment, Freer Gallery of Art (F1935.11).

· TWO ·

SILLA

The Birthplace of the Pilgrim

Hyecho's native Korea was not a unified kingdom over the first six centuries of the Common Era; the Korean Peninsula contained three kingdoms: one very large, Goguryeo, and two very small kingdoms far to the south: Baekje and Silla. Despite its distance by land from the Chinese court, Silla had established a close relationship with China, requesting military aid from Emperor Yang of the Sui Dynasty in 611 and sending envoys to the Tang court in 621. The king of Silla during this period, Jinpyeong (r. 579–632), was a strong patron of Buddhism. By the seventh century, it was common for Korean monks to go to China to study, many remaining there for the rest of their lives. Some, like Hyecho, were relatively obscure during their lifetimes. Others would become distinguished scholars.

THE STORY

One monk who decided to make the journey to China was Wonhyo (617–686). Word had reached Korea that the Chinese monk Xuanzang had returned to the Tang capital in 645 after an eighteen-year pilgrimage to India. Not only had he brought back more than six hundred Buddhist manuscripts, written in Sanskrit, but he had spent years studying at the renowned Nālandā monastery, receiving instruction from the 106-year-old master Śīlabhadra on the doctrines of the Yogācāra school, whose most famous doctrine was that there is no external world, that everything is "mind only." Now Xuanzang was back, ensconced in Chang'an at the Great Wild Goose Pagoda, which had been built especially for him to house his manuscripts. Wonhyo and his friend Uisang (625–702) decided to make the pilgrimage to China and become his disciples.

They chose to travel by the long land route through Silla's enemy, Goguryeo. Setting out in 650, they safely traversed the length of the Korean Peninsula and reached the border with China. Goguryeo and China had been at war since 645. The Tang emperor Taizong had been preparing a major invasion in 649 but died before he could lead it. Fearing that the two monks were Goguryeo spies, the Chinese border guards arrested Wonhyo and Uisang and threw them into prison. They were able to escape and make the long journey back to Silla.

Undeterred, they decided to try again, this time by sea. Gyeongju, the capital of Silla, was on the southeastern coast of the Korean Peninsula. In order to sail to China, they first needed to make their way to the port of Dangseong, far to the north on the western coast, near the modern city of Hwaseong, not far from Incheon. While they were walking at night through

the countryside, they were caught in a violent thunderstorm. As they stumbled through the darkness looking for shelter, a flash of lightning illuminated an earthen shrine ahead, and they entered it to wait out the storm. The rain continued to fall, submerging the floor of the shrine. Although standing in water, Wonhyo became thirsty and felt around in the water until he felt a gourd floating on the surface. Using it as a cup, he dipped it into the water and drank his fill. The water was pure and sweet.

By the next morning, the rain had stopped. In the light of day, Uisang and Wonhyo saw that they had spent the night not in a shrine but in a tomb. When Wonhyo looked down, he saw that the gourd that he had used as a cup was a skull and that a rotting corpse was floating in the water that had tasted so sweet the night before. As he was about to vomit, he experienced a flash of insight. The purity or pollution of the water that he had drunk lay not in the water but in his own mind. He declared, "The three worlds are merely mind, and all the things of the world are merely consciousness. Clean water and dirty water are in my mind; their true nature is not to be found in the water." He concluded that if everything is merely mind, there was no point in traveling across the sea in search of a teacher; there was no point in searching for enlightenment outside of his mind. There was no reason to go to China.

Uisang did not agree with his companion and continued on alone, safely reaching China in 661. He became a great master of the Huayan school and a close friend of perhaps its greatest figure, the monk Fazang (643–712). He also became a master of the monastic code (vinaya). Uisang could have remained comfortably in China for the rest of his life, but when he learned that the new Tang emperor was planning to invade his native Silla, he returned home in 671 to warn his king. The Silla forces, thus well prepared when the Chinese troops invaded, drove them out of the Korean Peninsula.

And so Wonhyo remained behind, not interested in the learning or the fame that he might find in China. Instead, he wrote commentaries on a number of important texts, likely some of the same texts that Uisang was studying in China. He composed more than one hundred commentaries. Yet he was also known for his unconventional lifestyle. While still a monk, he had an affair with a widowed princess. Their son went on to become a famous scholar, inventing a vernacular writing system for Korean (which had used Chinese up to that point). Having broken his vow of celibacy, Wonhyo abandoned his monk's robes for lay dress and wandered through the countryside, dancing and singing, exhorting the common people to practice the dharma. He became the most famous Buddhist teacher in Korean history.

Wonhyo thus demonstrated that it was not necessary for Korean monks to go on pilgrimage to China to find enlightenment. Enlightenment could be found in their own homeland. In some ways, this was a political claim. As Silla became a military power, with an army that could defeat the Tang, it was no longer necessary to defer to China in all things. However, it was primarily a religious claim. Xuanzang had made the long pilgrimage to India, and so Uisang and Wonhyo decided to make a pilgrimage to Xuanzang. After the night in the tomb, Wonhyo decided not to go. He made a decision about the nature of the mind, and thus a decision about the nature of enlightenment. Enlightenment is here; enlightenment is now. Yet, thirty-six years after Wonhyo's death, Hyecho set out on his pilgrimage to India.

THE COMMENTARY

When Buddhism has spread from one nation to another, as it has many times over its long history, its fortunes have often rested on its success at court. Kings and emperors have tended to be interested in Buddhism not for its critique of the human condition or for its formulation of the doctrine of no self, but for its claims to bestow benefits in this life. The royal patrons of the Buddha made offerings to the monastic community because it accumulated merit for themselves and their kingdoms, merit that would bear fruit in the form of happiness in this lifetime and the next. After the death of the Buddha, a number of texts specifically promised protection from worldly harms. For example, in the twenty-fifth chapter of the *Lotus Sūtra*, the Buddha delineates a long list of fears; one need only call upon the bodhisattva Avalokiteśvara to be protected from them. Thus, we read, "In a dispute before judges or fearful in the midst of battle, if you contemplate the power of Avalokiteśvara, all enemies will flee away." In the next chapter of the sūtra, a set of spells, called *dhāraṇī*, is provided that will protect those who expound the *Lotus Sūtra* from all manner of enemies, human and demonic. Other texts, such as the *Sūtra of the Golden Light* (*Suvarṇaprabhāsottama*) and the apocryphal *Sūtra for Humane Kings* (*Renwang jing*) offer kingdoms divine protection from natural disasters and foreign invaders if they uphold the sūtra and the monks who expound it. So important were these texts in East Asia that a Chinese term was coined to describe their cult: *huguo fojiao*, "state protection Buddhism."

Buddhism could be employed not only to protect the state but also to extend it. We find in Indian Buddhist literature the figure of the *cakravartin*, often translated as "universal monarch" but literally meaning "wheel

turner" because of a particular magical accoutrement: a huge wheel or disc that rolls across regions, bringing them under the king's dominion. Depending on whether the wheel is gold, silver, copper, or iron, the king rules over four, three, two, or one of the world's four continents. The rulers of the lands traversed by a golden wheel surrender to the *cakravartin* without a fight, but the *cakravartin* with an iron wheel must go to war to conquer his neighbors. Although the fourth-century exegete Vasubandhu (who articulated the fourfold system) stipulated that a *cakravartin* appears in the world only when the human lifespan is not less than eighty thousand years, the legends of the Indian emperor Aśoka declared that he had been an iron-wheeled *cakravartin*. Over the course of Buddhist history, many East Asian and Southeast Asian monarchs made the same claim.

Buddhism thus offered a monarch both protection from invasion by foreign armies and success in battle when he invaded foreign lands. Perhaps nowhere was this more important to the importation of Buddhism than in Korea. The introduction of Buddhism into a new land is often marked by the construction of the first monastery and the ordination of local males as monks. In the case of Hyecho's homeland of Silla, this was the monastery of Hwangnyongsa, which was built between 553 and 569 on the order of King Jinheung (r. 540–576). A queen later constructed a nine-story pagoda on its grounds after being told by a monk that doing so would ensure Silla's conquest of its enemies. During the wars for the unification of the Korean Peninsula, eventually won by Silla, Silla kings consistently employed Buddhist categories to promote and justify their cause, declaring, for example, that the royal family was, like the Buddha, part of the warrior (*kṣatriya*) caste of ancient India. King Jinheung, seeing himself as the successor of the emperor Aśoka, the iron-wheel *cakravartin*, named his sons "Copper Wheel" and "Gold Wheel." A subsequent king, Jinpyeong (r. 579–632), called his queen and himself the Korean translations of Māyā and Śuddhodana, the mother and father of the Buddha. King Munmu (r. 661–681) departed from the traditional practice of having his body buried in a mound, leaving instructions that he be cremated, the proper death ritual for a *cakravartin*, as specified by the Buddha himself.

Silla kings served as patrons of the saṃgha. The saṃgha in turn provided a powerful ideology to justify their kingship. The Silla vinaya master Jajang (590–658) returned from Wutaishan (see chapter 12) not only with relics of the Buddha's skull and finger bone to be enshrined in pagodas, but with word that he had been informed by an emanation of the bodhisattva Mañjuśrī that Hwangnyongsa had been built on the place where the ancient

buddha Kāśyapa had taught the dharma, thus transforming Silla into a sacred Buddhist land.

None of this would have been possible without Buddhist monks to interpret texts and perform state rituals, especially those prescribed in the *Sūtra for Humane Kings*. As in China, however, the Buddhist saṃgha remained under the control of the state; offerings to monasteries could be made only with the approval of the throne; men could become monks only on "ordination platforms" approved by the throne. Monks often represented themselves not as those who had renounced the world but as vassals of the king, a king who supported monks, built monasteries, and sponsored rituals to protect the king and his kingdom. Thus, the saṃgha was subordinate to the state, with monks sometimes dispatched to China by royal decree.

This was the Buddhist world in Hyecho's Silla homeland as he set out for China and then for distant India, the birthplace of the Buddha, the site of his teaching, and the source of his relics that were now enshrined across Asia.

THE ART

We have two very different pieces from two very different periods of Korean Buddhism. The first piece (fig. 4) is the head of a buddha, excavated in 1917. Art historians date it to the Unified Silla period, that is, the period when the Silla king brought much of the Korean Peninsula under his control. Although there is some question about the date, it may be as early as the eighth century, that is, Hyecho's time. The bronze head is quite small, only about two inches high, suggesting that if the full figure was a standing buddha, it would only be about a foot tall. Since it lacks a body and hand gestures and a pedestal with an inscription, it cannot be said with certainty which buddha this is, since all buddhas share the same physical features from the neck up.

One of those features is a perfect symmetry, something that this piece seems to lack, with the left side of the face, especially the eye and eyebrow, appearing somewhat skewed. If these irregularities were present in the clay mold or the wax form, the piece would not have been cast in bronze, suggesting that there might have been an error in the casting process or damage from fire. In fact, it is possible that this head was never placed on its body because of its irregular face. Regardless of the current condition of the piece, it gives some sense of how the Buddha was depicted in Korea during Hyecho's time.

The second piece (fig. 5) is much more refined, much more sumptuous, and comes from a later period of Korean history. It is a painting of

Avalokiteśvara (Guanyin in Chinese, Gwaneum in Korean), the bodhisattva of compassion, whom we will meet again in chapter 3. The painting, about thirty-nine inches high and almost nineteen inches wide, dates from the mid-fourteenth century, the Late Goryeo period of Korean history.

In East Asia, Avalokiteśvara is thought to take on thirty-three different forms, usually traced back to the twenty-fifth chapter of the *Lotus Sūtra*. Among them are the willow, the white-robed, and the "water-moon" manifestations. In visual terms, these three are often conflated, sometimes also including the "waterfall viewing" Avalokiteśvara. The "water-moon" form is usually envisioned on a rock on the seashore of Mount Potalaka, from which the bodhisattva views the moon reflected in the water. The iconography varies, but often the bodhisattva carries a vase and a willow branch. In some versions, the bodhisattva is also clothed in a white robe. The particular form of the bodhisattva in our painting is a "water-moon" Avalokiteśvara, a form that originated in Tang China in the eighth century. It is therefore a form of Avalokiteśvara that Hyecho would have known and likely encountered during his studies and travels through China, even before his monastic compatriots would have brought images of this form of the bodhisattva to Korea.

Avalokiteśvara was a male bodhisattva in India. Yet, among the thirty-three manifestations of Avalokiteśvara listed in the *Lotus Sūtra*, seven are female manifestations, suggesting that a bodhisattva can take on any form to save sentient beings. Up through the tenth century, almost all depictions of Guanyin in China had masculine attributes, and most sculptures of the deity continued to have a distinct mustache. From about the twelfth century, a distinctly feminine version of the deity began to appear. Early European visitors to China who encountered images of Guanyin in white flowing robes holding an infant often made parallels to the Virgin Mary and called her the "goddess of mercy." In modern China, the majority of the images of Guanyin are feminine.

The gender of the bodhisattva in this painting is unclear. The raiment is that of a woman, but a mustache and a goatee are visible on the face. Other elements of the iconography are standard for the bodhisattva. Because s/he is strongly connected to the buddha Amitābha, and attends him in his pure land, Avalokiteśvara is often depicted with an image of Amitābha in her/his hair, just visible in the piece here. Two familiar accoutrements are the jeweled rosary in the right hand and the vessel of pure water sitting on a rock on the left side of the painting. The rocky crags that surround the bodhisattva's throne suggest that s/he is in her/his abode on Mount Potalaka, described

in a passage in the *Gaṇḍavyūha Sūtra*. The site of the mountain has been the subject of much speculation over the centuries. Although Xuanzang said it was in southern India, for centuries Buddhists in East Asia have identified it as the mountainous island that they call Putuoshan, off the eastern coast of Zhejiang Province. A further connection with the *Gaṇḍavyūha Sūtra* is suggested by the small supplicant at the bodhisattva's feet, who may be Sudhana, the protagonist pilgrim of the text.

The artist was clearly seeking to depict the sacred splendor of the bodhisattva, seated rather languidly in her/his mountain abode, adorned with opulent silks and jewelry. Typical Korean stylistic features are the extensive gold highlighting of the undersurfaces of the oddly shaped rocks, the textile patterns on the robes (including the diaphanous gauze veil), and the double outlines on the red lower garment. Indeed, the delicacy of gauze garments is one of the hallmarks of Korean Buddhist painting during this period. While the gold-painted body appears rather flat, subtle three-dimensional effects are achieved on the drapery through layers of fabric and combinations of shades and hues.

The Goryeo Dynasty ended in 1392, and with it much of the state sponsorship of Buddhism. It is not the case, as is sometimes suggested, that the Korean nobility suddenly became Neo-Confucian. However, the fortunes of Buddhism waned. Until the early twentieth century, Buddhist monks and nuns were forbidden to enter the gates of Seoul. For these reasons and a variety of others, much Korean Buddhist art left Korea, often ending up in Japan. Both of the pieces represented here came to Charles Freer via Japan. Works of art often make their own pilgrimages and do not always find their way back home.

FURTHER READING

Kim Lena, *Buddhist Sculpture of Korea*, 8th ed. (Seoul: Korea Foundation, 2013).

Kim Youn-mi, ed., *New Perspectives on Early Korean Art: From Silla to Koryŏ* (Cambridge, MA: Korea Institute, Harvard University, 2013).

Lee Soyoung and Denise Patry Leidy, *Silla: Korea's Golden Kingdom* (New York: Metropolitan Museum of Art, 2013).

Richard D. McBride II, *Domesticating the Dharma: Buddhist Cults and the Hwaŏm Synthesis in Silla Korea* (Honolulu: University of Hawaii Press, 2008).

Washizuka Hiromitsu, Park Youngbok, and Kang Woo-bang, eds., *Transmitting the Forms of Divinity: Early Buddhist Art from Korea and Japan* (New York: Japan Society, 2003).

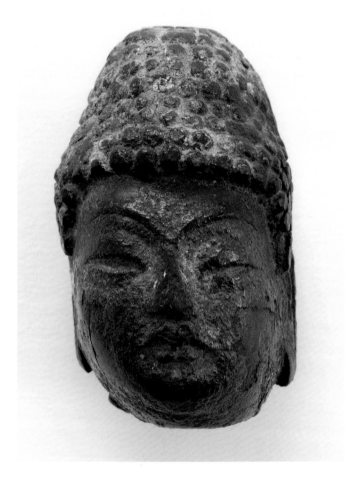

A Head of the Buddha from Silla, Unified Silla period, Korea
(eighth century). Bronze, 2 1/6 × 1 5/8 in. Gift of Charles Lang
Freer, Freer Gallery of Art (F1917.532).

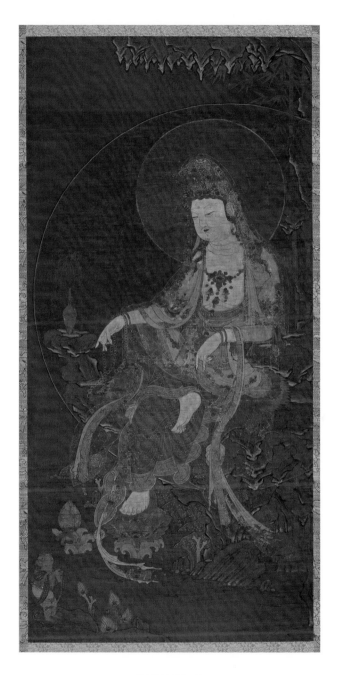

FIGURE 5

Water-Moon Avalokiteśvara, Late Goryeo period, Korea
(mid-fourteenth century). Ink, color, and gold on silk, 38 ¹¹/₁₆
× 18 ³/₄ in. Gift of Charles Lang Freer, Freer Gallery of Art
(F1904.13).

· THREE ·

AT SEA

The Pilgrim Sails for
the Holy Land

Although the first part of Hyecho's travel journal is lost—it begins when he is already in India—Huilin's *Pronunciations and Meanings of All the Scriptures* contains a number of terms from the lost portion of Hyecho's text that suggest that he traveled from China to India by sea. The sea route between India (and Sri Lanka) and China was well established by the time of Hyecho's journey, and many Buddhist monks had made the journey, including Hyecho's future teacher Vajrabodhi. We note that Bodhidharma, who, according to legend, brought Zen from India to China, is said to have traveled by sea.

THE STORY

Sea travel—with its great rewards of riches and its great dangers of horrible death—appears often in Buddhist literature, including in the *jātaka* collections, the stories of the Buddha's past lives, where the future buddha is sometimes himself a sea captain, a "navigator of the oceans." Perhaps the most famous of these was the story of his birth as Supāraga, "he who crosses easily to the other shore." Here is how he is described:

> Through knowing the movement of the stars, the Great One was never confused about the position of the directions. Well-versed in normal, incidental, and miraculous omens, he was skilled in the order of timely and untimely events and proficient in recognizing sections of the sea through clues such as fish, water-color, terrain, birds, and crags. Alert and in control of weariness and sleep, he could endure the exhaustion brought on by cold, heat, rain, and other afflictions. Vigilant and brave, he delivered merchandise to its destination through his skill in drawing into land, steering clear of obstacles, and other talents.[25]

In the story, Supāraga, although old and blind, agrees to accompany some merchants on a sea voyage. Despite his blindness, he is able to guide them through uncharted seas and eventually saves them from falling off the ends of the earth.

Thus, a common theme in these Buddhist stories is the dangers of the sea and how the pious survive them. Sometimes these dangers are found in the strange lands that the ships encounter. Some are populated by *rakṣasīs*, female demons who, like the sirens in the *Odyssey*, lure sailors ashore with their beautiful bodies, making love to them when they land and then devouring them when they fall asleep. The merchant Siṃhala mounts a

magical black-eared horse that explains that he will carry Siṃhala and his 499 companions back to India. However, they must think of the three jewels and not look back. Only Siṃhala survives; the others look back when they hear the pleas of their demon lovers.[26]

In the story of the monk Saṃgharakṣita, with the permission of the Buddha the young monk sets out on a voyage with five hundred merchants. When some unknown force stops the ship in the middle of the sea, a voice from the sky demands that Saṃgharakṣita jump overboard. Taking his robe and bowl, he does so, and is transported to the underwater palace of the nāgas, a kind of sea creature depicted with the torso of a human and the lower body of a snake. Lamenting that their vile form has prevented them from receiving the dharma, the nāgas ask Saṃgharakṣita to teach them, which he does. After he remains with them for some time, they throw him back on board and the ship proceeds. The presence of a Buddhist monk seems, therefore, to have been regarded as auspicious. The monk could teach the dharma to the merchants during the voyage, and his presence could avert danger. In the story of the monk Purṇa, he does not even need to leave shore. When his brother's ship is attacked by a monster, angered because the crew is cutting down the precious sandalwood trees on his island, the brother calls out to Purṇa, who miraculously appears on deck, seated in the meditation posture. Immediately, the great tempest that the monster caused is quelled. When Purṇa explains that the sandalwood will be offered to the Buddha, the monster immediately relents, saying he had not heard that a buddha has been born in this world.[27]

Indeed, by the early centuries of the Common Era, sea travel seems to have been so common among Buddhists that saving sailors had become a specialty of perhaps the most famous of all bodhisattvas, Avalokiteśvara, the bodhisattva of compassion. In the twenty-fifth chapter of the *Lotus Sūtra*, perhaps the most famous of the Mahāyāna sūtras, we read of the miraculous powers of Avalokiteśvara (Guanyin in Chinese, Gwaneum in Korean):

> If innumerable hundreds of thousands of myriads of *koṭi*s of sentient be-ings who experience suffering hear of bodhisattva Avalokiteśvara and wholeheartedly chant his name, bodhisattva Avalokiteśvara will imme-diately perceive their voices and free them from their suffering. Even if those who hold to the name of bodhisattva Avalokiteśvara were to enter a great fire, because of this bodhisattva's transcendent power, the fire would not be able to burn them. If they were adrift on the great waters, by chanting his name they would reach the shallows. There are hundreds

of thousands of myriads of *koṭi*s of sentient beings who enter the great
ocean to seek such treasures as gold, silver, lapis lazuli, mother-of-pearl,
agate, coral, amber, and pearl. Even if a cyclone were to blow the ship of
one of these toward the land of *rākṣasa* demons, they would all become
free from the danger of those *rākṣasa* demons if there were even a single
person among them who chanted the name of bodhisattva Avalokiteś-
vara. For this reason he is called Avalokiteśvara.[28]

At the beginning of the twenty-fifth chapter, the Buddha declares that
Avalokiteśvara would free the faithful from fire, water, staves and swords,
demons, prison, and thieves. In China, all manner of miracle stories were
composed, recounting the ways that Avalokiteśvara would rescue those
who called his name. These were compiled into various collections, with
titles like *Responsive Manifestations of Avalokiteśvara* (*Guangshiyin ying-
yanji*), compiled around 399; *A Sequel to the Responsive Manifestations of
Avalokiteśvara* (*Xu Guangshiyin yingyanji*), compiled in the early decades
of the fifth century; and *A Further Sequel of the Responsive Manifestations
of Avalokiteśvara* (*Xi Guanshiyin yingyanji*), compiled in 501. All of these
would have been known in Hyecho's time. Here is a story from *Responsive
Manifestations of Avalokiteśvara*:

Xu Rong was a native of Langya (north of present-day Nanjing). One
day he returned from Mount Ding (southeast of present-day Hangzhou) by
boat. However, the boatmen were unfamiliar with the waters, and the boat
became caught in a whirlpool and started to sink. Xu Rong called the name
of Avalokiteśvara. In an instant, the boat was lifted up as if by a group of
men. Freed from the whirlpool, the boat sailed safely toward its destina-
tion. However, when night fell, a great storm arose. Blinded by the churning
waves, the boatmen could not see the shore and became lost. Xu continued
to chant the name of Avalokiteśvara. Soon they noticed a fire blazing on top
of a mountain. They sailed toward the fire and landed safely.

As soon as they disembarked, they looked up at the mountain, but the
fire had disappeared. The next day they asked the local people, "What was
that fire on the mountain top last night?" They replied, "With such a big
storm last night, how could there be a fire?" And so it became clear that the
fire was divine.

In *A Further Sequel of the Responsive Manifestations of Avalokiteśvara*,
there is the story of a man named Liu Cheng from the state of Pei (present-
day Xuzhou City, Jiangsu Province) who was traveling by boat to Guang-
zhou with his family. When the ships sailed around the island Zuoli in Lake

Poyang, they encountered a strong wind. Liu's mother had been a Buddhist from a very young age. She and two nuns on board began chanting the name of Avalokiteśvara. Two men wearing black robes suddenly appeared. Floating in the air, they grabbed the black sails of the ship and directed it back on course. Although the ship was battered by the waves, it did not sink. They finally reached Guangzhou safely. Liu's wife was on another ship, which sank in the storm.

THE COMMENTARY

A fascinating and somewhat understudied element of the Buddhist tradition is what might be called "Maritime Buddhism." With the important exception of Xuanzang, many of the East Asian pilgrims to India traveled by sea, and many of them stopped, in some cases for years at a time, in what is today Indonesia. The records of these travelers, the unearthing of works of art and architecture, and the excavation of shipwrecks provide important insights into the international and cosmopolitan nature of Buddhism over the centuries of its long history. Buddhist travelers carried with them not only the disembodied dharma, but also artistic and architectural inspiration, in addition to all manner of more "secular" elements in the domains of medicine, language, food, and new technologies.

Long before Hyecho set out to sea, ocean travel was a common theme in the Buddhist scriptures of India. In ancient India, the oceans were perceived as places of great danger. For members of the brahmin caste, they were places of pollution. As late as the nineteenth century, Mohandas Gandhi (who was not a brahmin) was warned that an ocean voyage to England would cause him to lose his caste purity. In the third chapter of the *Laws of Manu* (3.158), there is a list of disreputable people to be shunned, including a dancer, a one-eyed man, the son of an adulteress, a drunk, a gambler, an epileptic, a leper, and a lunatic. Reading through this long list, we find "a navigator of the ocean." The Buddha was a member of the warrior caste (*kṣatriya*), and much of the support for him and his community of monks seems to have come from merchants, who had fewer compunctions about sea travel. Indeed, the ships that took Buddhist monks between India and China were certainly merchant ships, traveling along what were likely well-established routes. The voyage was a long one, requiring that the ships stop often along the way. One route would have taken a ship along the coastline, but more direct routes would have taken the ship to the Malay Archipelago and the islands of Sumatra and Java in what is today Indonesia. During the

period of Hyecho's travels, this region was part of the kingdom of Śrīvijaya, which eventually extended its influence to much of Sumatra, the Malay Peninsula, and probably western Java and parts of Borneo. Its rise coincided with the advent of the huge Chinese market that opened after the reunification of China under the Sui and Tang dynasties, thus allowing Southeast Asian merchants and their goods to participate alongside the long-distance Persian Gulf traders. Malay shippers capitalized on the situation with their centuries-old skill in constructing and sailing large trading vessels.[29]

In addition to being a thriving center of trade, Śrīvijaya was an important center of Buddhism in its own right. Unfortunately, our knowledge of Buddhism in the region derives almost entirely from archaeological evidence. The most important account of Buddhist practice there comes from a pilgrim. The Chinese monk Yijing (635–713) made extended stays there on voyages both to and from India, spending as many as ten years on Sumatra. He began with a short stay of about six months on his outward journey in 671 and then remained a much longer time on his journey home, before returning to China in 695.

As noted in the introduction, Chinese pilgrims to India, like Hyecho, found Buddhism in decline, sometimes serious decline, in many regions that they visited. In contrast, Yijing found a flourishing Buddhist community in Śrīvijaya. This is confirmed by archaeological evidence. Although there had been centuries of economic and cultural exchange along maritime routes in the Indian Ocean and the South China Sea, artifacts suggest that when Yijing arrived, Buddhism had rather recently gained a prominent position; the earliest Buddhist artifacts discovered in Indonesia seem to date from the seventh century. The earliest Buddhist icons are stylistically similar to those from southern India and Sri Lanka, in what became an international style in Buddhist Southeast Asia. For example, votive tablets discovered in Bali are similar to those found in what are today Thailand, Myanmar, and Vietnam. Many of these tablets depict a buddha seated on a throne with legs pendant, his feet resting on a lotus. He is flanked by two standing bodhisattvas. The buddha's right shoulder is uncovered, his left hand rests in his lap, and his right is in the gesture of teaching (*vitarkamudrā*). Wooden buddha images from the sixth and seventh centuries have been discovered in regions far removed from urban centers, suggesting that devotion to the Buddha was not limited to the court.

In the realms of art and architecture, the golden age of Buddhism in Śrīvijaya seems to have occurred after the visit of Yijing. Statuary from the eighth and ninth centuries suggests a strong Mahāyāna presence, with

images of Avalokiteśvara, Mañjuśrī, Samantabhadra, and Kṣitigarbha. Indeed, Vajrabodhi, who spent five months in Śrīvijaya on his way to China, brought with him a statue of a twelve-armed Avalokiteśvara.

Borobudur, arguably the grandest monument in the Buddhist world, was built on the island of Java during this period, with construction beginning around 790 and continuing over a period of about sixty years. Scholars continue to debate about the precise purpose of the massive stone complex, which includes more than a thousand bas reliefs that are narrative (rather than decorative). Some illustrate the law of the cause and effect of actions, how virtuous deeds lead to happiness and nonvirtuous deeds lead to suffering. There are many scenes from the past lives of the Buddha as well as scenes from the final lifetime of Śākyamuni. In addition, Sudhana's journey in search of enlightenment from the *Gaṇḍavyūha Sūtra* is presented in a series of four hundred sixty panels. The sequence of panels of the complex suggests a spiritual pilgrimage, as the visitor ascends to the summit, crowned by a single empty stūpa. The construction of Borobudur would have begun at the end of Hyecho's life. However, that such a massive and sophisticated project could have been undertaken implies the presence of a vibrant and wealthy Buddhist community in Śrīvijaya in the eighth century, when Hyecho stopped there on his way to India.

There is evidence that Śrīvijaya had direct contact with the great monastery of Nālandā and that this contact continued for an extended period. Because of the large number of foreign monks at the monastery, it was not uncommon for them to stay in dormitories for monks from specific regions. In 860, King Bālaputra of Śrīvijaya founded a monastic house at Nālandā; in 1006, another king of Śrīvijaya founded a second house. In the early eleventh century, the Bengali master Atiśa, who would later play a major role in the formation of Tibetan Buddhism, is said to have spent twelve years in Sumatra, studying with a monk named Dharmakīrtiśrī, renowned as a teacher of *bodhicitta*, the aspiration to enlightenment for the sake of all sentient beings. However, apart from Atiśa's praise for his teacher and an account of his harrowing sea voyage, we know little of the Buddhist life he encountered in Sumatra. By this time, the Śrīvijaya capital had moved north to Jambi. The kingdom eventually fell in the thirteenth century.

Our primary source, therefore, is Yijing's account of his time there. The primary focus of his pilgrimage to India was the vinaya, the monastic code. This massive collection of rules and stories is obviously of Indian origin, containing all manner of terminology and rituals derived from an Indian world—both seen and unseen—that would not have been immediately comprehensible in China. Yijing therefore sought to observe Indian monastic

life in person so that he could take the proper practice of Buddhist monasticism back to China and accurately translate the vinaya texts that he brought back from his journey. His account of his travels is called *Tales of Returning from the South Seas with the Inner Dharma* (*Nanhai jigui neifa zhuan*); in Takakusu's famous translation, the title is rendered as *A Record of the Buddhist Religion as Practised in India and the Malay Archipelago*. There we find detailed descriptions of matters that at first glance seem far from the lofty path to enlightenment but are essential for the daily life of those who seek it. Thus, there are instructions on the proper uses of tooth-sticks for cleaning one's teeth, on how to use the toilet, on how to bathe, on how and when to sleep, on which medicines are permitted, on how to chant, and on how to behave toward one's teacher. Yijing gives detailed descriptions of the procedures of ordination and the fortnightly confession ceremony. His account thus provides an invaluable ethnography of monastic life, one that explains how instructions in a text are to be put into practice. He was deeply impressed by the monastic community that he joined in Śrīvijaya and suggested that all Chinese monks making their way to India stop there to study Sanskrit and accustom themselves to proper monastic conduct.

Yijing describes his route to India in some detail. He says that he left Guangzhou, on what he calls a Persian ship, in the eleventh lunar month of 671 and arrived at Tāmralipti on the eastern coast of India on the eighth day of the second lunar month of 673. He says that after the ship left China, it encountered the monsoon, with high seas and strong winds. During the storm, the ship's two canvas sails blew away. Nonetheless, the ship survived, reaching what he calls Śrībhoga twenty days after departing from China. Scholars speculate that this is modern-day Palembang in Sumatra, at that time the capital of the recently founded Śrīvijaya kingdom. There Yijing found a thriving Buddhist community of more than a thousand monks, most of the Mūlasarvāstivāda school. He reports that most of the monks are Hīnayāna, with a small number of Mahāyāna. Yijing wrote in *Great Tang Biographies of Eminent Monks Who Sought the Dharma in the Western Regions* (*Da Tang xiyu qiufa gaoseng zhuan*): "In the city of Foshi [Śrīvijaya], there are more than a thousand Buddhist priests whose minds are turned to study and good works. They examine and study every possible subject, just as in Madhyadeśa [India]; the rules and ceremonies are identical. If a Chinese priest wishes to go to the West to hear and read [the original Buddhist texts], he would do better to stay in Foshi for a year or two and practice the appropriate rules; then he could go on to central India."[30]

Yijing spent the next six months there studying Sanskrit. He then continued his journey, onboard what he calls the king's ship, sailing north for ten

days to the Land of the Naked People (perhaps the Andaman and Nicobar Islands). From there he sailed for about a half month to reach Tāmralipti.

In 689, after a brief trip to Guangzhou, where he had gone to fetch four assistants, Yijing returned to Śrīvijaya, and he wrote his two memoirs there. In 692, he sent his manuscripts to China, returning there himself in 695. This was also the year in which Śrīvijaya sent its first ambassadorial mission to China. Some twenty-five years later, Hyecho would land on these same shores.

THE ART

The first piece (fig. 6) is a head of the Buddha from Java, dating from Hyecho's period, the late eighth and early ninth century. It is made from andesite, a dark gray volcanic stone, a material evocative of the region's volatile geology. The head is about twelve and a half inches tall, suggesting that the full statue, whether seated or standing, was life-sized. As is common of works from the region, the Buddha's hair is depicted as individual ringlets, curling to the right, as specified in the list of the thirty-two marks of a superman (*mahāpuruṣa*). The crown protrusion (*uṣṇīṣa*) is well defined and located toward the back of his head. His long earlobes signify his earlier life in the palace, when he wore heavy earrings. Despite the rather rough texture of the stone, the artist skillfully represents the flesh of the face and the Buddha's serene mien.

The second piece (fig. 7) depicts Bhaiṣajyaguru, literally "Medicine Teacher," known in English as the "Medicine Buddha" or the "Healing Buddha," who was said to have the power to cure illness and offer protection from hunger, thirst, cold, and mosquitoes. Along with Amitābha and Akṣobhya, he is among the most important buddhas of the Mahāyāna, worshipped throughout East Asia and Tibet. Like them, he has his own pure land, called Vaiḍūryanirbhāsa ("Pure Lapis Lazuli"), located in the east. His body is said to be a brilliant blue, the color of lapis. Though his origins are in India, Bhaiṣajyaguru was clearly known in Java, because in 707, during Yijing's time in Śrīvijaya, he translated the *Sūtra of the Original Vows of the Medicine Buddha of Lapis Lazuli Radiance and the Seven Past Buddhas* (*Yaoshi liuliguang qifo benyuan gongde jing*) from Sanskrit into Chinese.

The piece here also dates from Hyecho's time, the eighth or ninth century, and it is similar to images likely seen and perhaps worshipped by the Korean pilgrim during his stay in Śrīvijaya. It is made of high tin bronze and is about twelve inches tall. Bhaiṣajyaguru is seated on a lotus throne, with both hands extended. In his right hand, he holds a *myrobalan* fruit,

long used in traditional Indian medicines. In his left hand, he holds a Buddhist scripture in the form of a palm-leaf manuscript. Behind him is a mandorla or halo; tongues of flame are visible around its edge. Above is a parasol, commonly placed above buddha images and stūpas. On the back of the mandorla, someone has engraved the so-called *ye dharma*, a passage in Sanskrit that begins with those words, perhaps the most famous statement in all of Buddhism. It means, "Of those phenomena produced through causes, the Tathāgata has proclaimed their causes and also their cessation. Thus has spoken the great renunciant." This is meant to be a summary of the Buddha's teaching of the four noble truths: he has identified the causes of suffering and also the cessation of suffering. This statement came to serve as a substitute for the body of the Buddha and was often enshrined in stūpas. It was also used to consecrate Buddhist images, and that may have been its purpose here. The style of this sculpture echoes that of pieces from northeastern India during this period. Given what appears to have been regular contact between Nālandā and Śrīvijaya, as well as the persistent circulation of pilgrims between Indonesia and India, small devotional bronzes such as this would have been brought to Java. There, they became new objects of worship and new models for artistic production. Sojourners themselves, such images of the Medicine Buddha were particularly important for travelers who, like Hyecho, journeyed by land and by sea between their homelands and the Buddhist holy land of India.

FURTHER READING

Andrea Acri, *Esoteric Buddhism in Mediaeval Maritime Asia: Networks of Masters, Texts, Icons* (Singapore: ISEAS-Yusof Ishak Institute, 2016).

John Guy, ed., *Lost Kingdoms: Hindu-Buddhist Sculpture of Early Southeast Asia* (New York: Metropolitan Museum of Art, 2014).

Michel Jacq-Hergoualc'h, *The Malay Peninsula: Crossroads of the Maritime Silk Road (100 BC–1300 AD)* (Leiden: Brill, 2002).

Tansen Sen, "Buddhism and the Maritime Crossings," in *China and Beyond in the Mediaeval Period: Cultural Crossings and Inter-Regional Connections*, ed. Dorothy C. Wong and Gustav Heldt (New York: Cambria Press, 2014), pp. 39–62.

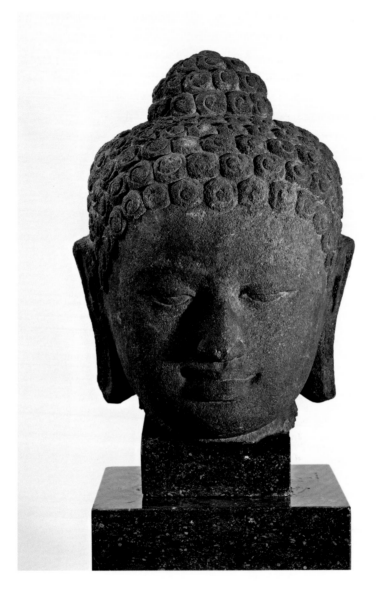

FIGURE 6

A Head of the Buddha, Śailendra period, Java, Indonesia
(eighth to ninth century). Volcanic stone (andesite), 12 ⁵/₈ ×
8 ¹¹/₁₆ × 9 ⁵/₈ in. Transfer from the National Museum of Natural
History, Smithsonian Institution, Washington, DC; Freer
Gallery of Art (F1978.35).

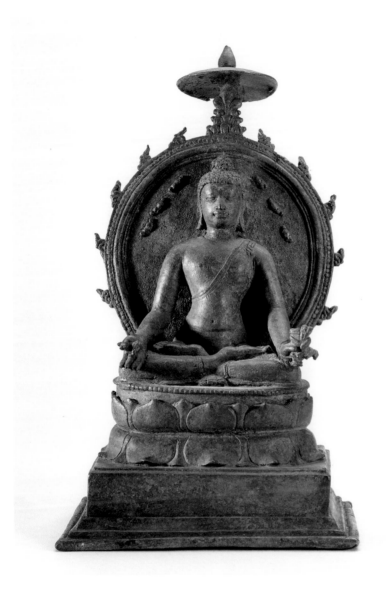

FIGURE 7

The Medicine Buddha (Bhaiṣajyaguru), Indonesia (eighth
to ninth century). High tin bronze, 12 ¼ × 7 ¹/₁₆ × 7 ³/₁₆ in.
Gift of Ann and Gilbert Kinney, Arthur M. Sackler Gallery
(S2015.25).

· FOUR ·

KUŚINAGARA

The Buddha Enters Nirvāṇa

"I arrived at Kuśinagara. This is the place where the Buddha entered nir-vāṇa. As for the city, it is in ruins, and no one lives there. There is a stūpa constructed on the site where the Buddha entered nirvāṇa and a master tends to it, keeping the area clean. Every year on the eighth day of the lunar month, monks, nuns, laywomen, and laymen gather here and present a grand offering. On that day, countless flags appear in the sky around the stūpa. As a host of people see them, there are many who commit themselves to the dharma."[31]

Hyecho visited Kuśinagara, the site of the Buddha's passage into nir-vāṇa, more than a millennium after that epochal event, which scholars date to around 400 BCE. Although this was the site of the Buddha's passing, an event that is described in one of the longest texts of the early canon, by the time Hyecho visited, it was largely deserted. He finds a stūpa with only a single monk serving as the custodian. Hyecho reports that a great festival is held there annually on the eighth day of the eighth lunar month—the date of the Buddha's passing according to one tradition—but it does not appear that he witnessed it. He notes that there is another monastery thirty *li* (about nine miles) southeast of the stūpa at Kuśinagara, which he called Subha Bandhana. This is presumably a monastery built at the site of the Buddha's cremation, said to have taken place seven days after his passing.

The most common sight noted by Hyecho in his travel journal is the stūpa, the most ubiquitous of Buddhist structures. Stūpa construction and worship is perhaps the most pervasive and prevailing practice of the Buddhist community from its beginning, predating any extant texts.

Yet the building of stūpas is described in a famous text, a text associated with Kuśinagara. Indeed, stūpas—as reliquaries, monuments, markers of sacred sites, and makers of merit—across India and the rest of the Buddhist world, as well as the practice of pilgrimage to worship them, have their creation myth in the foundational events at Kuśinagara. It may have been this story that set Hyecho on his journey.

THE STORY

According to the *Great Discourse on the Final Nirvāṇa* (*Mahāparinibbāna Sutta*), the Buddha died, or, as the tradition describes it, passed into nir-vāṇa, when he was eighty. He did so in an obscure village called Kuśinaga-ra. When the Buddha's attendant Ānanda complains that it is unworthy of what is about to take place there, the Buddha explains that in the past it was the capital of a *cakravartin*, a universal emperor (see chapter 2). The account of the Buddha's last days, set forth in the *Great Discourse on the Final*

Nirvāṇa, is one of the most interesting and detailed in the canon. The Buddha's health is clearly failing; he describes his body as being like an old wooden cart held together by leather straps. His condition improves during a brief meditation retreat with Ānanda, during which he tells him—three times—that a buddha can live for an aeon or until the end of aeon if he is asked to do so. Distracted, Ānanda does not take the hint.

The Buddha accepts a meal from a blacksmith named Cunda, instructing him that the dish—according to some sources pork, according to others, truffles—should be served only to him and not to his monks; what the Buddha does not eat should be buried. The Buddha suffers a severe bout of dysentery after that and lies down between two trees, his head facing north. The trees immediately bloom, out of season.

Learning that the end is near, a large assembly of gods, monks, nuns, and laypeople surround the Buddha, many of them overcome by sadness. The Buddha gives various instructions on a variety of topics and ordains a man who wishes to become a monk. He tells the monks that they can disregard the minor rules of the monastic code after he is gone. When Ānanda asks who will be the teacher after he is gone, the Buddha says that the dharma and the vinaya—the doctrine and the discipline—will be the teacher. He asks his followers whether they have any final questions. When they remain silent, he says, "All conditioned things are subject to decay. Strive on with diligence." He then entered into a state of meditation; in fact, he passed through a series of meditative states, before he passed into final nirvāṇa, never to be reborn again.

For Hyecho's story, and the story of Buddhist pilgrimage, two statements that the Buddha made before he died, and a series of events after he died, were of great importance. In response to Ānanda's question of what should be done with his body, the Buddha says that he should be cremated and gives detailed instructions for the preparation of the body. The relics should then be buried in a mound, called a "stūpa" (the source of the English word "tope"), that should be erected at a crossroads. "And whosoever shall bring to that place garlands or incense or sandalpaste, or pay reverence, and whose mind becomes calm there—it will be to his well being and happiness for a long time."

Ānanda says that when the monks had completed their annual retreat during the monsoon season, they gained great benefit from going to see the Buddha and from meeting the other monks who came from far and wide to honor him. With the Buddha gone, he laments the loss of that benefit. In response, the Buddha explains that a pious person should visit four sites: the place where the Buddha was born, the place where he was enlightened,

the place where he gave his first sermon, and the place where he passed into nirvāṇa. He says:

> These, Ānanda, are the four places that a pious person should visit and look upon with feelings of reverence. And truly there will come to these places, Ānanda, pious monks and nuns, laymen and laywomen, reflecting: "Here the Tathāgata was born. Here the Tathāgata became fully enlightened in unsurpassed, supreme enlightenment. Here the Tathāgata set rolling the unexcelled wheel of the dharma. Here the Tathāgata passed away into the state of nirvāṇa in which no element of clinging remains." And whoever, Ānanda, should die on such a pilgrimage with his heart established in faith, at the breaking up of the body, after death, will be reborn in a realm of heavenly happiness.

This passage is the *locus classicus* for the practice of pilgrimage in Buddhism—the call to the road heeded by Hyecho—although the number of sacred sites would quickly expand beyond these four.

The Buddha's body was prepared for cremation and placed on the funeral pyre at a place called Makuṭa Bandhana. However, when it was touched with a torch, it could not be ignited, despite resting in a casket of oil. The Buddha's chief disciple, the monk Mahākāśyapa, was not present when the Buddha passed away, arriving only after the Buddha's body had been placed on the pyre. He uncovered the Buddha's feet and touched them with his head. At that moment, the Buddha's body spontaneously burst into flame.

When the relics were gathered from the ashes, a dispute broke out among several groups of the Buddha's lay followers, each making its own claim for possession of the relics. To avoid violence, a brahmin named Droṇa used an urn to divide the relics into eight portions, which were given to the various groups. Someone else took the ashes, and Droṇa kept the urn that had contained the holy relics. Each of these—the eight portions, the ashes, and the urn—was enshrined in a stūpa, ten stūpas in all. It is said that the emperor Aśoka, some two hundred years later, broke these ten stūpas open, gathered the relics, and enshrined them in eighty-four thousand stūpas.

THE COMMENTARY

Among the many fascinating elements in the lengthy *Great Discourse on the Final Nirvāṇa*, two are of crucial importance for the Buddhist practice of pilgrimage. The first is the Buddha's instructions that those who wish to see him after his death should visit the place where he was born, the place

where he achieved enlightenment, the place where he first turned the wheel of the dharma, and the place where he passed into nirvāṇa. He adds that those who die while on such a pilgrimage will be reborn in one of the heavens. Since all Buddhist teachings, even those that he did not give, need to be somehow traced back to the Buddha, this passage is essential for the future practice of Buddhist pilgrimage. Scholars speculate that this instruction of the Buddha as he lay on his deathbed is in fact posthumous, perhaps even an interpolation into the original account of his passing. That is, scholars hypothesize that the passage was composed not only after the Buddha's death but after the four sites had already been established as places of pilgrimage. Thus, in a certain sense, an advertisement for pilgrimage was placed in the mouth of the Buddha on his deathbed.

The locations of the first three sites are obvious. In chapter 7 we discuss the association of the Buddha's birth with an already active shrine to a sacred tree at Lumbinī. The place of the Buddha's enlightenment, Bodh Gayā, is a mere six miles outside Gayā, a city in Magadha that figures prominently in Hindu mythology. Sarnath, the place of the Buddha's first sermon, is a suburb of the ancient city of Vārāṇasī. But the place of the Buddha's passing is more remote. As noted above, in the *Great Discourse on the Final Nirvāṇa*, Ānanda has the same question, asking why the Buddha does not pass away in one of the great cities of Magadha; he mentions several, including Rājagṛha, Śrāvastī, and Vārāṇasī. Why must the Buddha pass away in this uncivilized village in the middle of the jungle? The Buddha explains that in the distant past, a *cakravartin* had his capital there, and it was a prosperous and populous city. It is therefore a suitable place for the passing of the Buddha. Kuśinagara, and Ānanda's query about it, raises a host of questions, leading one to wonder whether the Buddha in fact died there or whether the authors of the text wanted to expand the range of Buddhist pilgrimage, placing a site between the places of the Buddha's enlightenment and first teaching, to the south, and the place of his birth, to the north.

The Buddha's recommendation of pilgrimage to the four sites is thus seen as a means of encouraging pilgrimage, an essential element of the Buddhist economy, both the spiritual economy and the material economy. The spiritual economy is the exchange between pilgrims (whether lay or monastic) and the monks who lived at the place of pilgrimage. It was considered particularly meritorious to make offerings at these holy places, and the local monks were the obvious recipients of such offerings. And should the pilgrim happen to die at the place of pilgrimage, being reborn in heaven as the Buddha had promised, the local monks were there to perform the funeral rituals. The material economy—familiar to any pilgrim of any era,

of any region, of any religion—refers to the exchange of wealth in return for the several creature comforts required by the pilgrim: food, shelter, and the mementos to be taken back home; the archaeological record suggests that such mementos have a long history.

The second important passage in the *Great Discourse on the Final Nirvāṇa* is the Buddha's instructions on the disposal of his corpse. When Ānanda asks what to do with his body, the Buddha says that it should be treated like the body of a *cakravartin*, a wheel-turning king, the righteous monarch described in chapter 2. We find a certain symmetry here as we recall that at the time of his birth, the court astrologers told the Buddha's father that his son would either become a *cakravartin* or a buddha. He became a buddha, but his funeral was that of a *cakravartin*. But even at the time of the Buddha, it seems that the *cakravartin* was a figure of the ancient past; Ānanda had to ask the Buddha how the body of a *cakravartin* was to be treated.

The Buddha provides elaborate instructions. Two large iron vessels are to be acquired, one placed inside the other. The inner vessel is then filled with oil. The body is wrapped in cotton cloth and then again in wool. This is repeated until there are five hundred layers of cotton and five hundred layers of wool. The body, thus wrapped, is then placed in the inner vessel of oil, which is closed inside the outer vessel. Various fragrant woods are then placed around the vessel and lit. The relics that remain when the fire finally goes out are to be entombed in a mound, called a stūpa, at a crossroads. He goes on to say that four beings are worthy of a stūpa: a buddha, a *pratyekabuddha* (a particular kind of enlightened disciple of the Buddha), a disciple of the Buddha, and a *cakravartin*.

In ancient India there were various means of disposing of the dead, known from textual and archaeological evidence. In the Hindu Vedas, one finds descriptions of cremation, after which the bones were gathered, placed in a basket, and buried. Those who gathered the bones required purification. Elsewhere, there are references to the burial of the corpse in a tumulus or brickwork tomb away from an inhabited area, exposing the corpse to the elements, or throwing it in a river. The origins of the stūpa and of stūpa worship remain something of a mystery. Since the nineteenth century, scholars of Buddhism have been puzzled by what appears to be a Buddhist obsession with the charred remains of their teacher, in a culture in which the dead and the remains of the dead are regarded as a source of pollution. This obsession did not go unnoticed by the critics of Buddhism. In the great Hindu epic, the *Mahābhārata*, it says that in the dark age of the Kali Yuga, humans will turn away from building temples and worshipping the gods, instead dotting the earth with a structure called an *eḍūka*, which they will worship.

According to the Sanskrit dictionary, an *eḍūka* is a structure enclosing rubbish or bones; it is another word for a stūpa. What was strange, it seems, was not that a corpse would be cremated and then entombed; it was that anyone would worship such a tomb.[32]

Yet it is difficult to overstate the importance of the stūpa in Buddhism, and of the relics it contains. This importance even finds its way into the technical doctrine called the *abhidharma*. For example, in the most famous *abhidharma* text, the *Abhidharmakośa* (and its autocommentary), by the fourth-century monk Vasubandhu, we learn that beings are born into the cycle of rebirth in four ways: from an egg, from a womb, from moisture (in ancient India it was believed that certain insects were created from heat and moisture), and as an apparition. This last category refers to those beings who enter a realm of rebirth fully formed, without needing to develop in a womb and grow to adulthood. This is the kind of birth found in the many Buddhist hells and in the realm of the gods. Given the unique powers of the Buddha, Vasubandhu takes up the question of why the Buddha is born from a womb rather than being born in the apparitional manner, appearing in the world fully formed. Vasubandhu explains, "The bodhisattva has taken up the womb in order that his body remains as relics after his nirvāṇa: through the adoration of these relics, humans and other creatures by the thousands obtain heaven and deliverance."[33] In other words, the Buddha decides to be born with a body of flesh and blood so that that body can be burned and the relics can be entombed in stūpas. In many ways, therefore, the stūpa becomes an extension of the Buddha's body and the Buddha's biography, persisting in saṃsāra long after he has passed into nirvāṇa.

As such, stūpas were to be treated with the utmost reverence and respect; a wide range of activities, including sexual intercourse, are prohibited in their vicinity. In the Buddhist ethical system, there are five deeds so heinous that one who commits them is doomed to rebirth in hell in the person's next lifetime: killing one's mother, killing one's father, killing an arhat, wounding the Buddha, and causing dissent in the saṃgha. In the *Abhidharmakośa*, Vasubandhu lists five misdeeds that are almost as heinous: having sex with a female arhat who is one's mother, killing a bodhisattva who has attained a certain level on the path, killing a "disciple" (someone who has achieved one of the first three levels of enlightenment), depriving the saṃgha of its livelihood, and breaking open a stūpa. Engraved in several of the great stūpa complexes of ancient India are curses on those who would remove any of their stonework.[34]

Although the Buddha has entered nirvāṇa, he remains alive inside his stūpa (see chapter 5). Stūpas, called by many names in many languages—*ta*

in Chinese, *chöten* in Tibetan, *chedi* in Thai—came to mark the Buddhist world, providing all manner of places of pilgrimage across Asia, bringing the body of the Buddha to those who could not make the long pilgrimage to the four great sites. The "pagodas" seen across East Asia are in fact stūpas.

According to Buddhist doctrine, those relics will remain entombed inside their stūpas until it is time for the next buddha to appear in the world. At that time, the stūpas will break open and the relics will emerge and fly to Bodh Gayā, where they will reunite under the Bodhi Tree. Once reassembled, the body of the Buddha will be worshipped by the gods one last time. And then it will burst into flames.

THE ART

The first piece (fig. 8) is a large Japanese painting depicting the Buddha's passage into nirvāṇa. About six feet square, it dates from the early fourteenth century. It shows the Buddha on his deathbed in a grove, lying on his right side beneath four pairs of *śāla* trees. In the story, the trees blossomed out of season when he lay down between them. In our painting, two trees in the grove seem to have withered in grief. In many depictions of the nirvāṇa in Southeast Asia, the Buddha is lying comfortably on his right side, his head resting in his hand, supported by his elbow. Here, however, the Buddha is rather rigidly portrayed, as if an image of the standing Buddha had simply been laid on its side, his knees slightly bent, his head resting on his right arm. He is surrounded by all manner of mourners, traditionally said to include fifty-two types of beings, including monks, nuns, bodhisattvas, gods, laypeople, and animals. Sometimes in depictions of the Buddha's passing, his mother is depicted in the upper right, witnessing from heaven the death of her son. Here, she has descended on a cloud and stands among the branches of a tree, covering her face with her robe as she weeps; her presence in the tree evokes her association with tree worship (see chapter 7). There is a particular poignancy here. She had grasped the branch of a blossoming *śāla* tree (also called an *aśoka* tree) eighty years before as the future Buddha emerged, standing up, from her right side, to take seven steps upon the ground. Now, having died long ago and having been reborn in heaven, she returns to earth as a youthful god, this time to stand among the branches of a *śāla* tree that has withered, with her aged son, stretched out on the earth below, on his right side.

Artists of this scene often took particular delight in portraying birds and forest animals in various postures of mournful hysterics. In the front, an elephant rolls on its back. In the foreground, one monk seeks to revive

another, who seems to have fainted. On the right, a fierce red-faced warrior god cries uncontrollably. Whether one wailed, quietly wept, or looked on impassively was regarded as the sign of one's level of spiritual attainment. In the *Great Discourse on the Final Nirvāṇa*, a monk admonishes the monks for crying, saying, "Friends, enough of your weeping and wailing! Has not the Lord already told you that all things that are pleasant and delightful are changeable, subject to separation and becoming other?"

In Japan, paintings of the death of the Buddha became so famous that they sometimes were the subject of parody. In one late-eighteenth-century painting, called *Vegetable Nirvāṇa* (*Yasai Nehan*), the Buddha is depicted as a large daikon, lying on an overturned basket, surrounded by other vegetables. In Japanese erotic art, there is a version in which several of the figures, including the Buddha himself, are penises of various shapes and sizes. But this iconic scene of a reclining Buddha, at peace in the moments before his death, was ubiquitous throughout Asia long before it was famous enough to be parodied. Hyecho could have seen it carved into the cave temples of southern India, embedded on the stūpas of Gandhāra, and painted on the frescoes of Kizil.

This painting served a ritual function at the temple that owned it. It was displayed each year as part of the *nehan-e*, or "nirvāṇa rite," to mark the Buddha's passing, usually held in Japan on the fifteenth day of the second lunar month, in this case at Enmei-ji in Mie Prefecture. This date of the Buddha's death is different from the one observed in South and Southeast Asia, where it is believed that the Buddha was born, enlightened, and died on the same date: the full moon of the fourth lunar month. The Japanese tradition of marking the Buddha's passing dates back to the Nara period (710–794 CE). The oldest known depiction of the scene is in a clay tableau from c. 711. The oldest painting of the scene dates to 1086.

In Japan there were several genres for depicting this famous scene. For example, there is a genre of painting called "the eight aspects of Śākyamuni nirvāṇa painting" (*Shaka hassō nehan-zu*). According to one famous list from China, the eight are descending from Tuṣita, entering the womb, birth, renouncing the world to become a mendicant, subjugating demons, enlightenment, turning the wheel of the dharma, and entering nirvāṇa. There are paintings in which his death is featured in a central panel with the other seven major events in his life arrayed around the central death scene.

Because this painting would have been rolled up and stored during much of the year, it sustained considerable damage over the centuries, especially the loss of pigment. The restoration and conservation of the painting at the Freer required two years of work.

The second piece (fig. 9) in a sense depicts the Buddha after he has been cremated and his relics entombed inside a stūpa. It is a much simpler, and much less elaborate, representation of the Buddha's passing. As noted in chapter 6, in the earliest examples of Buddhist art in India, the Buddha is not depicted in human form. Instead, in scenes of the enlightenment, he is represented by a tree; and in scenes of his teaching, he is represented by a wheel. In scenes of his death, he is represented by a stūpa. Thus, it is possible that this carving is intended to depict the Buddha's passage into nirvāṇa. However, because of the absence of other elements of that scene, it is more likely that the stūpa represents an actual stūpa.

The piece is made of sandstone and is a fragment of fence from the Bharhut stūpa complex in Madhya Pradesh near the town of Satna. It dates from the second century before the Common Era. It is about eighteen and a half inches wide and twenty and a half inches high.

The stūpa complex at Bharhut was one of the grandest of ancient India. During the reign of Aśoka, a brick stūpa covered in plaster was constructed there. During the Śuṅga Dynasty (second to first century BCE), the stūpa was enclosed with a lavishly decorated stone railing that was eighty-eight feet in diameter, with a ten-foot-wide paved circumambulation walkway between the railing and the stūpa. The stone railing was adorned with a multitude of sculptures on both the inner and the outer faces. At some point after the stūpa had fallen into disuse, some of those railings were split, preserving the carvings on each side. The piece here is a fragment of one side of the carvings on the railing. The other side of the railing appears in chapter 8.

Like the depiction of the Buddha's enlightenment in chapter 6, the carving here depicts movement; although there appear to be six human figures around the stūpa, in fact there are only two. The first is a female figure (identified by her anklets, bare breasts, and long hair); she is depicted twice. First, she stands reverently at the left. We must imagine her then circumambulating the stūpa in a clockwise direction, arriving at the other side, where she kneels and touches the stūpa with her forehead to receive its blessing.

The male figure is depicted four times. We see him stand reverently at the right. We see him kneeling at the left side of the stūpa, touching it with his forehead to receive its blessing before rising to circumambulate the stūpa in a clockwise direction—we see both his back and his front as he makes his way around it. The two trees framing the scene and those smaller trees in the background grant the composition a sense of depth that reinforces the three-dimensional and 360-degree circumambulation portrayed by the artist, who depicts the moving devotee—both back-turned and face-forward—with a shoulder hidden behind the stūpa, to give the illusion that

he is moving around and behind the monument within the confined space of the relief. The artist thus rather skillfully depicts motion carved in stone. In the sky above, two goddesses hover over the stūpa, one holding a flower, the other holding a garland, both intended as offerings to the stūpa.

The form of the stūpa here mirrors the actual stūpa at Bharhut; the solid dome rests on a circular base, surrounded by a fence made of plinth and posts with lateral sockets for three rows of rails. Both an inner (upper) railing and an outer (lower) railing can be seen. Above the dome is a square "mansion" (*harmika*), flanked by flowers. The drum of the stūpa is bedecked with garlands of flowers. Along the bottom, devotees have left their handprints, perhaps after dipping their hands in scented paste, both to decorate the stūpa and to receive its blessing. Although the Buddha has entered nirvāṇa, the relics of the Buddha provide an opportunity to make merit. Thus the carving depicts the ritual activities of the actual stūpa that it adorned. One might almost see the carving as a kind of illustrated instruction manual, carved on the outside of the railing, showing visitors how to properly worship a stūpa. Near the top is a parasol (*chattra*) supported by a staff, again flanked by two flowers. The two large trees evoke the *śāla* trees between which the Buddha lay when he passed into nirvāṇa.

Taken together, the two pieces, one Japanese, one Indian; one in paint, one in stone; separated in time by a millennium and a half, make clear that the final nirvāṇa of the Buddha is essential to the visual culture of Buddhism, foundational to its doctrine, and central to its practice. Although this painting postdates Hyecho by some six hundred years and the carving predates him by eight hundred years, he knew the story of the Buddha's passing and thus the scene that the painting depicts. He would likely have had this scene in mind when he visited Kuśinagara and worshipped there as a pilgrim. Indeed, like the devotees in the carving, he may have circumambulated the stūpa in a clockwise direction, pausing to kneel down and touch it with his forehead to receive its blessing.

FURTHER READING

Vidya Dehejia, ed., *Unseen Presence: The Buddha and Sanchi* (Mumbai: Marg, 1996).

Jason D. Hawkes, "Bharhut: A Reassessment," *South Asian Studies* 24, no. 1 (2008): 1–14.

Adriana Proser, ed., *Pilgrimage and Buddhist Art* (New York: Asia Society, 2010).

John S. Strong, *Relics of the Buddha* (Princeton, NJ: Princeton University Press, 2004).

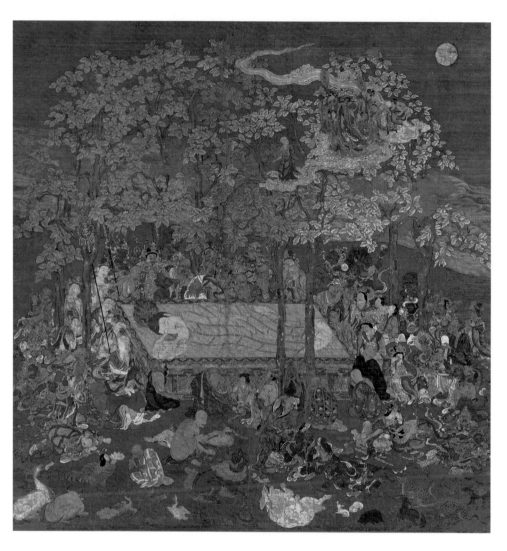

FIGURE 8

The Buddha Passes into Nirvāṇa, Kamakura period, Japan
(early fourteenth century). Ink, color, gold, and silver on
silk, 77 ¹/₁₆ × 74 ⁷/₁₆ in. Purchase—Charles Lang Freer En-
dowment, Freer Gallery of Art (F1970.30).

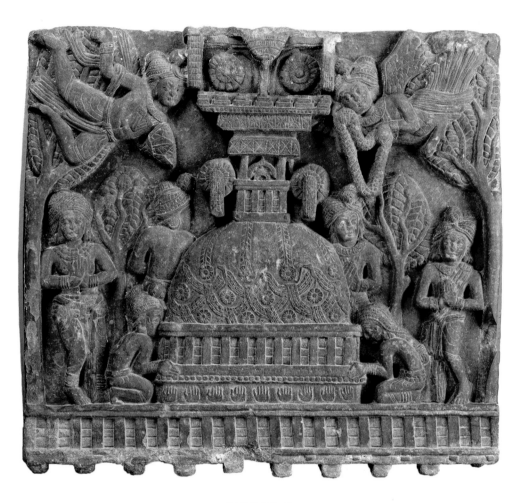

Worship of a Stūpa, Bharhut, Madhya Pradesh, India (early
second century BCE). Sandstone, 18 $^{11}/_{16}$ × 20 $^{7}/_{16}$ × 3 $^{1}/_{8}$ in.
Purchase—Charles Lang Freer Endowment, Freer Gallery
of Art (F1932.26).

VULTURE PEAK

*Two Buddhas Seated
Side by Side*

As discussed in the introduction, the first part of Hyecho's account of his travels in India is lost. The existing manuscript begins with what appears to be the conclusion of his description of an unidentified city; scholars speculate that it is either Śrāvastī or Vaiśālī. Vulture Peak is not among the sacred sites that he describes, but he includes two different lists of "four great stūpas" that he says he visited. One of these lists includes Rājagṛha.

Vulture Peak is a mountain outside the city of Rājagṛha, the capital of King Bimbisāra, a friend and patron of the Buddha. Its name in Sanskrit is Gṛdhrakūṭaparvata, literally, "Vulture Promontory Mountain" or "Mass of Vultures Mountain." Buddhist commentators explain the name in a number of ways: it is shaped like a mass of vultures; it is shaped like a vulture; it is protected by vultures; and vultures gather at its summit. It was a favorite abode of the Buddha and the site of many of his teachings, including many of the perfection of wisdom sūtras. It was there, it is said, that the *Heart Sūtra*, known for its declaration "Form is emptiness; emptiness is form," was taught.

It was while the Buddha was walking in the shadow of Vulture Peak that his evil cousin Devadatta tried to kill him by rolling a boulder down the mountain. However, an outcropping of rock miraculously grew out of its slope, blocking the boulder and smashing it into pieces. One piece nicked the Buddha's toe, causing it to bleed. One of the five deeds that dooms one to Avīci, the most torturous of the Buddhist hells, is "causing blood to flow from the Buddha." Devadatta suffered this fate for his crime.

Hyecho would likely have known all of this, but Vulture Peak would have been particularly important to him because it was there that the Buddha taught the *Lotus Sūtra*, which declares that all beings will become buddhas and that the lifespan of the Buddha is limitless. The *Lotus Sūtra* was first translated into Chinese in 255; the most famous translation into Chinese was completed by Kumārajīva in 406. It went on to become the most influential sūtra in East Asia. That it was taught on Vulture Peak made the mountain particularly sacred. But Vulture Peak was also the site of one of the most dramatic moments in all of Buddhist literature.

THE STORY

At the beginning of the eleventh chapter of the *Lotus Sūtra*, a massive stūpa suddenly emerges from beneath the earth and hovers in the air. It is five hundred *yojanas* high and fifty *yojanas* wide. A *yojana* is a unit of distance in ancient India: the distance that a yoked team of oxen can pull a cart in a day, often estimated to be about eight miles. The stūpa is adorned with

seven types of precious substances; decorated with banners, flags, garlands, and bells; and has the fragrance of sandalwood. A stūpa is a tomb, a giant reliquary, said to contain a relic of the Buddha or of a Buddhist saint, often a tooth or a piece of bone. As we saw in chapter 4, at the time of his passage into nirvāṇa, the Buddha instructed his disciples to cremate his body and place his relics in a stūpa. However, the *Lotus Sūtra* is said to have been taught when the Buddha was seventy-five, five years before his death. The stūpa that emerges from the earth must, therefore, contain the relics of another buddha. The scene becomes even stranger when a voice is heard from inside the stūpa, offering words of praise to the Buddha.

The Buddha explains that long ago, in another universe, there was a buddha named Prabhūtaratna ("Abundant Jewels"). Before he became a buddha, he vowed that after his passage into nirvāṇa, his stūpa would appear wherever the *Lotus Sūtra* was being taught. The Buddha explains that Prabhūtaratna is inside the stūpa. When someone asks whether it would be possible to see him, the Buddha explains that Prabhūtaratna's vow stipulated that before he can be revealed, the present buddha must gather together all of his emanations that are teaching the dharma throughout the universe.

Śākyamuni emits a beam of light from the tuft of hair between his eyebrows, extending to the ten directions (the four cardinal directions, the four intermediate directions, plus up and down) to summon these buddhas. To prepare a proper place for them, he makes the world completely flat, with no towns, oceans, rivers, mountains, or forests. Its roads are laid out like a chessboard and are bordered with cords of gold. There are jeweled trees and incense, and the ground is covered with flower blossoms. To make room, all the gods, humans, animals, ghosts, and denizens of hell are temporarily relocated.

When all the buddhas and their bodhisattva attendants have arrived, Śākyamuni rises into the air in front of the door of the huge stūpa. With his right finger, he pushes back the bolt. The door opens with a loud creak, revealing not a tooth or a bone but a buddha seated on a lion throne in the posture of meditation, his body whole and undecayed. Prabhūtaratna then moves over on his lion throne and invites Śākyamuni to sit down next to him. A buddha of the past and the buddha of the present sit side by side. Because all of this is happening up in the air, the assembly cannot see very well. The Buddha levitates the audience so that they can see better.

Because the *Lotus Sūtra* was taught on Vulture Peak, it holds a special place in the universe. In the sixteenth chapter, the Buddha declares that Vulture Peak is eternal and will not be destroyed by the seven suns that will incinerate the world at the end of the current cosmic cycle. The Buddha

says, "For innumerable *kalpas* (aeons) I have constantly resided on Mount Gṛdhrakūṭa and elsewhere. When sentient beings see themselves amidst a conflagration at the end of a *kalpa*, it is in fact my tranquil land, always full of *devas* [gods] and humans."[35] Indeed, it is said that only two places on earth will avoid destruction during the end time: Vulture Peak and the "diamond seat" (*vajrāsana*) at Bodh Gayā, where all the buddhas of our world system achieve enlightenment.

THE COMMENTARY

This scene from the *Lotus Sūtra* provides all manner of legitimation for the sutra itself and, by extension, for the Mahāyāna. The *Lotus Sūtra* is famous for two doctrines. The first is that there are not three vehicles to liberation from rebirth, as had been previously understood in the tradition—the vehicle of the *śrāvaka*, the vehicle of the *pratyekabuddha*, and the vehicle of the bodhisattva—but one, called the single vehicle and the buddha vehicle. Hence, the Buddha's previous exposition of three vehicles was but his skillful method (*upāya*) of leading all beings to the single vehicle; in fact, all beings in the universe are destined for buddhahood. The second doctrine is that of the immortality of the Buddha. In the sixteenth chapter, the Buddha declares that he only pretends to pass into nirvāṇa, that his lifespan is in fact limitless.

Both of these were radical positions at the time of the composition of the *Lotus Sūtra*; scholars speculate that the sūtra evolved over time, with the earliest elements being composed between 100 and 50 BCE and the text reaching its final form around 200 CE. The authors of the texts were presenting a new vision of the person of the Buddha and a new vision of his central teaching, visions that were at odds with what they perceived as a conservative monastic community. However, they also understood that such a vision must be announced by the Buddha himself. And so they, and the authors of the other Mahāyāna sūtras, composed works that represented themselves as having been spoken by the historical Buddha, even though they were composing those sūtras centuries after his death. The authors not only place the *Lotus Sūtra* in the lifetime of the Buddha; they make it the eternal teaching of all the buddhas of the past.

In the early tradition, it was held that there was only one buddha per universe. A particular cosmology was presented in which a buddha appeared in the world only after the teachings of the previous buddha had entirely disappeared from human memory. As long as the teachings of a buddha were still remembered, his teachings could be practiced; when the world was

once again bereft of instructions on how to escape from the cycle of birth and death, it was then, and only then, that a new buddha would appear in the world. This amnesia explained why there was no historical record of the previous buddhas, serving as a retort to non-Buddhists who might accuse the Buddhists of the sin of innovation, of lacking the eternal truths of the Hindu Vedas, for example. According to various enumerations, Śākyamuni is the fourth, seventh, or twenty-fifth buddha of our universe, with billions of years separating the death of one buddha and the birth of the next. The appearance of the bejeweled stūpa is thus an astounding occurrence, and not simply because a structure four hundred miles high and forty miles wide emerges from beneath the surface of the earth. Like the goddess of the earth bearing witness to the future Buddha's virtue, here a stūpa rises out of the earth, bearing witness to the truth of the dharma. It is important to note that both places, Bodh Gayā and Vulture Peak, became places of pilgrimage, with pilgrims like Hyecho traversing the earth to worship there.

In order for the *Lotus Sūtra* to have any hope of legitimacy, its authors needed to present Śākyamuni Buddha, the buddha of the present age, teaching the *Lotus Sūtra*. But this was not enough; he had taught many sūtras. Why should the *Lotus* supersede all others? The miracle of the bejeweled stūpa was not so much its size or its aerodynamics but the fact that there was a living buddha inside, a buddha who praised Śākyamuni for preaching the *Lotus*. The buddhas of the past were therefore not gone, reduced to charred bits of bone inside a stūpa, their teachings long lost to oblivion. The buddhas of the past were alive inside their stūpas. And this buddha, Prabhūtaratna, had made a vow in the far distant past to appear in his stūpa whenever and wherever the *Lotus Sūtra* was being taught. This meant that the *Lotus Sūtra* had been taught many times in the past by many other buddhas. It was not yet another sūtra taught by Śākyamuni; it was the most important teaching of all the buddhas of the past, of whom there were not three, six, or twenty-four, but thousands. A living buddha, Prabhūtaratna, had arrived from beneath the earth to bear witness to this truth.

When Śākyamuni opens the door of the stūpa to reveal a living buddha inside, two standard doctrines are overturned. The first is that when a buddha dies, passes into nirvāṇa, is cremated, and his relics are enshrined in a stūpa, that stūpa is then a memorial to a buddha who has passed from this world, never to appear to teach the dharma again. The presence of Prabhūtaratna proves that buddhas of the past remain alive, intimating that Śākyamuni himself will not pass into nirvāṇa, something that he will proclaim in the sixteenth chapter of the *Lotus Sūtra*.

When Prabhūtaratna invites Śākyamuni to sit beside him inside his stūpa, a second doctrine is overturned: that there can be only one buddha present in a given universe at a time. Another buddha has come from another universe, and Śākyamuni has invited thousands of other buddhas from thousands of other universes to witness his arrival. If there is a second buddha, and if there are thousands more, simultaneously teaching the dharma in myriad worlds, all able to magically appear in our own, then Śākyamuni's declaration that all sentient beings will become buddhas receives powerful confirmation. We therefore should not be surprised that paintings and sculptures of the two buddhas seated side by side, portraying this potent moment, are so common in East Asian Buddhism.

The title of the *Lotus Sūtra* in Sanskrit is the *Saddharmapuṇḍarīka*, literally, "The White Lotus of the True Dharma." Because the term "dharma" is ubiquitous in Indian literature and especially Indian religions, Buddhist authors often used the term *saddharma*, "true dharma," to distinguish the Buddha's teachings from those of other teachers. In the case of the *Lotus Sūtra*, however, it is likely that the authors chose the title to distinguish the sūtra and its teachings not from those of non-Buddhists but from those of other Buddhists; the title implies that the *Lotus* surpasses the Buddha's previous teachings, as he himself declares in the text. Supremacy, however, cannot simply be doctrinal.

We know that pilgrimage was an important part of the Buddhist economy of ancient India, with different sites competing for stops on the pilgrimage routes that developed in the centuries after the Buddha's death. These sites required the consistent presence of pilgrims to provide support to the monastic and lay communities that surrounded them. We note that Hyecho found even Kuśinagara, the site of the Buddha's passage (or according to the *Lotus*, his apparent passage) into nirvāṇa, largely deserted, tended by a single monk. If the authors of the *Lotus Sūtra* wanted to supplant the authority of earlier teachings, they needed also to supplant the associations of its sites. They wanted Vulture Peak to be famous not as the place where the Buddha taught so many other sūtras, not as the place where the council of five hundred arhats first codified the Buddha's teachings after his death, but as the place where a giant stūpa emerged from the earth, a place that the Buddha declared would survive the conflagration that will incinerate our world when seven suns rise in the sky. It would survive because the *Lotus Sūtra* had been taught there. When the *Lotus Sūtra* became an object of especial devotion in China and Japan, there were those who claimed that Vulture Peak had, like the stūpa that emerged out of the earth and floated in

the air, come unmoored from the soil of India and flown (according to the Chinese) to China, (according to the Japanese) to Japan, or (according to the Koreans) to Korea. In Hyecho's native land, Yeongchuksan, the site of Tongdosa monastery, is said to be Vulture Peak. The story of a different sacred mountain making its way to Korea is told in chapter 12. Despite the miraculously flying mountains, however, the *Lotus Sūtra* was enough to lure pilgrims, Hyecho likely among them, to the original site of the Buddha's famous discourse.

<div align="center">T H E A R T</div>

As noted above, a standard doctrine of the early Buddhist tradition is that buddhas come but rarely into the world, appearing only when the teachings of the previous buddha have been completely forgotten. In Buddhist cosmology, the time between the death of one buddha and the appearance of the next is often measured in aeons. In an important text of the Pāli tradition called *The Questions of Milinda* (*Milindapañha*), likely dating from the second century CE, a Greek king of northwestern India engages in a dialogue with a Buddhist monk on various points of doctrine. One of the king's questions is why there cannot be more than one buddha in the world at a time, offering the suggestion that additional buddhas might be able to assist each other. The monk replies that the presence of a buddha is an epochal event of such momentous potency that the world can barely support one, that two buddhas in the world would be like two men trying to ride in a boat made for one; the boat would sink.

One of the most influential compendiums of mainstream Buddhist doctrine, the *Abhidharmakośa* (and its autocommentary), by the monk and scholar Vasubandhu, makes the same point, arguing that there are four reasons why two buddhas do not appear in the same universe: (1) there is no need for two buddhas in the same universe at the same time; (2) each bodhisattva who becomes a buddha vows to become a buddha "in a world blind and without a protector"; if there is already a buddha in the world, the world already has a protector; (3) a buddha receives greater respect from the beings of the world if he is the only buddha; (4) the sentient beings who inhabit the world will feel a greater urgency to follow his teachings if they know how rare it is for a buddha to appear in their world and that they will no longer have a protector when he passes into nirvāṇa. It is important to note that Vasubandhu wrote the *Abhidharmakośa* in the fourth century, long after the *Lotus Sūtra* had reached its final form, further evidence that not all

of the famous doctrines of the Mahāyāna won universal support during the long history of Buddhism in India.

Part of the power of the *Lotus Sūtra* scene of two buddhas seated side by side is the challenge that it presents to this doctrine. Two buddhas appear together on the same seat and the world does not capsize. If two buddhas can be alive in the world at one time, there can be many more coexisting as well. This is one of the reasons why the image of Śākyamuni and Prabhūtaratna seated together inside the floating stūpa is so commonly depicted in paintings and sculpture in East Asia, from at least the early sixth century.

Our image (fig. 10) comes from China. The two buddhas are made of gilded bronze and are mounted on a gilt stand. The piece is small, only eight and a half inches high and five and a half inches wide. The framing around them is meant to represent the door of Prabhūtaratna's stūpa. On the back of the stand there is an inscription, rather crudely scratched into the base, stating that the statue of the two buddhas was made in 609 by "the devoted religious daughter Zhang Pengle" for her father and her mother.

The inscription does not mean that the statue was cast by the daughter but rather that it was commissioned by her. That it was created for her parents likely does not mean that she had it made as a gift for them but rather that she was dedicating the merit of having a buddha image made to the welfare of her parents—who may have already been deceased—in the next lifetime, so that they would have a happy rebirth. Although the notion of "filial piety" is most often associated with China and with the Confucian tradition, it is clear from inscriptions found in India and across the Buddhist world that pious Buddhists—including monks and nuns who were supposed to have renounced familial ties—had statues made, scriptures copied, shrines constructed, and rituals performed for the welfare of their parents, often adding, "and for all sentient beings." This piece thus served the dual purpose of benefiting Zhang Pengle's parents and serving as an object of devotion for those who saw it, likely in a niche of a simple domestic shrine. It is not a work of high artistic quality or made of precious materials. It is a simple piece likely commissioned by a pious woman of modest means.

The two buddhas appear to be identical, perhaps cast from the same mold. Their identity does not simply suggest the economy of the craftsman; it also makes an important doctrinal point. All buddhas of the past, present, and future are similar in a great many ways. Their bodies are all adorned with the thirty-two marks and the eighty characteristics of a superman (*mahāpuruṣa*), including forty teeth, a long tongue, hair that curls to the

right, and a crown protrusion (*uṣṇīṣa*) on the top of the head. In the lifetime in which they achieve enlightenment, they all sit cross-legged in their mother's womb; immediately after birth they all take seven steps to the north; they all renounce the world after seeing the four sights (an old man, a sick man, a dead man, and a mendicant) and after the birth of a son; they all achieve enlightenment seated on a bed of grass; they stride first with their right foot when they walk; they never stoop to pass through a door; they all found a community of monks; they all can live for an aeon; and they never die before their teaching is complete. Buddhas can differ from each other in only eight ways: lifespan, height, caste (either the priestly caste or the warrior caste), the conveyance in which they go forth from the world, the period of time spent in the practice of asceticism prior to their enlightenment, the kind of tree they sit under on the night of their enlightenment, the size of their seat there, and the extent of their aura.[36]

In this Sui Dynasty image, produced less than a century before Hyecho was born, even their aureoles are the same size. And each makes the same gestures, called a "mudrā," with their hands: the gesture of protection with the right hand and the gesture of giving with the left. At certain points in the *Lotus Sūtra*, Śākyamuni suggests that he is not simply the most recent in a long line of buddhas of the past, present, and future, but that he has a more cosmic identity. He is all the buddhas and all the buddhas are manifestations of him. To those who saw Zhang Pengle's shrine and who had read the entire *Lotus Sūtra* (likely a small percentage of the sūtra's devotees), the similarity of the two buddhas would have intimated Śākyamuni's deeper identity.

In the centuries after the passing of the Buddha, his teachings were often preserved orally, memorized and chanted by monks. This accounts, for example, for the formulaic repetitions that occur throughout so many of the early sūtras. According to traditional accounts, the teachings of the Buddha were first committed to writing in the last decades before the Common Era, not in India but in Sri Lanka, because it was feared that the monks who had committed the sūtras to memory might be killed in a war. One of the innovations of what has come to be called Mahāyāna Buddhism was the strong emphasis on writing. Despite their aura of aurality (beginning with the phrase "Thus did I hear") the Mahāyāna sūtras are written compositions. Beyond the novel use of script to produce these new scriptures, the texts themselves often exhorted their readers to copy the work they were reading. Perhaps no text was more persistent on this point than the *Lotus Sūtra*, where the Buddha constantly exhorts his disciples to "copy, preserve,

recite, and revere this sūtra and expound it for the sake of others." This was one of the many ways that the sūtra sought to promulgate itself.

The Buddha's exhortation was taken to heart by thousands of devotees of the *Lotus Sūtra* across East Asia. Indeed, some of the most beautiful calligraphy in China, Korea, and Japan is found in copies of the *Lotus Sūtra*, sometimes written in the calligrapher's own blood. Copying the sūtra became a sacred ritual. Since each of the 69,384 Chinese characters in the text was considered to be a buddha—a relic of enlightened speech encapsulated in the sound and shape of the character—some who copied the sūtra would perform a prostration before writing each character. Others would draw a small stūpa around each character.

Along with the fragment of Hyecho's journal that is the subject of this volume, more than a thousand copies of the *Lotus Sūtra* were discovered in the Library Cave at Dunhuang. The scroll reproduced here (fig. 11) may be one of those copies. Likely dating from around Hyecho's time (the late eighth century), it is, like the statue of the two buddhas, not a work of great artistic merit; instead, it was meant to serve a more utilitarian purpose. It is difficult to reconstruct the circumstances of Hyecho's encounter with the *Lotus Sūtra*, but for the everyday purposes of reading and studying, a monk like Hyecho would have probably used a manuscript like this, rather than one more elaborately decorated or precisely written.

The scroll here shows the end of the eighth chapter and the beginning of the ninth chapter of the *Lotus Sūtra*. One of the great messages of the sūtra is that all sentient beings will achieve buddhahood. The earlier tradition had held that buddhas were rare beings, that the disciples of the Buddha would become arhats and enter nirvāṇa at their death. But in the *Lotus Sūtra*, the Buddha reveals that even the arhats will become buddhas in the future. It was standard Buddhist doctrine that the rare being who would become a buddha in the future must receive a prophecy from a living buddha, in which the future buddha's name and land would be foretold. Thus, in the eighth and ninth chapters of the *Lotus Sūtra*, many monks come forth, clamoring for their prophecy, and the Buddha provides it. In chapter 8, he foretells the buddhahood of the arhats; and in chapter 9 those who are not yet arhats, notably the Buddha's cousin and personal attendant, Ānanda, and the Buddha's own son, Rāhula, receive their prophecies.

The magnificent scrolls of the *Lotus Sūtra* found in museums around the world were produced as acts of devotion and for future veneration; they were not made to be studied. Our scroll is different. It seems to be a scripture that was meant to be read. Although the scribe adopted the

seventeen-character-per-column format that is typical of more formal copies of the sūtra, this manuscript is less rigid than such works. For example, the five-character blocks of verse in the middle of the manuscript are not aligned, as they would be in a more formal work. Chapter 9 starts without any line or page break, suggesting an informal work by someone who is trying to preserve paper. Furthermore, the paper is not decorated and does not seem to be of especially high quality. The person who copied the text, whether for lack of skill or lack of interest, does not seem to have sought to make the characters particularly beautiful; for example, the strokes of the characters do not take advantage of the modulations possible with the use of a flexible brush. The strokes are those of someone with a practiced but not especially careful hand. Indeed, the way some of the characters are abbreviated suggests that the sūtra was copied by someone familiar with the conventions of professional sūtra copiers (perhaps a monk in a monastery) but who was not a professional himself. His main interest seems to have been in legibility, suggesting that this was a copy made for personal study, something necessary in order to "preserve, recite, and revere this sūtra and expound it for the sake of others."

FURTHER READING

Donald S. Lopez Jr., *The Lotus Sūtra: A Biography* (Princeton, NJ: Princeton University Press, 2016).

Eugene Wang, *Shaping the Lotus Sutra: Buddhist Visual Culture in Medieval China* (Seattle: University of Washington Press, 2005).

Brook A. Ziporyn, *Emptiness and Omnipresence: An Essential Introduction to Tiantai Buddhism* (Bloomington: Indiana University Press, 2016).

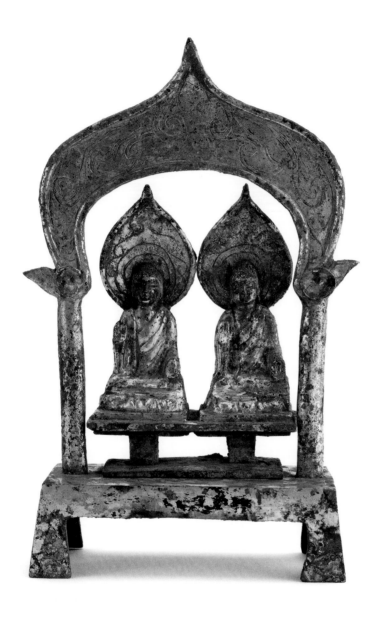

Two Buddhas Seated Side by Side, Sui Dynasty, China (609).
Gilt bronze, 8 ⁹/₁₆ × 5 ⁹/₁₆ × 2 ³/₁₆ in. Purchase—Charles Lang
Freer Endowment, Freer Art Gallery (F1945.30a–b).

FIGURE 11

A Page from the Lotus Sūtra, Tang Dynasty, China (late eighth century). Ink and color on paper, 9 13/16 × 18 11/16 in. The Dr. Paul Singer Collection of Chinese Art of the Arthur M. Sackler Gallery, Smithsonian Institution, Washington, DC. A joint gift of the Arthur M. Sackler Foundation, Paul Singer, the AMS Foundation for the Arts, Sciences, and Humanities, and the Children of Arthur M. Sackler (RLS1997.48.4698).

BODH GAYĀ

The Buddha Attains
Enlightenment

After describing Sarnath, the site of the Buddha's first sermon, Hyecho next writes about Bodh Gayā, the site of the Buddha's enlightenment. It is unclear from his description whether he visited these two of the famous "four sites" (the others being the place of the Buddha's birth and the place of his death) in that order. If he did, Hyecho retraced the route of the Buddha himself, but in the opposite direction: after achieving enlightenment, the Buddha went out in search of the "group of five" who would become his first disciples. It was to them that he famously set forth the middle way, the four noble truths, and the eightfold path.

At Bodh Gayā, Hyecho departs from his rather dry reportage to say that he had long dreamed of seeing the Mahābodhi, the temple that commemorates the moment and marks the site of the Buddha's enlightenment. Five poems survive in the existing manuscript of Hyecho's journey, and of these, four are expressions of sorrow and longing for home. The one poem that seems to find delight in India is his poem about Bodh Gayā, discussed in the introduction.

> Undaunted by the distance to buddhahood,
> Why should I think the Deer Park far?
> I am only daunted by the dangers of rugged mountain paths;
> I give no thought to the gusts of karmic winds.
> The eight stūpas are difficult to truly see.
> They have all passed through the cosmic fires.
> How can my own vow be fulfilled?
> Yet I saw them with my own eyes this very day.

Long before there was Mecca, Bodh Gayā was the Mecca of Buddhism, the central place of pilgrimage and, in some ways, the axis mundi of the Buddhist world, located in the center of the continent of Jambudvīpa. Its prominence derived in part from the many central episodes in the life of the Buddha that took place in its vicinity. Of all the places that Hyecho visited, it would have been the most sacred to him.

THE STORY

We should note, however, that the term "Bodh Gayā" is a modern place name. In the life stories of the Buddha, it is the seat beneath the Bodhi Tree that is most often named, referred to in various Buddhist languages as the "platform of enlightenment" and the "vajra seat." "Vajra" here connotes

indestructibility and immutability, qualities central to the cosmic significance of the seat.

It was on the banks of the Nairañjanā River that Prince Siddhārtha, who would become the Buddha, and his five fellow ascetics practiced various austerities. It was while bathing in the river that the prince came to the conclusion that self-mortification did not lead to liberation and so accepted a bowl of rice milk from the maiden Sujātā. His comrades regarded his disavowal of asceticism as a betrayal and abandoned him. From there, he proceeded into the forest, where he selected the tree under which he would meditate. His selection of the tree is described in some detail in various accounts. In one, knowing that the tree is indestructible but unable to identify it in the forest, the prince emits a bolt of flames, incinerating all of the trees except the Bodhi Tree. In another account, not knowing which side of the tree to sit under, the prince tries each, finding that the earth tilts wildly when he sits in three of the four directions, so he finally sits in the correct direction, facing east. Having taken his seat, he does not rise until he is enlightened; the Sanskrit term "buddha" is more accurately rendered as "awakened."

Prior to that (or, in some accounts, afterward), however, he was attacked by his nemesis, Māra, the deity of desire and death, who first tried to destroy him with his army of demons and then tried to dissuade him with his seductive daughters, to no avail. When Māra finally challenged the prince's right to occupy that small square of earth under the tree, the prince touched the earth with his right hand to call the goddess of the earth to bear witness to all the good deeds he had done in his past lives. That particular gesture—his upturned left hand resting in his lap, his right hand extended to touch the ground—became the most common form in which he was depicted, when sculptures of the Buddha began to be made, several centuries after his death.

The various accounts agree that he meditated all night, on the full moon of the fourth lunar month (and his thirty-fifth birthday). The Indian night was traditionally divided into three watches. During the first watch of the night, the prince had a vision of all of his past lives (and in Buddhism, the number of past lives is infinite). In the second watch of the night, he saw "how beings rise and fall according to their deeds"; that is, he witnessed the operation of the law of karma. It was in the third watch of the night, as the sun rose on the new day, that he became enlightened.

Now he was a buddha, an "awakened one." The texts dwell at length on the events of the next seven weeks, spent in silent solitude in the environs of the Bodhi Tree, with a specific activity (and an attendant sacred site)

described for each week. For example, according to one version, in the second week he sat facing the Bodhi Tree without closing his eyes. In the third week he walked back and forth in meditation. It was during the fifth week that he decided to teach, after the god Brahmā descended from his heaven and implored him to do so. In the sixth week, the great snake Mucilinda wrapped himself around the seated Buddha seven times and spread out his hood above him to protect the Buddha from a torrential downpour. It was in the seventh week that he ate for the first time since consuming Sujātā's gift; he accepted some honey cakes from two merchants who passed by, and he gave them some of his hair in return. The sites of these events are marked by shrines at Bodh Gayā; Xuanzang describes them in his lengthy description of the area.

At the end of seven weeks, the Buddha left the confines of the Bodhi Tree and set out to teach. He concluded that his first meditation teachers were most deserving of learning what he had understood. However, they had both recently died. He therefore set out to teach "the group of five," the five ascetics with whom he had practiced austerities for six years and who had abandoned him when he broke his fast and accepted the meal from Sujātā. He found them in the Deer Park in Sarnath, outside Vārāṇasī.

COMMENTARY

The Buddha's enlightenment is the central event in the history of the Buddhist tradition, making its site, the Mahābodhi, or "Great Enlightenment" as Hyecho calls it, the most sacred place in the Buddhist world. As discussed above, the Buddha's enlightenment was preceded by violent attack of Māra. And yet this pivotal, even epochal event from the Buddhist perspective, occurred in the midst of a forest in the middle of the night, observed by no one. A single ascetic sat silently in darkness beneath a tree. The enlightenment, the event itself, if it can even be described as an event, lacks all drama: the drama of the angel grabbing the hand of Abraham before he cuts Isaac's throat, as we see in Caravaggio's painting; the drama of the crucifixion as Jesus dies above a crowd that includes his weeping mother and those throwing dice to see who wins his seamless robe; the drama of the angel Gabriel commanding the young Muhammad, "Recite."

The accounts of the night of the Buddha's enlightenment describe his vision of his past lives in the first watch of the night in some detail, explaining the various elements of each of his past lives that he saw, including his family members of each lifetime. The vision of the second watch of the night, in which he saw "how beings rise and fall according to their deeds,"

suggests the observation of how the law of karma plays out in the lives of others, as some thrive as a result of their virtues and others suffer for their sins. Strangely, or not, it is the final watch of the night, the time in which he becomes *buddha*, "awakened," that receives the least comment. The origin of buddhahood, and of Buddhism, is thus ineffable. This same ineffability, however, provides endless occasions for interpretation. Buddhism is endlessly interpretable because its central event is unrecoverable.

This was a boon for Buddhist philosophy as, over the course of the centuries and millennia that followed, Buddhist thinkers from across the tradition sought to articulate the silence of the Buddha's enlightenment. However, a place where nothing happens does not make a potent pilgrimage site or a compelling subject for a work of art. How does one represent enlightenment and the enlightened person?

The general consensus among scholars is that the Buddha died around 400 BCE (see chapter 7). Yet no images of him have been discovered that date before the first century BCE, some three centuries after he passed into nirvāṇa. The earliest known image of the Buddha is found on the Bimaran Casket, a small gold reliquary discovered in eastern Afghanistan in the 1830s (now in the British Museum); art historians tentatively date it to the last decades before the Common Era. The widespread use of images of the Buddha does not seem to have occurred until the first century of the Common Era.

This does not mean, however, that the Buddha is not somehow represented in Buddhist sculpture in the preceding centuries. Buddhist monuments seem to have represented the presence of the Buddha by his absence. Instead of the standing Buddha or the seated Buddha that are now so familiar, there are instead footprints, an empty throne, a riderless horse. Elsewhere, specific objects seem to represent the Buddha, depending on the scene: a lotus for his birth; a tree for his enlightenment; a *dharmacakra*, or "wheel of the teaching" for his first sermon, traditionally called his "turning the wheel of the dharma"; a *stūpa* for his passage into nirvāṇa. It is important to note that these carvings contain many figural images of gods, humans, and sometimes animals. It is the Buddha himself who is absent. European and, later, American art historians observed this absence when various sites in India were excavated by the British in the nineteenth century. Since then, and to the present day, a number of theories have been put forward to explain it. Their first assumption was that, just as Islam prohibited the depiction of humans in religious art, so the Buddha, or his immediate followers, had forbidden the making or worship of his image. They expected that just as this prohibition occurs in the Muslim *hadith*, the Buddhist prohibition

must occur somewhere in the Buddhist canon. However, among the volu-
minous and intricate rules that constitute the Buddhist vinaya, no such rule
has yet been found, with one interesting exception: a passage preserved in a
Chinese translation of the monastic code of one sect, in which the Buddha's
patron Anāthapiṇḍada says, "Since it is not permitted to make a likeness of
the Buddha's body, I pray that the Buddha will grant permission to make
an image of [the Buddha when he was] a bodhisattva."[37] The Buddha agrees.

One art historian has argued that the absence of the Buddha is not
the result of any prohibition, claiming that the carvings do not depict events
from the life of the Buddha but instead represent places of pilgrimages at
a time after his demise, such as the Bodhi Tree, or festivals celebrating
the key moments in his biography, in which a riderless horse would be led
from the city to commemorate his departure from the royal palace on his
loyal steed.

It should be noted that the nineteenth- and early-twentieth-century the-
ory that the Buddha himself had prohibited the worship of his form is quite
consistent with that period's portrayal of the Buddha as a teacher of ethics,
an enemy of superstition and priestcraft, and the founder of a philosophy,
not a religion; he would never have allowed himself to be turned into an
idol to be worshipped. The making and worship of icons could therefore
have occurred only as a concession to the masses in the centuries after his
passage into nirvāṇa.

Many of these same art historians argued that the representation of the
Buddha was thus introduced to Buddhism from abroad, specifically from
the pagan cultures of the Hellenistic world. In 327 BCE, Alexander the
Great led his army into the Punjab and conquered the regions of Bactria,
Gandhāra, and Swat. The Indo-Greek kingdoms that formed after his death
were initially counted as part of the larger Hellenistic world. Thus, the Bac-
trian city of Ai Khanoum in Afghanistan (occupied from the fourth century
BCE to about 145 BCE) had many characteristics of a provincial Greek col-
ony, with Greek artisans making works for a local populace. By the early
first century CE, the Kushans, a central Asian people, had taken control of
most of northern India, Gandhāra proper, and the ancient Afghan regions
of Bactria and Nagarahara, bringing political stability and economic pros-
perity to these areas. This period subsequently saw the flourishing of inter-
national trade along well-established land and sea routes and the settlement
and growth of Buddhist communities. Indeed, art historians have specu-
lated that it was the Kushans who introduced the Buddha image. The style
of the images retained a Hellenistic character, in fact, more Roman than
Greek. Gandhāra had contact with the Roman Empire beginning in the first

centuries of the Common Era; by the second century CE, Gandhāran art-ists were incorporating classical motifs that later became part of the local cultural identity.

Against this argument that the Buddha image derives from Greek in-fluence (a theory in keeping with nineteenth-century theories of the sup-posed kinship of Indo-Aryan peoples), other art historians noted a separate tradition of statues of the Buddha, originating in the same period in the region of Mathurā, about eighty miles south of modern Delhi and far from Greek influence. These images had much more in common with Hindu and Jain sculpture from the region. The Buddha did not look like Apollo. It was from these two regions, Gandhāra and Mathurā—two areas traversed by Hyecho—that a visual vocabulary of buddhahood would emerge.

THE ART

As in most chapters, here we have two very different pieces from two differ-ent periods, from two regions of the Buddhist world. The first piece (fig. 12) is called *The Defeat of Māra*.

This piece is from a set of four panels depicting the four key moments in the life of the Buddha (each of which had its own place of pilgrimage, each of which was visited by Hyecho): his birth, his enlightenment, his first teaching, and his passage into nirvāṇa. The set comes from the Gandhāra region of ancient India (which encompassed areas of modern Pakistan and Afghanistan). It dates from the late second or early third century of the Common Era. This panel depicts the Buddha's enlightenment, not the scene of silent meditation described above, but the dramatic and violent moment that preceded it: the attack of Māra and his minions. Māra, the deity of de-sire and death, is seeking to prevent the future Buddha from destroying de-sire and escaping from death. He leads a motley army of human soldiers, an-imals, and demons: a monkey rides a horse, another monkey raises a sword; one demon hurls a boulder, another holds a cobra about to strike; demons with the heads of boars and rams wield weapons. There is a dog, an elephant, and a camel, this last animal reflecting the cosmopolitan world of Gandhāra, crisscrossed by trade routes traversed by camels.

In their midst, the future Buddha—with halo, crown protrusion (*uṣṇīṣa*), and *urṇa* (the dot between his eyes)—sits beneath the bower of the Bodhi Tree, repelling the assault simply by touching the earth with his right hand, calling the goddess of the earth to bear witness to his virtue. Two soldiers—perhaps dressed in the armor of foreigners—seem to have fallen to the ground as the earth quaked; one raises his shield in defense, the other is

upended, falling headlong, dropping his halberd. The swirling chaos of the attack is frozen in motion, as the Buddha touches the earth, immobilizing Māra and his minions, suspending this momentous moment in time—for all time.

This set of four panels (see also chapter 7) once decorated a stūpa, which would have been circumambulated clockwise by its devotees. The four scenes were therefore placed in chronological order from right to left, the pious viewing the panels over their right shoulders. This also means that the dramatic movement of each of the scenes occurs from right to left. This is why Māra, his hair tied up in a royal turban, his body dressed in an elaborate dhoti, appears three times in a continuous narrative that moves in the same direction. To the Buddha's left, Māra draws his sword with his right hand while his attendant attempts to hold him back. To the Buddha's immediate right, Māra's sword is now sheathed; he raises his left hand in a gesture of angry despair as his attendant tries to lead him away. Finally, at the far left, he sits alone in demoralized defeat, staring off into the distance, his head in his hand. The Buddha is beyond his power.

Scenes of the *māravijaya*, the "defeat of Māra," became ubiquitous across the Buddhist world. Xuanzang mentions specifically that the image of the Buddha inside the Mahābodhi temple depicted the Buddha with the earth-touching gesture. Hyecho would have known the story before he arrived in India; when he reached the Mahābodhi, he would have seen the same statue that Xuanzang had seen. Buddhas in this same posture would have faced Hyecho from Bodh Gayā to Gandhāra, from Afghanistan back to China.

The second piece (fig. 13) is called *The Tiger-Taming Luohan*. According to a legend, prior to his passage into nirvāṇa, the Buddha ordered sixteen of his disciples, all arhats and thus destined for nirvāṇa at the time of their own deaths, to postpone their entry into nirvāṇa and to extend their lives for millennia. Their task was to preserve the dharma until the advent of the next buddha, Maitreya. Although the story of the sixteen is known in India (where they are called the sixteen *sthavira*, or elders), these figures became especially popular in China, where their long lives and wizened features evoked Daoist immortals. Called the sixteen *luohan* (Chinese for "arhat"), they were often depicted in poetry and art. Indeed, their number was increased to eighteen by adding two not mentioned in the Indian sources: the Tiger-Taming Luohan and the Dragon-Taming Luohan. According to the story of the Tiger-Taming Luohan, his name comes from the time he domesticated a man-eating tiger that howled outside the monastery by feeding it vegetarian food. This luohan's hidden, paradisiacal realm is suggested by

the small door over his right shoulder. The painting evokes several of the traits of the luohan: the ideal of reclusive practice in nature, longevity, and purity, as well as the convergence of natural and supernatural powers, particularly over the natural world in which he lives. The luohan, a distinctively Chinese motif, is combined in the work here with an object associated across the Buddhist world with India: a leaf from the Bodhi Tree.

Trees were sacred in ancient India, believed to be the abodes of spirits; and trees figure prominently in the life of the Buddha. His mother grasps the branch of a tree when he is born (see chapter 7); he is mistaken for a tree spirit when he receives his first meal after six years of asceticism; when he is about to die, he lies down between two trees, which immediately bloom out of season (see chapter 4). No tree, however, is more important than the Bodhi Tree, where the Buddha sits on the night of his enlightenment. During the seven weeks that he spent in the vicinity of the tree after that night, he spent one week staring at the tree, never closing his eyes, and thus performed the first act in homage of the tree. It is the axis mundi of the Buddhist world and figures prominently in Buddhist history and lore. In the legend of the emperor Aśoka, the monarch becomes so devoted to the tree that his wife becomes jealous and tries to kill it with black magic. He saves it by watering it with milk. When Aśoka sends his son and daughter (a monk and a nun) to bring the dharma to Sri Lanka, he sends with his daughter a cutting from the Bodhi Tree, which remains one of the most sacred sites on the island and is the subject of its own chronicle. In the "aniconic" period of Buddhist art, the Bodhi Tree represented the enlightenment of the Buddha. Over its long history, the Bodhi Tree was cut down by Hindu kings, but it always somehow came back to life.

Pilgrims from across the Buddhist world who visited Bodh Gayā took back leaves as sacred objects and took back seeds that they planted in their homelands. The botanical name for the tree is *ficus religiosa*; also known as a pipal tree, it is a kind of fig tree that grows to be very tall, with a thick trunk. It also has a long life. Its large, heart-shaped leaves have a distinctive tip. While luohan paintings were long an important genre within the Chinese tradition of Buddhist art, the practice of painting on leaves seems to be a technique developed during the Qing Dynasty. Leaves were soaked in water for up to three weeks in preparation for painting, and during this time the green of the leaf would fade. The result was the delicate leaf we see here, akin to fine paper or gauze. One wonders if Hyecho, so moved by finally reaching the Mahābodhi that he was inspired to write a poem, did not also take a leaf from the Bodhi Tree as a token of his visit.

FURTHER READING

Robert DeCaroli, *Image Problems: The Origin and Development of the Buddha's Image in Early South Asia* (Seattle: University of Washington Press, 2015).

John Kieschnick and Meir Shahar, eds., *India in the Chinese Imagination: Myth, Religion, and Thought* (Philadelphia: University of Pennsylvania Press, 2013).

Dietrich Seckel, *Before and Beyond the Image: Aniconic Symbolism in Buddhist Art* (Zurich: Artibus Asiae, 2004).

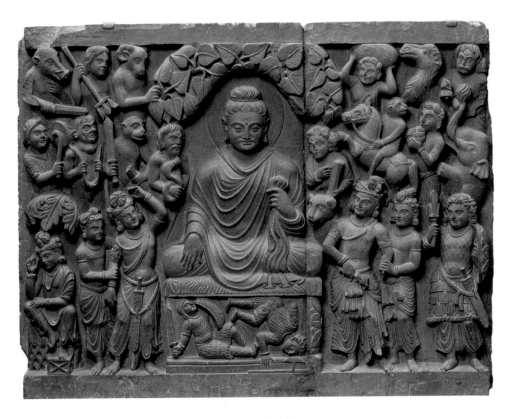

The Defeat of Māra, Kushan Dynasty, Pakistan or Afghanistan (second to third century) (detail). Stone, 26 ³/₈ × 114 ¹/₈ × 3 ⁷/₈ in. Purchase—Charles Lang Freer Endowment, Freer Gallery of Art (F1949.9a–d).

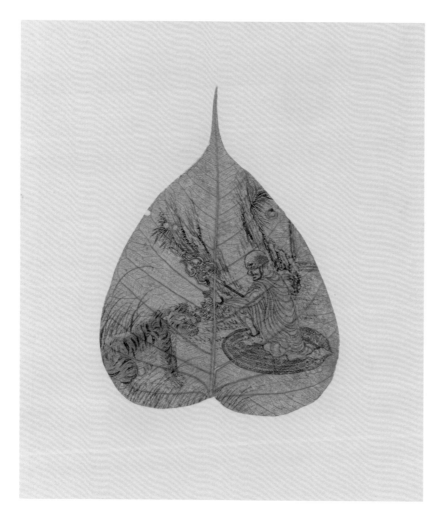

The Tiger-Taming Luohan, a Painted Leaf from the Bodhi Tree, Qing Dynasty, China (1644–1911). Ink on leaf, 5 $^7/_8$ × 4 $^5/_{16}$ in. Gift of Charles Lang Freer, Freer Gallery of Art (F1911.504a–t).

LUMBINĪ

The Buddha Is Born

"The third [of the four great] stūpas is in Kapilavastu, the birthplace of the Buddha. The *aśoka* tree can still be seen, but whatever city once existed is now only ruins. The stūpa is there, but there are neither monks nor villagers living nearby. The city is located northernmost of these four, where the surrounding forests are thick and the roads are frequented by bandits, making it very difficult for pilgrims who wish to come here."[38]

As discussed in the introduction, Hyecho's precise route is difficult to reconstruct. However, if he visited Vulture Peak, he would likely have then traveled north to Vaiśālī, the site of a number of discourses by the Buddha and the place where he spent his final rains retreat before his death. It was when the Buddha was en route from his home city of Kapilavastu to Vaiśālī that he was stopped by a group of women, led by his stepmother, Mahāprajāpatī, who implored him to establish an order of nuns, which he grudgingly agreed to do. Vaiśālī was also the site of the second Buddhist council, said to have taken place a hundred years after the Buddha passed into nirvāṇa. Hyecho mentions Āmrapālī, the mango grove given to the Buddha by the wealthy courtesan of the same name. Hyecho finds a stūpa there, but the monastery is deserted, in ruins.

From Vaiśālī, he continued north to what he calls Kapila (short for Kapilavastu), the city of King Śuddhodana, the Buddha's father, and where Prince Siddhārtha spent the first twenty-nine years of his life, before "the great departure." However, the Buddha was born in Lumbinī, located some fifteen miles north. It is unclear which place Hyecho is describing; presumably, it is Lumbinī. Regardless, Hyecho found it deserted. There was a stūpa commemorating the Buddha's birth, but no monks to attend it and no villages in the vicinity. Hyecho described it as a dangerous place, surrounded by thick forests that were the lairs of bandits. All that seemed to remain was an *aśoka* tree.

THE STORY

The birth of a buddha is a momentous event in the history of the universe. Buddhas appear but rarely to teach the path to liberation from the sufferings of saṃsāra. After a buddha dies and passes into nirvāṇa, his teachings slowly fade from human memory, becoming more difficult to remember, and so more difficult to practice, with each passing generation. Eventually his teachings disappear forever, only to be restored when the next buddha appears. Fortunate are those whose past deeds transport them to the time and place of this rare event, the life of a buddha.

That life does not begin with the birth of a baby on earth but in a heaven above. There, in a heaven called Tuṣita ("Joyous"), the bodhisattva, the future buddha, knows that in his next lifetime he will achieve the buddhahood he has sought for billions of past lives, that he will discover the path to freedom and he will teach it to the world. Other, less advanced, beings are blown by the winds of karma to their next birth, whether into the womb of a human or into the womb of an animal, into a horrible hell or into a palatial heaven; their birth is not a matter of choice but of destiny. The bodhisattva, however, is able to choose the time and the place of his last lifetime. The gods in heaven implore him to take his final birth, for they know that their time in heaven will end, that they will die there and be reborn elsewhere. They are the most powerful beings in the world, but they do not know the path to liberation; they must learn it from a buddha. And so stories of the Buddha's birth begin with a god, lord of the Tuṣita heaven, deciding that the time has come to descend to earth. He surveys the entire world to decide the time, the place, the caste, and the mother.

The time was when the average human lifespan was one hundred years. The place was the city of Kapilavastu in the land of Magadha on the continent called Jambudvīpa. Among the four castes of ancient India, buddhas are born into either the priestly caste or the warrior caste, whichever is more respected at the time. The mother of the future buddha is a moral woman who has accumulated virtue over thousands of lifetimes.

In the land of the Śākya clan, there was a king of the warrior caste named Śuddhodana. One night, his wife, Queen Māyā, had a dream that her bed was lifted by four deities and taken to the high Himalayas, where she was bathed by goddesses and dressed in divine robes. She was then transported to a silver mountain and placed on a heavenly couch. A white elephant holding a white lotus in his trunk descended from a golden mountain, circled the couch three times, and entered her womb. Her pregnancy was blissful and her womb was a sumptuous palace for the future Buddha, who sat cross-legged there for ten lunar months.

At that time, she decided to visit her father, who was king of a neighboring land, and she set out, carried in a palanquin. En route, the queen and her entourage stopped in a garden called Lumbinī, where all of the trees were in full bloom. The queen emerged from her palanquin and grasped the bower of an *aśoka* tree with her right hand. The infant emerged from her right side without causing her the slightest pain. He was caught on a golden net held by four gods, and two streams of water, one warm and one cold, descended from the skies to bathe him. The child could immediately walk and talk. He looked around in all directions and then took seven steps to the north, a

lotus blossoming under his foot at each step. He pointed with his right hand to heaven and with his left hand to earth and declared, "Chief am I in all the world. Eldest am I in all the world. This is my last birth. No more will I be reborn." The earth quaked, a brilliant light suffused the world, the blind could suddenly see, the deaf could hear, the lame could walk, the fires of hell were extinguished, trees bore perfect flowers and fruit, and the salt sea turned sweet.

THE COMMENTARY

In 1956 Buddhist leaders from around the world gathered in Bodh Gayā, the site of the Buddha's enlightenment, to celebrate the Buddha Jayanti ("jubilee" or "festival"), the twenty-five-hundredth anniversary of the Buddha's passage into nirvāṇa. In Rangoon, the Sixth Buddhist Council, a meeting of twenty-five hundred monks, completed their redaction of the canon, a project begun two years earlier. According to one Buddhist sūtra, the *Great Discourse on the Final Nirvāṇa* (*Mahāparinibbāna Sutta*, discussed in chapter 4) the Buddha lived for eighty years. Thus, if 1956 marked the twenty-five-hundredth anniversary of his death, the Buddha's dates are 624–544 BCE. Many scholars of Buddhism are convinced that these dates are wrong.

Among all the dates in the history of Buddhism, none is more important than the year of the death of the Buddha. It does not merely mark the death of the founder and thus the beginning of the tradition that he founded. It also marks the reference point for all subsequent events in the history of the tradition. Just as the Christian world marks time beginning with the birth of Jesus, designating each year after that as AD (Anno Domini), the Buddhist world marks time beginning with the death of the Buddha, using various terms that in the nineteenth century came to be rendered in English as A.N. (After the Nirvāṇa). Thus, the Second Buddhist Council is said to have taken place in the city of Vaiśālī, one hundred years after the Buddha passed into nirvāṇa. The great philosopher Nāgārjuna is said to have been born four hundred years after the Buddha passed into nirvāṇa.

The birth date of Jesus has been the subject of much scholarly speculation. The Gospels do not say when Jesus was born, only that he was born during the reign of Herod the Great. Roman records indicate that Herod died in 4 BCE. Most biblical scholars therefore place the birth of Jesus sometime between 6 and 4 BCE. Scholars of Buddhism also have a number of opinions on the date of the Buddha's birth, but their disagreements range over a period of two centuries rather than two years. Traditional Buddhist sources range wildly, from as early as 2420 BCE to as late as 290 BCE.

As in the case of Jesus, the calculation of the date of the Buddha's birth essentially rests on establishing the date of a king, in this case, the emperor Aśoka of the Mauryan Dynasty. Prior to the reign of Aśoka, no dates appear in ancient Indian records that can be independently confirmed. The calculation of dates for Aśoka comes from two sources. Alexander the Great invaded India in 326 BCE, leaving regions of what is today Pakistan under the rule of his captains. The Greeks were defeated on the battlefield by the troops of the Indian king Candragupta Maurya (Aśoka's grandfather). Greek sources record a treaty with Candragupta in 303. After the reign of his son Bindusāra, Aśoka ascended to the throne sometime between 280 and 267; a number of modern scholars use the date 268. He vastly extended the empire of his grandfather. Evidence of the extent of his reign is provided by some three dozen inscriptions (called "edicts") found throughout India and beyond, carved on pillars and rock faces; inscriptions in Greek and Aramaic were discovered in Kandahar in modern Afghanistan. These inscriptions remained illegible and their contents unknown for centuries, until James Prinsep of the East India Company was able to decipher their Brahmī script, publishing them in a series of articles beginning in 1836. The inscriptions provide a number of verifiable dates and mention contemporary rulers such as Antiochus II of Syria and Ptolemy II of Egypt.

Two Sri Lankan chronicles give a large and likely mythical role to Aśoka in the introduction of Buddhism to the island. Without recourse to his edicts, they place the coronation of Aśoka in 326 BCE and state that the Buddha entered nirvāṇa 218 years before that. Their date of 544 as the year of the Buddha's death derives from this calculation. Using the more accurate date of c. 268 for Aśoka's coronation, European scholars accepted the Sri Lankan figure of 218 years and recalculated the Buddha's dates as 567–487 or 563–483 BCE; the latter range continues to appear in many reference works. Since the 1990s, however, those dates have also been called into question, based in part on archaeological evidence. For example, excavations at the site in southern Nepal identified (not without some controversy) as Kapilavastu, the city where Prince Siddhārtha spent the first twenty-nine years of his life, found no evidence of a settlement there (and hardly the grand palace described in Buddhist texts) prior to 500 BCE. The birth of the Buddha therefore needed to be pushed forward in time to the fifth century. This view is supported by textual evidence in Sanskrit sources, a number of which state that Aśoka ascended to the throne one hundred years after the Buddha passed into nirvāṇa. Although the round number of this date is a reason for some skepticism, it nonetheless conforms generally with the

archaeological evidence, and would place the death of the Buddha as late as 367 BCE. At present, there is no scholarly consensus on the precise dates of the Buddha, and, barring new evidence, there is likely to be none. It can be said, however, that many scholars have rejected the traditional Theravāda dating of 624–544 BCE as well as the revised date of 563–483 BCE and would say that the Buddha died sometime between 420 and 380 BCE.

At Lumbinī, however, we are concerned with the date and the place not of the Buddha's death, but of the Buddha's birth. If the Buddha lived for eighty years, he would have been born some time between 500 and 460 BCE. The place of his birth also remains the subject of debate, with some archaeologists placing Kapilavastu near the southern border of Nepal and others placing it at Piprahwa in Uttar Pradesh in northern India. There is no dispute, however, on the location of Lumbinī, the grove where Queen Māyā stopped on her way to visit her parents in Devadaha. The site of Buddhist shrines at Lumbinī is some fifteen miles from the Nepalese site of Kapilavastu, some forty miles from the Indian site. We know that from the time of Aśoka, Lumbinī was regarded as the Buddha's birthplace. As described in one of his pillar inscriptions there, the emperor himself made a pilgrimage to Lumbinī in the twentieth year of his reign, had a pillar and a stone railing built there, and reduced the tax rate for the region.

One of the many puzzles about Hyecho's visit, a thousand years later, is that he names the place as Kapila (short for Kapilavastu), but he describes Lumbinī, many miles away. The great French scholar of Indian Buddhism André Bareau (1921–1993) offered a fascinating theory. He speculates that Kapilavastu was likely the site of the Buddha's birth. However, as the Buddhist community sought to support itself via pilgrimage, it needed to associate the events of the life of the Buddha with already established sites. Trees have long been venerated in India, and trees figure prominently in the life of the Buddha; he is mistaken for a tree spirit when he receives a meal from Sujātā, and he achieves enlightenment under a tree. There is archaeological evidence of an ancient tree shrine at Lumbinī, one that likely predates the birth of the Buddha. Bareau speculated that the Buddhists decided to place the Buddha's birth there, with his mysterious mother, who died seven days after his birth, holding a branch of a sacred tree (the tree that already had its own cultus) as the bodhisattva emerged from her right side. If Bareau is correct, we see here yet another example of what we might term the "pilgrimization" of Buddhism. This process was obviously successful; by the time Aśoka visited, some one hundred fifty years after the death of the Buddha, Lumbinī was accepted as his birthplace.

By the time Hyecho arrived, there was a stūpa there but no monks; he makes no mention of the pillar that the emperor Aśoka had erected there; it was unearthed by the German archaeologist Alois Anton Führer in 1895. All that Hyecho found was the tree.

THE ART

The carving of the Buddha's birth (fig. 14) comes from the same set of four panels described in chapter 6; they depict the four key moments in the life of the Buddha (each of which had its own place of pilgrimage and each of which was visited by Hyecho): his birth, his enlightenment, his first teaching, and his passage into nirvāṇa. The set is from the Gandhāra region of ancient India (which encompassed regions of modern Pakistan and Afghanistan). It dates from the late second or early third century of the Common Era, the period when biographies of the Buddha began to be composed. The set of four panels once decorated a stūpa, which would have been circumambulated clockwise by devotees. The four scenes were therefore placed in chronological order from right to left, meaning that the dramatic movement of each of the scenes also occurs from right to left; devotees would have viewed the scenes over their right shoulders.

Unlike the panel of the Buddha's enlightenment, this panel does not depict different moments in the narrative. Instead, the momentous moment of the future Buddha's birth encompasses all three sections. Thus, on the right, two ladies in waiting discuss the scene, while a god, perhaps Brahmā, hovers in the sky, his palms joined in reverence. On the left, two attendants of the god Indra look on, one with palms joined, the other holding a tree branch with his right hand, while his left hand grasps his chin in a gesture of astonishment.

The center section depicts the miracle. Queen Māyā stands in the center, supported by a lady in waiting on her left. As the story is told, on the way to visit her family, she stopped to enjoy a grove of blossoming trees in Lumbinī Garden. In some versions of the story, they are called *śāla* trees; in others they are called *aśoka* trees. Entering the grove, she raised her right arm to grasp the branch of a tree. As noted above, scholars speculate that this scene is an interpolation into the story of the Buddha's birth, added to link it to an already existing tree cult in Lumbinī, associating Queen Māyā with the local tree spirit (*yakṣī*). Such a theory is supported by our image, where Queen Māyā does not appear to grasp the branch of a tree but is the tree, her body forming the trunk, the leaves literally growing out of the top of her head. In the textual versions of the tale, she reaches up to grasp a

branch (which in some versions drops down to receive her hand) for support. Here, however, it is she who provides the support, her graceful pose further suggesting her stability. She grasps not a firm branch but a soft leaf, not to steady her balance but to allow her remarkable son to emerge.

To her right stands a god, likely either Indra or Brahmā. In some versions of the story, four gods from the heaven of Mahābrahmā appear, each holding the corner of a net to catch the infant as he emerges. Here, however, a single god stands next to the queen, holding a cloth to receive the child; the other deities—two in the sky above—may reference the four gods of the story. They may also be the gods of the four directions who abide on the four slopes of Mount Sumeru; in some versions of the story, they are also said to have arrived to witness the Buddha's birth.

As is often the case in medieval paintings of the Annunciation to the Virgin Mary, the savior appears not in the form of an infant but as a miniature adult. The carving here includes other anachronisms. First, the infant already has a halo; this could signify his sanctity as the bodhisattva, but more often it signifies his enlightenment, which did not occur until thirty-five years later. Rather more strange is his hair. He not only has a full head of hair, but it has already been gathered in a bun on the top of his head, an intrauterine coiffeur. According to the standard story, the prince did not adopt this hairstyle until he left the palace and cut off his long princely locks. The presence of the chignon here may suggest that by the time this piece was carved, the bun may have already become a bump, the crown protrusion (uṣṇīṣa) that is one of the thirty-two marks of the superman (mahāpuruṣa) that the bodhisattva bore from birth. A further sign of the infant's independence is that he does not fall into the waiting arms of the god; he appears to be reaching for the cloth to wash himself. The next piece illustrates what happened next.

According to the story, after the baby Buddha emerged from his mother's right side, he was bathed by streams of water that descended from the sky; in East Asian accounts, the water is provided by two dragons. Then the infant Buddha took seven steps to the north, a lotus blooming under his feet with each step. In some versions he announces that he is supreme in the world and that this is his last rebirth; in others, he points to the sky above and the earth below and says, "In heaven and on earth, I alone am worthy of worship." This latter version, popular in East Asia, is depicted in figure 15, a gilt bronze statue found in Japan. Again shown as a miniature adult, again with the crown protrusion, the infant has already donned a loincloth.

According to traditional histories, Buddhism entered Japan in 538 (or 552), when the Japanese emperor Kinmei received a gilt bronze image of the

Buddha from King Seong of Korea, not the Unified Silla kingdom of Hye-cho but the earlier Baekje kingdom that presided over southwestern Korea until 660. The first Buddhist temple was constructed in Japan around 590. Very shortly after that, in 606, there are records of rituals being performed to celebrate the Buddha's birth. In 685 an imperial edict was sent to all provinces, declaring that every household should have a Buddhist icon. Many of these images were made by Koreans, either Korean immigrants already in Japan or Korean sculptors brought to Japan for that purpose.

This image of the infant Buddha is from this period. It is quite small, only four and a half inches tall. It was likely used as part of a popular Japanese Buddhist ritual that continues to the present day to celebrate the Buddha's birth. It is called "bathing the Buddha," referring to a practice that can be traced back to India. In the Chinese pilgrim Yijing's account of his travels there, he reports, "After stretching a jewelled canopy over the court of the monastery, and ranging perfumed water-jars in rows at the side of the temple, an image in either gold, silver, copper, or stone is put in a basin of the same material, while a band of girls plays music there. The image having been anointed with scent, water with perfume is poured over it. . . . After having been washed, it is wiped with a clean white cloth; then it is set up in the temple, where all sorts of beautiful flowers are furnished."[39] He goes on to report that monks bathe the statue of the Buddha in their individual cells every day.

As we see in the first image from Gandhāra (see chapter 11), representations of the Buddha's birth began in India as early as the second or third century CE. The particular image of the baby Buddha with one hand pointing to the sky and the other to the earth originated from Indian relief carvings and paintings depicting the birth scene, although no independent statue of the infant Buddha survives there. In China, the motif first appeared in relief carvings on the back of the mandorlas of stone Buddhist statues. Of particular interest is an example dated 543 from Henan Province (now preserved only in the form of a rubbing), which depicts the infant Buddha walking with right arm upraised, nine dragons above showering him with water. Here, for the first time, the scenes of the infant Buddha declaring his supremacy and of being bathed are combined.[40] Although the bathing ritual is believed to have been held frequently in China during the Northern and Southern Dynasties, very few statues survive; intriguingly, none of them depict the infant Buddha raising his right arm.

The first recorded celebration of this ritual in Japan (known as *kanbutsu-e*) was in 606, not long before this image was made. It was held on the traditional date of the Buddha's birth (the eighth day of the fourth lunar

month in the Chinese lunar calendar, which the Japanese used until 1873). Indeed, the seventh-century Freer image is of considerable historical importance because of its antiquity, dating from one of the earliest periods of Buddhist art in Japan; it is the oldest Japanese work in the Freer collection. The elongated facial features and the stylized folds of the garment, tied around the waist with a double cord, closely resemble the earliest known Japanese image of the Buddha at birth at Shōgenji in Aichi Prefecture.

The bathing ritual involved pouring water over the statue of the Buddha in commemoration of the bath provided by the two dragons. According to historical documents of the Nara period (710–794), the ritual was held on a grand scale at all the major temples in Nara. Its popularity increased further in the Heian period (794–1185), when it became an annual event at the imperial court. Today the ritual is performed widely across the Buddhist world, with children sometimes pouring the water over statues far chubbier and more toddlerlike than the rather austere baby Buddha here. One can imagine Hyecho, as a young monk in China, bathing his own little Buddha.

FURTHER READING

Heinz Bechert, ed., *When Did the Buddha Live?: The Controversy on the Dating of the Historical Buddha* (Delhi: Sri Satguru, 1995).

Patricia Karetzky, *Early Buddhist Narrative Art: Illustrations of the Life of the Buddha from Central Asia to China, Korea and Japan* (Lanham, MD: University Press of America, 2000).

Donald F. McCallum, *Hakuhō Sculpture* (Seattle: University of Washington Press, 2012).

Washizuka Hiromitsu, Park Youngbok, and Kang Woo-bang, eds., *Transmitting the Forms of Divinity: Early Buddhist Art from Korea and Japan* (New York: Japan Society, 2003).

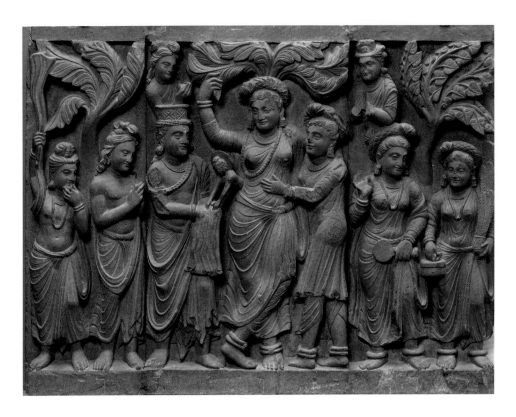

FIGURE 14

The Birth of the Buddha, Kushan Dynasty, Pakistan or
Afghanistan (second to third century) (detail). Stone, 26 ³/₈ ×
114 ¹/₈ × 3 ⁷/₈ in. Purchase—Charles Lang Freer Endowment,
Freer Gallery of Art (F1949.9a–d).

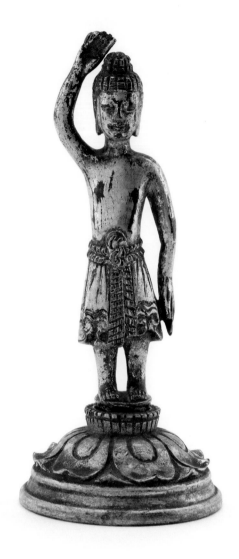

FIGURE 15

The Baby Buddha, Asuka period, Japan (seventh century).
Gilt bronze, 4 ⅝ × 2 ¹/₁₆ in. Gift of Sylvan Barnet and William
Burto in honor of Yanagi Takashi, Freer Gallery of Art
(F2005.9a–b).

ŚRĀVASTĪ

City of the Buddha's Miracles

Scholars speculate that Hyecho's journal had three parts: an account of his journey from his native Korea to China and then to India; an account of his travels in India, Central Asia, and Arabia; and an account of his journey back to China. Only the second of the three parts survives, and even it is fragmentary. The text begins with what scholars assume is his account of Śrāvastī. This is one of the most sacred sites in the Buddhist world, where the Buddha spent many years; he is said to have passed twenty-five rains retreats in the city. He preached many sūtras in the city's Jetavana Grove, a gift from his most famous lay disciple and patron, Anāthapiṇḍada.

Hyecho mentions none of this, describing instead the naked Hindu ascetics: "their feet and bodies naked." Scholars therefore speculate that all that remains of his description of the city is the final sentences. Elsewhere in the text, he lists Śrāvastī as the site of one of the "four great stūpas," suggesting that he knew about the wondrous events that took place there.

THE STORY

In the city of Rājagṛha there lived six masters who were opponents of the Buddha. Their names were Pūraṇa Kāśyapa, Maskarin, Saṃjayin, Ajita Keśakambala, Kakuda Kātyāyana, and Nirgrantha. They resented the fact that they were no longer honored and respected by kings, ministers, city dwellers, villagers, and merchants, receiving all manner of offerings, as they had been before the Buddha arrived. Now it was he who garnered respect and received offerings. To win back their prior status and support, they decided to challenge the Buddha to a miracle contest.

Learning of their plan, Māra, the Buddha's nemesis, secretly endowed each of the six with the ability to fly and to produce flames, rain, and lightning. The six masters thus believed that they possessed superhuman powers and could defeat the Buddha. They went to Bimbisāra, the king of Magadha (and a friend and patron of the Buddha) and announced their plan. The king tried to discourage them, saying they should challenge the Buddha only if they wished to become cadavers. He refused to allow such a contest to take place in his realm.

At this time, the Buddha reflected that it was in the city of Śrāvastī that the buddhas of the past had performed miracles for the welfare of sentient beings. The Buddha therefore decided to go to Śrāvastī, accompanied by his monks. When he arrived, he took up residence at the Jetavana Grove. Hearing of his arrival, the six masters went to Prasenajit, king of Kośala, and asked his permission to challenge the Buddha to a miracle contest. Before giving his answer, the king went to the Buddha and informed him

of the challenge, saying that he hoped the Buddha would accept the challenge and defeat the six masters: "May the Bhagavat confound the *tīrthyas*; may he satisfy *devas* and humans; may he delight the hearts and souls of virtuous people."

The Buddha replied, "Great king, I do not teach the dharma to my disciples by telling them: 'Go, O monks, and, with the aid of a supernatural power, perform superhuman miracles for the brahmins and householders that you meet'; but this is how I teach the law to my listeners: 'Live, O monks, hiding your good deeds and revealing your sins.'"

All buddhas perform ten deeds: a buddha does not enter into final nirvāṇa (1) as long as he has not made the prophecy that another person will one day become a buddha; (2) as long as he has not inspired another being to become a buddha; (3) as long as all those to be converted by him have not been converted; (4) as long as he has not exceeded three-quarters of the duration of his lifespan; (5) as long as he has not entrusted his duties to others; (6) as long as he has not appointed two of his disciples as the foremost; (7) as long as he has not descended from the heaven atop Mount Sumeru to the city of Sāṃkāśya; (8) as long as, gathered with his disciples at Lake Anavatapta, he has not expounded his previous deeds; (9) as long as he has not established his parents in the truths; and (10) as long as he has not performed a great miracle at Śrāvastī. Thus, when King Prasenajit repeated his request a second and then a third time, the Buddha agreed, saying that he would perform a great miracle seven days hence. The king promised to construct a pavilion for the purpose. He then returned to the city and informed the six masters that the Buddha had accepted their challenge.

Prasenajit had a younger brother named Kāla, who was also a disciple of the Buddha. Someone told the king that Kāla had seduced one of the king's women. Without determining that this was a lie, the hot-tempered king ordered his soldiers to cut off his hands and feet. They left him lying in the street. The six masters walked by and decided to use their magical powers to heal him but then decided not to, since Kāla was a disciple of the Buddha. The Buddha, knowing of the attack, sent his attendant Ānanda to restore the prince's appendages by performing an act of truth, a truthful statement whose utterance has magical powers. Not only was Kāla restored, but he attained the state of enlightenment called never-returner, becoming a monk.

When the seventh day arrived, the king and several hundred thousand citizens of the city gathered at the building he had constructed for the Buddha; the six masters went to a building that they had built for themselves. The king then sent a young man to invite the Buddha to come. The Buddha accepted the invitation and sent the young man back, flying through the

air, to the king. Prasenajit pointed out that the Buddha had just performed a miracle, but the six responded that, since the Buddha was not there, it was not possible to say that he had performed the miracle; anyone in the large crowd may have done so, including them. The Buddha then caused the pavilion built for him by the king to be engulfed in flames, but the building was not damaged. Again, the six sages refused to accept that the Buddha had performed a miracle. Next, the Buddha caused the world to be filled with golden light. Next, he caused two of his monks to retrieve exotic plants from distant lands. Next, he placed his feet on the ground, causing a great earthquake: "The eastern part sank, and the western rose; the south rose and the north sank; then the opposite movement occurred. The center rose, the ends sank; the center sank, the ends rose. The sun and the moon blazed, glittered, shined. Varied and marvelous apparitions were seen. The divinities of the atmosphere spread upon the Bhagavat divine lotuses of blue and red, as well as powders of *aguru*, sandalwood, *tagara*, *tamāla* leaves, and divine flowers of *mandārava*. They made their celestial instruments resound and made a rain of robes fall."

It was only then that the Buddha made his way to the building that King Prasenajit had built for him. Several disciples of the Buddha, both monastic and lay, offered to take up the challenge of the six sages, but the Buddha replied that because they had challenged him, he must respond himself.

The Buddha then entered a state of meditation and disappeared, reappearing in the western sky, performing the four postures of walking, standing, sitting, and lying down. Lights of different colors emanated from his body. Water shot out of the upper part of his body and flames shot out from the lower part of his body. He then repeated the same miracle in the other three directions of the sky. Returning to his seat, he said, "This supernatural power, O great king, is common to all the disciples of the Tathāgata."

Next, hundreds of thousands of gods descended from their heavenly abodes, circumambulated the Buddha three times, and bowed down at his feet. Two *nāga* kings created a one-thousand-petal lotus, the size of a chariot's wheel, with leaves of gold and a stem of diamonds. The Buddha then sat in the center of the lotus, entered into meditation, and created doubles of himself, above and around him, rising up into the sky. They appeared in all four postures, producing fire, rain, and lightning, with some asking questions and others answering. They all repeated these two stanzas:

> Begin, go forth [from the house], apply yourself to
> the law of the Buddha; annihilate the army of death,
> as an elephant knocks down a hut of reeds.

He who walks without distraction under the disci-
pline of this law, escaping from birth and the cycle
of the world, will put an end to suffering.

Telling his monks that his doubles were about to disappear, they imme-
diately did. Referring to the six sages, he said, "The insect shines as long as
the sun does not appear; but as soon as the sun has risen, the insect is con-
founded by its rays and shines no more."

King Prasenajit then invited the six sages to perform their miracles, but
they got up and ran away. The Buddha then gave a discourse. "In the end,
this entire gathering was absorbed in the Buddha, plunged into the dharma,
drawn into the saṃgha."[41]

THE COMMENTARY

Readers familiar with the portrayal of the Buddha as a rationalist philoso-
pher, an austere and ethical teacher of nonviolence, will likely be confused
by the extravagant miracles that took place at Śrāvastī. This particular por-
trait of the Buddha is of recent provenance, deriving from the nineteenth
century, and largely from Europe rather than Asia. Still, there is good rea-
son to be confused, since the Buddhist attitude toward what might be called
miracles and magic is not straightforward.

In the Buddhist monastic code, four offenses carry the penalty of ex-
pulsion from the order: killing a human, stealing, engaging in sexual in-
tercourse, and lying. This fourth offense differs from the other three in a
number of ways, most obviously because the first three entail a physical act,
whereas lying is merely verbal. Lying, at least on some level, is also much
more common in daily life, suggesting that the vow against it would be
much more difficult to maintain. However, in the context of the monastic
code, lying receives a special qualification: it applies only to lying about
spiritual attainments, or, in the words of the code, about having superhu-
man powers. Such powers in this context include deep meditative states,
the ability to remember past lives, clairvoyance, and clairaudience, as well
as more vulgar displays of power such as creating doubles of oneself, walk-
ing through walls, walking on water, and levitating.

As is the case for all legal codes, rules are not made to prevent things that
are not done. The rule against claiming superhuman powers therefore sug-
gests that in the early Buddhist community, there were those who claimed
those powers without having them and that such claims were considered

sufficiently serious to warrant counting them as one of the four violations of the monastic code that entailed expulsion, among some two hundred fifty other violations.

One of the many fascinating elements of the Buddhist monastic code is that, according to the tradition, it was not imposed on the monastic community as a complete set of rules. The Buddha's first disciples quickly achieved one of the four levels of enlightenment and so were naturally ethical, such that no rules were required. It was only when the community began to grow that a code of conduct became necessary. Even then, however, the Buddha only made a rule after what he perceived as a transgression. That is, the law was not made until after a particular act was designated as a crime. In fairness to the transgressor, the Buddha did not expel him from the order, because there had been no rule at the time of the deed. The monastic code, at least as it is described by the tradition, thus developed organically, and each of the scores of rules has a story about the deed that led to its making. The first rule was the prohibition against sexual intercourse, instituted after a monk who had been a married man returned to his wife to provide his family with an heir.

In the vinaya, to falsely claim to have superhuman powers is cause for expulsion. Yet a rule against falsely claiming to possess superhuman powers suggests that such powers exist. And so, in the monastic code, there is also a rule against displaying superhuman powers without a good reason; violation of this rule is considered a lesser offense. Here is the story of how the Buddha made this rule.

Piṇḍola is said to have become a monk out of gluttony, having seen the generous offerings of food that Buddhist monks received in their begging bowls. After becoming a monk, he was known for carrying a particularly large bowl. Yet he persevered in his practice and became an arhat. In the city of Rājagṛha, a wealthy merchant took an alms bowl made of sandalwood (and thus very valuable) and placed it on top of a long pole, promising to give it to any of the many ascetics of the day who could retrieve it using their magical powers. A group of non-Buddhist ascetics tried—indeed, the same group of six whom the Buddha would later defeat at Śrāvastī—and failed. Egged on by another monk, Piṇḍola used his powers of levitation to take the bowl and then flew around the city three times. When the Buddha heard of this miracle, he chastised Piṇḍola for using his powers for something as mundane as a begging bowl and ordered the bowl to be ground into sandalwood paste. He furthermore forbade Piṇḍola from entering nirvāṇa until the advent of the future buddha. Piṇḍola therefore became one of the sixteen arhats who came to be revered in East Asia (see chapter 6).

Thus, a monk cannot claim to have superhuman powers that he does not possess, and a monk who possesses those powers cannot display them for crass purposes. And yet the Buddha displays the same powers, and more—levitating, creating doubles of himself, shooting fire and water from his body—to defeat the same group of six antagonists. This is obviously not a violation, because these superhuman powers were displayed by the Buddha, but also because his reasons for doing so were not crass. His miracle converted many to the cause of the dharma and maintained the patronage of kings. Indeed, in the famous compendium of Buddhist doctrine, the *Abhidharmakośa*, by the fourth-century monk Vasubandhu, we find three "methods of conversion" listed: magical powers, knowing the minds of others, and teaching the dharma. Of these, the third is the best. As Vasubandhu explains, "The first two methods are only capable of captivating the mind of another for a short period of time, and they do not produce any important results. But the third method of conversion causes others to produce beneficial results; for by means of this method of conversion, the preacher teaches, in truth, the means to salvation and to well-being."[42]

As we ponder the fate of Buddhism in India in the centuries after the Buddha's death, we know that it relied strongly on both royal and lay support. We also know that the Buddhist community had to compete for support with various Hindu traditions. Buddhist monks were involved in scholastic battles with Hindu philosophers for centuries. Many of the greatest thinkers in the history of Buddhism, figures such as Bhāviveka, Dharmakīrti, and Śāntarakṣita, mounted vigorous textual attacks against Hindu claims for the infallibility and eternity of the Vedas, for the existence of a creator god, and for the sanctity of the caste system. Despite stories of Hindu gurus and their disciples converting en masse to Buddhism when defeated by Buddhist masters, these scholastic exchanges likely meant relatively little for the fortunes of the saṃgha. More important were the miraculous abilities of the Buddha. And thus the story of Śrāvastī has a particular power, as the Buddha takes on all comers. All of the opponents of the Buddha and of Buddhism are thus condensed into six caricatured figures, a group that appears again and again in the stories. They flee in defeat when the Buddha rises into the air, shooting water from the upper half of his body and fire from the lower half, and makes doubles of himself, who then have conversations with each other.

THE ART

The first piece (fig. 16), like the carving of the stūpa discussed in chapter 4, is from the stūpa complex at Bharhut, dating from the second century BCE.

A railing, richly carved on both sides, once encircled the great stūpa at this site. The piece in chapter 4 and the piece here are two sides of a block which, although now split in half, once constituted a complete segment of the railing. The carving here is the side that likely faced toward the stūpa.

As noted in chapter 6, in early Buddhist art, the Buddha was not depicted in human form. Instead, we see an empty throne under a tree from his enlightenment, a wheel for his teaching of the doctrine, a stūpa for his passage into nirvāṇa. In chapter 4, the stūpa likely did not represent the passing of the Buddha but instead showed an actual stūpa being worshipped after the Buddha's death. Here, however, the wheel in the center of the carving seems to represent the living Buddha. The carving has an inscription which, though not entirely legible, suggests that it was donated to the stūpa by a devout Buddhist.

In the story of the miracle of Śrāvastī, Prasenajit, king of Kośala, goes to see the Buddha to inform him of the challenge issued by his opponents. In the scene depicted here, a royal couple goes to visit the Buddha, perhaps at the monastery of Jetavana in Śrāvastī. Like the scene of the Buddha's enlightenment in chapter 6, the stone carving seeks to depict narrative movement. At the center is the wheel of the dharma (*dharmacakra*), standing upright on a flower-strewn throne inside a two-tiered structure; a garland of flowers hangs around its hub. In Buddhist discourse, when the Buddha teaches, he is said to "turn the wheel of the dharma." His first sermon—where he set forth the middle way, the four truths, and the eightfold path—is called "Setting the Wheel of the Dharma in Motion" (*Dhammacakka-ppavattana* in Pāli). The meaning of the wheel is not entirely clear. Scholars believe that it is an adaptation of the magical wheel of the *cakravartin* or "wheel turning" king, a wheel that rolls across the world, conquering the lands it reaches. When Prince Siddhārtha was born, the court astrologers predicted that he would be either a *cakravartin* or a buddha. He became a buddha, but, like the *cakravartin*, he has a wheel, which he turns with his teaching, its movement conveying the truth. Evoking the conquering wheel of the *cakravartin*, the fourth-century scholar Vasubandhu explains that the dharma is a wheel because it tames the untamed and triumphs over the afflictions. It was set in motion when the Buddha first set forth the four truths, transporting enlightenment from his mind to the minds of his disciples.

In the carving, on the right side of the scene, a king arrives in a chariot pulled by two bullocks. He stands to the right inside the chariot, his right hand raised, his head shielded by a parasol. To his left is his charioteer, the reins in his hands. In keeping with the clockwise motion so common in Indian Buddhist art, the left side of the carving seems to represent the end of

the king's procession as it passes through the gates of the monastery. Literally bringing up the rear is the rear end of a horse, its rider's head visible to the far left, having already passed under the gate. Ahead, an elephant in the procession reaches up to grasp a branch of a tree in the monastery's grove, its mahout leaning back; the artist uses the elephant and his raised trunk to suggest both space and depth. Thus, we have to imagine a long procession, led by the king's chariot, that has passed through the gate at the left, first proceeded clockwise around the Buddha (represented by the wheel), and then stopped to allow the king and his queen (imagined in a separate chariot behind his) to dismount and pay homage to the Buddha. That he gives them teachings is suggested by the use of the *dharmacakra*—an allusion to and marker of his teaching mode—as a representation of the Buddha, rather than merely an empty throne or another such symbol. The activity of this scene, therefore, seems to allude to the events at Śrāvastī, in the Jetavana Grove, and the archetypal acts of devotion performed by King Prasenajit.

In the center, two figures—perhaps the king and his queen—stand flanking the wheel, their hands joined in a gesture of reverence. In front of them, two figures kneel in reverence before the throne. As in the case of the couple worshipping the stūpa in chapter 4, it is likely that the two standing figures and the two kneeling figures represent not four but two people, in two different postures in two different moments of time. It is noteworthy that both of the kneeling figures seem not to wear the headdresses of the standing figures, as if they had removed them before kneeling before the Buddha. Indeed, the scene seems to describe a visit by a king described in a Buddhist text:

> As soon as he had laid aside his five insignias of royal power, that is to say the turban, the parasol, the dagger, the flyswatter made from the tail of a yak, and the shoes of various colors, he moved towards the Bhagavat, and having approached him, he saluted his feet by touching them with his head and sat to the side. The Bhagavat, seeing the king seated to the side, started to instruct him with a discourse on the law; he caused him to receive it, he aroused his zeal, he filled him with joy; and after having in more than one way instructed him with discourses on the law, after having caused him to receive it, after having aroused his zeal and overwhelmed him with joy, he remained silent.[43]

Hyecho seems to have visited Śrāvastī; he mentions it as the site of one of the "eight great stūpas" that he saw. The second piece (fig. 17) comes from a very different region, far to the north and west of Śrāvastī, yet a region

that Hyecho also passed through as he made his way back to China. It is a fragment of a wall mural from Kizil, a complex of more than two hundred caves carved into sandstone cliffs along the Muzart River in the kingdom of Kucha, a major center of Buddhist art and Buddhist practice along the Silk Road, located in what is today the Uighur Autonomous Region of Xinjiang Province in China. The painted murals of the Kizil caves are among the great artistic treasures in the Buddhist world, second only to the caves at Dunhuang in magnitude. Chinese sources report the presence of Buddhism there in the mid-fourth century, although Buddhism was likely established at Kizil earlier. The height of Buddhist activity there appears to have been the seventh century, the period when Xuanzang visited. Sometime later, for reasons that are unknown, the caves were abandoned.

There are thirteen cave temple sites in modern Xinjiang Province, including the famous Bezeklik Thousand Buddha caves, with 236 caves at Kizil alone; these caves seemed to have served both as temples and as dwelling places for monks. Those that served as temples tended to be painted, whereas those that were used as residences often were not. Since Hyecho visited Kucha, he presumably visited Kizil; but, as with so many other places he visited, he makes no mention of the most famous Buddhist site of the region. Xuanzang also visited there on his way to India, noting that it was a major center for the Sarvāstivāda, an important school of mainstream (that is, non-Mahāyāna) Buddhism, although birch-bark manuscripts discovered in the region suggest the presence of the Mahāyāna as well, perhaps during an earlier period.

The Kizil caves are magnificent testaments to the international character of Buddhism during Hyecho's time, with murals bringing together influences from India, Persia, and China. Yet Hyecho does not mention them. The historical and art historical importance of the Kizil murals was not lost on a number of latter-day pilgrims, however. Between 1902 and 1914, there were four German expeditions to Kizil, led by Albert Grünwedel (1856–1935) and Albert von Le Coq (1860–1930). They removed large sections of the murals and transported them to Europe. Many of the largest sections, kept in the Museum of Ethnology in Berlin, were destroyed in Allied bombing raids during the Second World War. The fragment here has been identified as coming from the fourth and final expedition, led by Le Coq; it was subsequently acquired by John Gellatly and donated to the Smithsonian.

One of the most spectacular caves at Kizil must have been Cave 224. It faces southeast and is entered through a rectangular antechamber. The barrel-vaulted main room features a large central pillar that divides it from the similarly vaulted rear chamber. On the basis of radiocarbon dating and

the analysis of various stylistic elements, scholars have dated the murals in Cave 224 to late sixth or early seventh century.

By examining the fragments remaining in situ and those held in various museums, it has been ascertained that the iconographic program of the cave's painted walls portrayed a number of powerful scenes, including the cremation of the Buddha and the distribution of his relics, the compilation of the canon, and the story of the famous parricide, Ajātaśatru. There are also scenes depicting the future buddha, Maitreya.

The sidewalls of the main chamber had two tiers showing the Buddha preaching to his assemblies, with four in each tier; thus there were sixteen scenes. The fragment here shows parts of two adjacent scenes: the left side would have been to the right of the Buddha in scene seven, and the right side would have been to left of the Buddha in scene eight, both on the lower register of the west wall of the cave. The fragment, pigment and plaster on gypsum, is about thirty-three inches high and thirty inches wide. On the left, a scantily clad woman dances; her thighs are missing, but her crossed legs can be seen below. She may be Śrīmatī (Sirimā in Pāli), a wealthy courtesan and patron of the Buddha. After her death, the Buddha displayed her corpse to a young monk who had fallen in love with her, as a lesson in impermanence and suffering. Śrīmatī would not be dancing in the presence of the Buddha. If this is indeed her, it suggests an unusual element in the murals, with the figures that the Buddha is describing coming to life in the scene around him. Next to the dancing figure is a woman holding a blue bowl. On the right, a bearded monk, dressed in a patchwork robe, stands holding a monk's staff. His beard and protruding ribs suggest that he may be an ascetic. That same monk appears at the far right, now kneeling in homage to the Buddha. The heads of other monks and deities are also visible. The cool palette of the painting, with many blues and greens, suggests possible Persian influence.

These fragments of the assemblies or audiences that surround the Buddha preaching in two separate scenes indicate that there were apparently narrative elements in the sermon scenes—we are accustomed to narrative depictions being reserved primarily for events in the life and past lives of the Buddha, but here it seems that the narrative is unfolding around the Buddha as he teaches.[44]

Discourses of the Buddha begin with a set formula. They begin with the words, "Thus did I hear." This statement is attributed to the Buddha's cousin and attendant Ānanda, who is reporting to the assembled monks at what is called the First Council, when five hundred arhats gathered shortly after the Buddha's death to memorize what the Teacher had taught. Next, Ānanda

reports the time and place. In many cases, that statement is, "At one time, the Bhagavan was staying in Śrāvastī, in Anāthapiṇḍada's Park in Jeta's Grove." Next, Ānanda reports who was in the audience, often telling how many people were there and listing by name prominent figures, such as the Buddha's most famous disciples. When Hyecho heard those sūtras or saw them depicted in carvings and paintings, he would have recalled their site.

In the murals at Kizil, there are many depictions of the Buddha preaching and representations of the content of his discourses, many of which took place at Śrāvastī. This major site of teachings and of miracles in Central India is projected on the walls of these in caves in Central Asia. Thus, although Śrāvastī is far away, it forms the implicit backdrop.

As the explicit location of so many important sermons and of the most famous miracles from the life of the Buddha, Śrāvastī is essential to the sacred geography of Buddhism. As a place of pilgrimage in India, it serves as a place to remember those teachings and those marvels and to pay homage to the Buddha who made them. But Śrāvastī is also replicated in sound whenever the opening lines of a sūtra mention it as its site. It is replicated in form whenever the miracle is portrayed in painting or stone. Thus, this sacred city multiplies and spreads throughout the Buddhist world. Without a specific iconography, Śrāvastī is instead implicit and can therefore take many forms: it is the shrine in the Bharhut relief; it is the sky where the Buddha's multiple forms appear; it is the empty space behind the sermon scenes in the Kizil murals.

Thus, after Hyecho went to Śrāvastī, he would encounter it again and again throughout his journey, as he made his way home, passing through Kucha, en route to Dunhuang, Chang'an, and finally, years later, to Wutaishan. While he was a rare pilgrim who had actually visited Śrāvastī, we can imagine that these vivid murals in dark caves would have transported him, as in a dream, back to Śrāvastī, a journey through time and space to the presence of the Buddha.

FURTHER READING

Vidya Dehejia, *Discourse in Early Buddhist Art: Visual Narratives of India* (New Delhi: Munshiram Manoharlal, 1997).

Miki Morita, "The Kizil Paintings in the Metropolitan Museum," *Metropolitan Museum Journal* 50, no. 1 (2015): 114–135.

Giuseppe Vignato, "Archaeological Survey of Kizil: Its Groups of Caves, Districts, Chronology and Buddhist Schools," *East and West* 56, no. 4 (December 2006): 359–416.

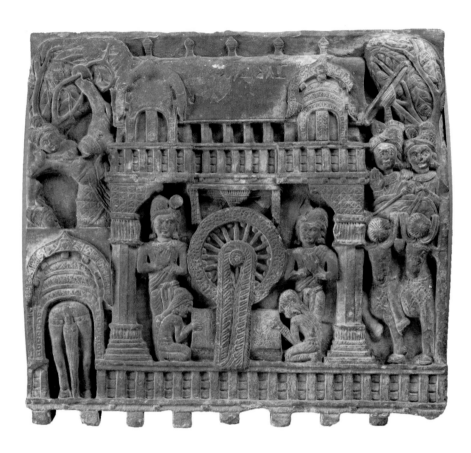

FIGURE 16

Worship of the Dharma Wheel, Bharhut, Madhya Pradesh, India (second century BCE). Sandstone, 18 7/8 × 20 13/16 × 3 1/2 in. Purchase—Charles Lang Freer Endowment, Freer Gallery of Art (F1932.25).

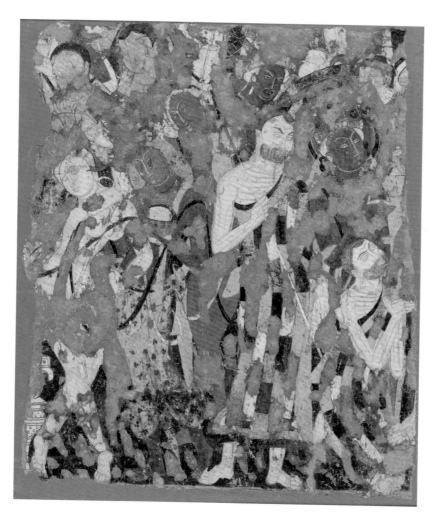

FIGURE 17

A Mural Fragment from the Kizil Caves (Cave 224), Ku-
cha, Xinjiang Province, China (late sixth to early seventh
century). Stucco with pigment, 33 ½ × 30 in. Long-term loan
from the American Art Museum, Smithsonian Institution,
Washington, DC; Gift of John Gellatly (LTS1985.1.325.5).

SĀṂKĀŚYA

The Buddha Descends
from Heaven

"The fourth stūpa, a triple-flight jeweled staircase, is a full seven-day trip to the west from the city where the central Indian king lives. It is located between two branches of the Ganges River. Here is where the Buddha descended from the Heaven of the Thirty-three Gods on the triple-flight staircase he made and set foot on Jambudvīpa. The left flight of the jeweled staircase is gold and the right is silver, with the center made of crystal glass. The center is where the Buddha descended, attended by Brahmā on his left and the Lord of Heaven (Śakra) on his right, and it is on this site that this stūpa was built. I also saw a temple."[45]

From Kānyakubja, today called Kannauj in the Indian state of Uttar Pradesh, Hyecho traveled for seven days to Sāṃkāśya, the site of one of the most dramatic scenes in the life of the Buddha, called "the descent of the deities."

THE STORY

The Buddha's mother, Queen Māyā, had died seven days after his birth. According to some accounts, she died of joy at having given birth to such a wondrous child; according to another account, she died because she would have died of a broken heart when her son renounced the world and left the palace twenty-nine years hence; according to yet other another account, she died because the womb that had held the bodhisattva could never be occupied by another being. For her great virtue in giving birth to the future buddha, she was reborn as a god in Tuṣita ("Joyous"), the same heaven from which her son had descended into her womb.

In the seventh year after his enlightenment, the Buddha decided that his mother deserved to benefit from his teaching and thus set out to find her. During the rains retreat when the monks were not permitted to wander, he ascended to the summit of Mount Sumeru, the great peak at the center of the world. Its four faces are entirely flat, each made of a different precious stone, polished to perfection: the north face is made of gold; the east face is made of silver; the south face is made of lapis; the west face is made of crystal. The light of the sun, reflecting off the four faces, makes the sky a different color in each of the cardinal directions. Because we live to the south of the great mountain, our sky is blue. Mount Sumeru is flat on top, its summit the site of the Heaven of the Thirty-Three, which is inhabited by thirty-three gods and their retinues, ruled by their king, the god Indra (known also as Śakra in Buddhism).

Each day the Buddha, using his magical powers, would fly to the Heaven of the Thirty-Three, where he would meet his mother—now a male god—who had descended from the Tuṣita heaven to receive his teachings. To his mother and the gods of the Heaven of the Thirty-Three, the Buddha did

not set forth the two famous components of his teaching: the dharma or doctrine and the vinaya or discipline. He taught something that he had not taught before, the *abhidharma*, a word difficult to translate that might be rendered as "higher dharma," the most technical teachings in what would become the Buddhist canon.

The Buddha was superior to the gods; one of his epithets is *devātideva*, "the god of the gods." Yet he was also a monk and bound by the monastic code that he himself set forth. He therefore had to return to earth each day to beg for alms. Because it was not proper that he bestow his higher teaching upon the gods and not on humans, as he was eating his noontime meal each day, Śāriputra, the wisest of his monks, would meet him, and the Buddha would repeat what he had taught on the summit of Mount Sumeru. This continued each day over the ninety days of the rains retreat.

Finally, when the teachings had concluded and the rains retreat had come to an end, it was time for the Buddha to return to the world of humans. To celebrate this auspicious moment, the two most powerful of the gods—Śakra, king of the Heaven of the Thirty-Three, and Brahmā, king of the Brahmaloka, the "world of Brahmā," located in the sky above Mount Sumeru—constructed a wondrous staircase, indeed three staircases: the one on the right was made of silver, the one in the center was made of seven jewels, and the one on the left was made of gold. Together, the two gods and the god of the gods descended: Brahmā down the stairs of silver, Śakra down the stairs of gold, the Buddha down the jeweled staircase. The place where this divine staircase touched the earth, the place where the gods descended to the world of men, was Sāṃkāśya.

Upon the Buddha's final return to earth, the divine staircase sank into the ground, leaving only seven steps standing. When the emperor Aśoka visited Sāṃkāśya several centuries later, he had his men dig deep into the earth to reveal the staircase. Yet, no matter how deep they dug, they could not reach the bottom. The emperor had a temple erected over the seven steps and had an image of the Buddha, fifty cubits tall, placed upon it.

And so Sāṃkāśya became a place of pilgrimage, indeed one of the "eight great sites," so famous that it became known by another name, *devāvatāra*, "descent of the deities." It had been visited by both Faxian and Xuanzang; Hyecho likely knew their accounts.

THE COMMENTARY

The story of the Buddha's sojourn in the Heaven of the Thirty-Three atop Mount Sumeru is made to serve several purposes. The first and most ob-

vious is that it allowed the Buddha to perform his filial duty. It would not seem right for the future Buddha to survey the world from Tuṣita, choose Queen Māyā among all the women of the earth to be his mother, and then have her death, seven days after his birth, deny her the benefit of his bud- dhahood. She departs for the very heaven from which her son had descend- ed ten lunar months before. And so, seven years after his enlightenment, he ascends to the summit of the world to teach her the dharma.

The dharma that he teaches her is the *abhidharma*, variously translat- ed as "higher dharma" and "pertaining to the dharma," the third category or "basket" of the Buddhist canon, called the *tripiṭaka*. Its three categories are the sūtras, or discourses of the Buddha; the vinaya or "discipline," the corpus on monastic conduct; and the *abhidharma*, consisting of works that might be termed "philosophy," analyzing the various constituents of both the external world and the functions of consciousness. However, there is no historical evidence that the Buddha taught the *abhidharma*. It seems to have evolved after his death, as the Buddha's followers sought to system- atize into a coherent body the many doctrines that the Buddha had taught over the forty-five years of their dispensation. And yet, if the *abhidharma* is to be counted as part of the *tripiṭaka*, it must be the word of the Bud- dha. This dilemma is solved by our story. There is no textual evidence of the Buddha teaching the *abhidharma* because he did not teach it on earth; he taught it in heaven. During the rainy season, when he was teaching the gods of the Heaven of the Thirty-Three, he only gave a summary of it to his wisest disciple, Śāriputra, when he descended each day to beg for his daily meal. It was Śāriputra, and the lineage of scholar-monks who were his disciples, who maintained the *abhidharma*. The story of the Buddha's visit to heaven serves yet another important purpose, which became particularly import- ant in East Asia. The story includes a subplot, one that Hyecho would have certainly known.

There is no historical evidence of images of the Buddha being made until centuries after his death; the archaeological record contains no figural im- ages that can be dated before the first century BCE, some three centuries after his death. Indeed, the origin of the Buddha image has been a topic of much debate among art historians for more than a century, continuing to the present day (see chapter 6). Yet, both authenticity and sanctity in Bud- dhism derive largely from lineage, from the ability—either through history or through myth—to trace origins back to the Buddha himself. This lineage is a line of sensory contact: from seeing the Buddha face to face, to hearing his words, to touching his relics or the reliquary that contains them. And so there are many stories about images of the Buddha being made during his

lifetime, tales of the Buddha posing for some of the most famous images in the Buddhist world, including the Mahāmuni statue in Myanmar and the statue of the Buddha in the Jokhang in Lhasa. There are stories of the Buddha posing for portraits, the artists drawing his reflection, because when they looked at him directly, they were blinded by his radiance.

A story that first appears in a Chinese translation from the late fourth century CE and is elaborated in later Chinese works explains the origin of what claims to be the first Buddha image. The king of Kauśāmbī, named Udayana, was a devout follower of the Buddha, so devoted that he was unable to bear the Buddha's absence during the rainy season that he spent atop Mount Sumeru. The king therefore approached the monk Maudgalyāyana, the close friend of Śāriputra. Just as Śāriputra surpassed all monks in wisdom, Maudgalyāyana surpassed all monks in magical powers. The king asked him to magically transport a five-foot piece of *gośīrṣa* (a particularly fragrant and valuable type of sandalwood) and thirty-two artists to the Heaven of the Thirty-Three. The artists were to carve a statue of the Buddha, with each one responsible for depicting one of the thirty-two marks of a superman (*mahāpuruṣa*) that adorned the Buddha's body. The completed statue was then returned to earth and presented to King Udayana. The statue, apparently of the Buddha in a seated posture, was present at the foot of the heavenly staircase when the Buddha made his return at Sāṃkāśya. The statue stood up when the Buddha descended and so became a standing image. According to Xuanzang's account, the Buddha asked the statue, "Are you tired from teaching the people? You are what we hope will enlighten the people at the last period of the Buddha-dharma." According to another account, the Buddha patted the statue on the head and predicted that one thousand years after the Buddha passed into nirvāṇa, the statue would be in China, bringing benefit to gods and humans.

In the account of his travels in India, Xuanzang reports seeing the statue. It is noteworthy that Faxian does not, which suggests that the statue may have been made sometime between Faxian's departure in 412 and Xuanzang's arrival in 630. Xuanzang saw what has come to be called the Udayana Buddha at a temple in Kauśāmbī, and reported, "It often shows spiritual signs and emits a divine light from time to time."[46] He said that many kings had tried to transport it to their own countries but had been unable to do so. In addition, Xuanzang reported that he saw a twenty-foot sandalwood statue of the Buddha in the Central Asian oasis kingdom of Khotan. The people told him that it was the original statue commissioned by King Udayana and that the statue had flown there from India.[47] There are many stories of the statue, or copies of the statue, being brought to China, including by the

great translator Kumārajīva. As a Korean monk trained in China and a successor of the great pilgrims, Hyecho would have undoubtedly known these stories of the Udayana Buddha.

The Japanese pilgrim Chōnen (938–1016), during his travels in China, saw a replica of the allegedly original Indian statue in Kaifeng. He hired the artisans to make an exact copy of this replica, which he then took to Japan in 986. In later versions of the story, not only was the replica in fact the original Indian statue, but after Chōnen's copy was made, the copy and the original magically changed places, so that the original Udayana Buddha image was not in India or China, but in Japan. That statue is today enshrined in the monastery of Seiryōji and so is known as the Seiryōji Buddha.

The story suggests a number of key elements of the Buddhist world. The first, and most obvious, is the importance of the image of the Buddha. Second, however, is the need for the image to have a direct relation to the Buddha himself. In this case, the Buddha posed for his statue during his sojourn on Mount Sumeru. In addition, it is important that an authentic image of the Buddha be transported to each of the lands to which Buddhism spreads. We often speak of the "spread of Buddhism," when in fact we are referring instead to individual monks traveling great distances. They tended to carry two things: texts and images, the words of the Buddha and the body of the Buddha. This has crucial implications for pilgrimage; instead of going to the Buddha, the Buddha comes to you, enshrined in a temple in your own land; the distant Buddha has come home.

THE ART

The first piece (fig. 18) is a standing Buddha, a remarkable work, even though its head is missing. It dates from the Gupta Dynasty (320–485 CE), a golden age for Buddhist art in India. The wealth of Mathurā, a major trade nexus at the crossroads of north-south and east-west merchant routes, made it a center for Buddhist patronage and art production. This sculpture is made from the fine sandstone native to that region that contributed to its reputation as an arts center. It is fifty-three inches tall, suggesting that the full statue was life-sized.

Particularly notable is the elegant draping of the robe; indeed the artist accurately portrayed the garb of a Buddhist monk, who wears a lower robe, tied by a belt, covered by a full outer robe; the belt and the lower robe are visible here. The Buddha holds the hem of his robe in his proper left hand; his right hand is raised, likely in the gesture of bestowing protection. Flanking the Buddha's feet, one can see the legs of two figures, kneeling in a posture of obeisance.

This piece exhibits the weaving together of stylistic antecedents with local innovation that is characteristic of the artistic production of Mathurā during the Gupta period. Although Gupta artists sought to abandon the dominant traditions of their Kushan predecessors, the persistent impact of works from Gandhāra (see chapter 10), with their graceful lines, as well as earlier works from the region of Mathurā, is evident in the development of a distinctive Gupta style. Thus, the image has both shoulders covered, typical of Gandhāra, and gives particular attention to the ample quality of the Buddha's body, typical of Mathurā. A break with the arts of the past and a turn toward a new artistic identity, however, is apparent in the elongation of the bodily proportions and the refinement of the symmetrical folds of the outer robe, rendered as cascading strings.

One can imagine the head of this sculpture encircled by a halo delicately carved with rays of light or large lotus petals surrounded by a band of densely swirling foliage and vegetative forms. The face would have had balanced and symmetrical features anchored by large, heavy-lidded eyes gazing downward in an introverted expression. Above them, arched eyebrows would have echoed the shape of a crescent moon, one of the eighty secondary marks of a superman (*mahāpuruṣa*) possessed by the Buddha. The prescribed conch-like neck, moreover, is translated as three concentric folds of skin. These attributes, named in Buddhist scriptures and listed in Indian iconographic texts, were interpreted by artists of previous generations, but in the Gupta period they came to be employed more systematically, to infuse the image with the potent presence of the figure depicted. While this Buddha's body is undoubtedly idealized—more superhuman than human—the slight bend in his right knee nonetheless grants the sculpture a sense of naturalism. It is as if he is about to begin walking, auspicious right foot first.[48]

As Indian missionaries and pilgrims from across Asia carried sculptures from Mathurā to the many corners of the Buddhist world, the artistic ideas and innovations of Gupta artists circulated with them. There thus emerged an international style, appearing in the artistic traditions of Sri Lanka, Thailand, Tibet, Nepal, and China. Each culture adopted the Gupta ideal in its own way, developing distinctive styles inspired by Mathuran principles. Hyecho therefore would have seen Gupta art in India and its ripple of sculptural effects throughout his travels. This pervasive presence of Gupta images and ideas throughout Asia, coupled with their well-known Indian origins, is perhaps the source of the identification of the Gupta-style standing Buddha, like this one, with the Udayana Buddha image, particularly in China. That is where the Udayana story first appears in the Buddhist canon, where the

original sandalwood sculpture was said to reside, and where the Udayana-type image was best known and most replicated.

The second work (fig. 19) is a Tibetan painting depicting the Buddha's descent from the Heaven of the Thirty-Three. This is a Tibetan scroll painting or *thangka*, painted on a canvas and then mounted in silk brocade. A panel sewn into the brocade below the painting serves as the "door" to the painting, allowing the viewer to enter the sacred scene. Dowels were placed at the top and the bottom so that the painting could be rolled up for travel or storage. Before doing so, the surface of the painting would have been protected by a silk cover, which is gathered at the top of the *thangka* when it is displayed. This painting from central Tibet dates from the late eighteenth or early nineteenth century and is likely one of a set depicting scenes from the life of the Buddha. It is quite large; including the brocade mounting, it is fifty-nine inches high and thirty-four inches wide; the painting itself is twenty-six inches high and seventeen and a half inches wide.

This painting is based on a woodblock print from the famous printing house in the eastern Tibetan town of Derge. Known primarily for the production of printed scriptures, this printing house also made woodcuts to be printed on canvas, painted with pigments, and mounted as *thangkas*. Within the canon of Tibetan art, there are several famous sets of paintings that are based on the compositions created, cut, and printed at Derge. One such series depicts the eight major events in the life of the Buddha, and it is to this set that this painting belongs. While all the paintings based on these woodcuts are stylistically connected, they vary based on the choices made by the artist who filled in the lines with pigments and patterns.

Like many other Tibetan paintings of the life of the Buddha, this one utilizes continuous narrative, depicting the Buddha multiple times to illustrate at least three moments in the story. In the upper right corner, the Buddha sits atop Mount Sumeru, the base of which extends down on the right side. In Buddhist cosmology, Mount Sumeru has four flat faces, each of which has tiers inhabited by various demigods and gods, whose palaces can be seen. As noted above, each face of Mount Sumeru is composed a different gemstone: gold, silver, crystal, and lapis lazuli. The side facing our continent is made of lapis. When the sun (the gold disk visible in front of the third tier of the mountain) shines on the lapis slope of Mount Sumeru, a blue light fills the sky; hence our sky is blue. The blue south face of Mount Sumeru is depicted in the painting.

The central mountain is said to be surrounded by seven mountain ranges, each separated from the others by an ocean. These are also visible. The sun and the moon orbit Mount Sumeru. Beneath the staircase, there is a

rabbit in a circle. This is the moon; in Indian mythology there is a rabbit (rather than a man) on the moon. On the flat summit of Mount Sumeru, the Buddha sits teaching the *abhidharma*; the deity to his immediate right is likely his mother. A monk flies through the skies nearby, probably Maudgalyāyana, known for his superhuman powers, who transported the block of sandalwood for the artists to carve.

In the bottom right corner, the Buddha receives a begging bowl of food while teaching a monk. This is likely Śāriputra. According to the story, during the rainy season that he spent on Mount Sumeru, the Buddha would descend each day to beg for his meal and would repeat to Śāriputra what he had taught to the gods. He sits at the base of a stūpa depicting Uṣṇīṣavijayā, a goddess connected to the cranial protuberance, sometimes called the "crown protrusion" (*uṣṇīṣa*) on the top of the Buddha's head. The cranial protuberance is one of the thirty-two major marks of a superman and the subject of much commentary in Buddhist literature. Uṣṇīṣavijayā plays a prominent role in the story in chapter 12. Here, evoking the shape of the Buddha's crown protrusion, she is depicted within the dome of a stūpa and is associated with the wisdom of the Buddha and, by extension, all buddhas. In Tibet, she comes to be worshipped as a long-life deity, together with the bodhisattva Tārā and the buddha of infinite life, Amitāyus, whose long-life vase Uṣṇīṣavijayā holds in her lap and whose image she holds in her upper right hand. Her place within this painting at the site of the Buddha's teaching to Śāriputra, therefore, seems to suggest or promise the longevity of the *abhidharma*, a teaching born of the Buddha's wisdom, as well as the somewhat more prosaic longevity of the patron of the painting.

The central scene is the Buddha's triumphal descent down the tripartite stairway. He is about to reach earth, his feet visible beneath his robes, which are the patchwork robes of a monk. His left hand makes the gesture of teaching, and his right hand is in the gesture of giving. The two gods who made the stairway stand to either side. The four-faced Brahmā (his back face is not visible) to his right and Indra, bearing an elaborate parasol, to his left, are each accompanied by an attendant. Two monks stand at his feet, likely Śāriputra and Maudgalyāyana; the white-faced figure behind them may be the nun Utpalavarṇā, who vowed to be the first person to greet the Buddha upon his return to earth. In the sky above, gods send down a rainbow and rain down flowers and various auspicious objects in celebration of this miraculous event.

At the base of the stairway, five goddesses make offerings to the Buddha. Representing the objects of the five senses, they offer pleasing things to see, hear, smell, taste, and touch. In the lower left, the king (either Prasenajit

or Udayana, depending on the story) arrives to greet the Buddha. Having dismounted from his white royal elephant, he bears the golden wheel of the *cakravartin*, the triumphant monarch. One can imagine Hyecho visiting the very spot where the Buddha stepped off the triple ladder, making an offering to a somewhat more modest version of the spectacular staircase.

FURTHER READING

Eva Allinger, "The Descent of the Buddha from the Heaven of the Trāyastriṃśa Gods—One of the Eight Great Events in the Life of the Buddha," in *From Turfan to Ajanta: Festschrift for Dieter Schlingloff on the Occasion of his Eightieth Birthday*, vol. 1, edited by Eli Franco and Monika Zin (Lumbini, Nepal: Lumbini International Research Institute, 2010), pp. 3–13.

John S. Strong, "The Triple Ladder at Sāṃkāśya: Traditions about the Buddha's Descent from Trāyastriṃśa Heaven," in *From Turfan to Ajanta: Festschrift for Dieter Schlingloff on the Occasion of his Eightieth Birthday*, vol. 2, edited by Eli Franco and Monika Zin (Lumbini, Nepal: Lumbini International Research Institute, 2010), pp. 967–978.

Joanna Gottfried Williams, *The Art of Gupta India: Empire and Province* (Princeton, NJ: Princeton University Press, 1982).

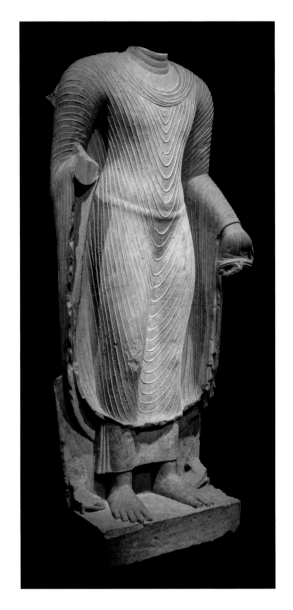

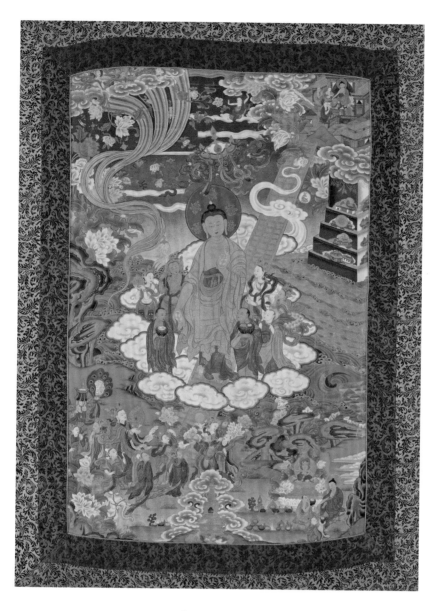

FIGURE 19

The Buddha Descends from Heaven, Central Tibet (late eighteenth to mid-nineteenth century). Mineral pigments and gold foil on sized cotton, 26 × 17 ½ in. The Alice S. Kandell Collection, Arthur M. Sackler Gallery (S2013.30).

· TEN ·

GANDHĀRA

Past Lives of the Buddha

. . .

Traveling northwest for a month from Kashmir, Hyecho arrived in Gandhāra, long a great center of Buddhist learning (as described in the introduction). He provides a lengthy description, primarily of the region and its people. However, at the end of his account he mentions, almost in passing, "To the southeast of the city some *li* is the place where in his past life as King Śibi, the Buddha saved a pigeon. There are monasteries and monks here now. In the mountains to the southeast of the city are the sites where the Buddha offered his eyes, his head, and allowed five *yakṣas* to eat his body. Each place has monasteries and monks and offerings are given to this day. Both Mahāyāna and Hīnayāna are practiced here."[49] He assumed, correctly, that his readers would know the stories. Here is the story of how the Buddha gave away his head.

THE STORY

In response to a question from his monks, the Buddha told the story of a king named Candraprabha.

Long ago, when the human lifespan was forty-four thousand years, in the Northern Country there was a city called Bhadraśilā, a huge city twelve leagues long and twelve leagues wide, inhabited by seventy-two billion people. Fragrant breezes, carrying the scent of aloe, sandalwood, and fragrant flowers, wafted through the streets. It had lotus ponds with clear cold water and gardens filled with exotic birds. The city was ruled by a wise and pious king named Candraprabha ("Moonlight"). As he walked through the streets of the city at night, he needed neither lamps nor torches, for his body glowed like the moon. He ruled with benevolence and generosity, levying no taxes. Outside the four gates of the city, his soldiers would beat kettledrums to summon the people, distributing food, drink, medicine, lamps, chariots, cattle, and clothing of the finest cloth to all. Soon, all of the inhabitants of the city and of all of the sixty-eight thousand cities of Jambudvīpa were so wealthy that no one traveled by foot, instead riding on elephants or driving chariots plated with silver and gold, drawn by four horses. But even this was not enough. The king declared, "May all you good people of Jambudvīpa entertain yourselves with the amusements of kings for as long as I live," and he gave away all manner of crowns, jewels, and royal raiment, so that soon all of the people of Jambudvīpa were dressed like the king, and the air was filled with all manner of music. King Candraprabha was beloved by all; his twelve thousand five hundred ministers constantly exhorted the people to practice the ten virtuous deeds.

One night, one of the king's two chief ministers had a dream that demons, the color of smoke, stole the king's crown. When he awoke, he feared

that a beggar might request the king's head. So generous was King Candraprabha that he might agree. Instead of telling the king about his dream, he had a jeweler make many heads out of jewels and placed them in the treasury. Anyone who requested the king's head would surely prefer a head of jewels. The other chief minister dreamed that the king's boat, made of many jewels, was destroyed. He summoned a soothsayer to interpret the dream. He said that soon someone would come to the city and request the head of the king. The minister thought, "King Candraprabha is benevolent in nature, compassionate, and affectionate toward living beings, yet now, he is suddenly threatened by the power of impermanence." When told of the dreams, the king dismissed them as illusions.

In the mountains there lived an evil brahmin sorcerer named Raudrarakṣa, who heard of the king's generosity and decided to test it, seeing whether he was willing to give away the most important part of his body, his head. Knowing his intention, the local deities became alarmed, the sky turned dark, and meteors streaked through the heavens. The sound of drums that usually resounded through the city ceased. Strong winds uprooted fruit trees. The people were terrified.

When the goddess who protected the city saw Raudrarakṣa approaching the gates, she raced to the king, warning him to defend himself. But the king, who by now had heard that Raudrarakṣa would request his head, instructed his chief minister to escort him into his presence. However, instead of doing so, the minister instructed the treasurer to pile the jeweled heads in front of the king's door and offer them to Raudrarakṣa. They asked him, "What do you want with the lord's head, full of marrow, mucus, and fat?" The brahmin said he was not interested in jeweled heads.

He was taken before the throne and said, "Bestow your head on me, with great compassion foremost in your mind. Give it to me. Satisfy me today." The king did not hesitate in his reply, "Even though it is as dear to me as an only son, take this head of mine. May your intentions bear fruit. And by the gift of my head, may I quickly attain enlightenment." The king removed his crown and prepared for his decapitation. At that moment, the crowns that adorned the heads of all the people of Bhadraśilā fell to the ground. The king's two chief ministers, unable to bear the sight, grasped the legs of the king, died, and were reborn in heaven. By this time, thousands of citizens had gathered at the doors of the palace. Not wishing to behead the king in their presence, Raudrarakṣa asked the king to take him to a private garden. The king did so, after encouraging the people to practice good deeds.

With the gates of the garden closed behind them, the king instructed the brahmin to cut off his head. But the brahmin could not bring himself to

do it and asked the king to do it himself. As he raised the knife, the goddess of the garden rushed forward, begging him to stop. The king explained to her that in this very garden he had given away his head thousands of times in past lives. It would be wrong for the goddess to try to stop him.

The king said, "I give up my own head not for the sake of kingship, not for the sake of heaven, not for the sake of wealth, not to become Śakra, not to become Brahmā, not for the victory of a universal emperor, and not for anything else. But having attained complete and perfect awakening, I will tame beings who are wild, pacify beings who are violent, rescue beings who are in danger, liberate beings who are not liberated, comfort beings who are troubled, and bring to nirvāṇa beings who have not attained nirvāṇa. By these words of truth, may this exertion bear fruit. And when I have attained nirvāṇa, may there be relics the size of fruit from the mustard tree. And in the middle of this Maṇiratnagarbha pleasure-park, may there be a great stūpa, more excellent than any other stūpa. And may those beings who go with pure bodies to the great holy site, wishing to worship it, feel at ease when they see that stūpa, full of relics and more excellent than any other stūpa. And when I have attained nirvāṇa, may crowds of people come to my holy sites, perform acts of worship, and be destined for heaven or liberation." He then cut off his head, handed it to the brahmin, and died, being reborn as a god in a heaven called Śubhakṛtsna, "Pervasive Purity." The earth quaked, flower blossoms fell from the sky, and heavenly music was heard. Raudra-rakṣa emerged from the garden, holding the king's head. Some people wept, but others sat down to meditate, dying on the spot and being reborn in various heavens.

The body of the king was burned on a pyre of fragrant wood, his relics gathered into a golden urn and interred in a stūpa built at the crossroads. Those who built the stūpa were reborn as gods in heaven. Those who worshipped the stūpa were inspired to seek rebirth in heaven or liberation from saṃsāra.

After telling the story, the Buddha explained that the ancient city of Bhadraśilā is now called Takṣaśilā. The Buddha himself had been King Candraprabha. His two chief ministers had been his chief disciples, Śāriputra and Maudgalyāyana. His evil cousin Devadatta had been Raudrarakṣa.[50]

COMMENTARY

This story is part of the large collection called the *jātaka* (literally "birth"), the tales of the Buddha's former lives. This is one of the most beloved, and important, genres of Buddhist literature.

According to Buddhist doctrine, the path to the Buddha's enlightenment did not begin when Prince Siddhārtha left the palace at age twenty-nine, achieving buddhahood under the Bodhi Tree six years later. The path began billions of years before. According to Buddhist doctrine, whether of the mainstream or of the Mahāyāna, the path to buddhahood is long. It begins when someone makes a vow to become a buddha. From the time that vow is made (and there are specific stipulations regarding how and by whom the vow is made), that person becomes a bodhisattva, a term of uncertain origin and literal translation but which means a person has the intention to achieve *bodhi*, enlightenment, and in this case, the enlightenment of a buddha. For a variety of reasons, the state of buddhahood is seen as far superior to that of an arhat, someone who achieves nirvāṇa based on the teachings of a buddha; there are many stories in the canon of such persons completing the path to liberation in a single lifetime.

The person who makes the vow to become a bodhisattva makes that promise in the presence of a buddha of the past and is said to have the capacity to become an arhat in that lifetime by following that buddha's teachings. However, he decides to forgo immediate liberation in order to instead become a buddha at a later time when there is no buddha in the world. This decision is the source of the often misunderstood statement that the bodhisattva "postpones his enlightenment." This is not the case. The bodhisattva decides to forgo a lesser form of enlightenment, the liberation of the arhat, in order to achieve a far greater and more consequential enlightenment, that of a buddha. Because of the great pedagogical powers of a buddha and because he achieves buddhahood at a time when there is no buddha in the world, the path of bodhisattva requires aeons to traverse. Over billions of subsequent lifetimes, the bodhisattva accumulates merit, the karmic power that will propel him across the aeons and bring him to buddhahood. That merit is gained through the performance of specific virtues, called "perfections" (*pāramitā*), which are listed as either six (giving, ethics, patience, effort, concentration, and wisdom) or ten (giving, ethics, renunciation, wisdom, effort, patience, truthfulness, resolve, love, and equanimity).

It is noteworthy that in the bodhisattva's last human lifetime before his birth as Prince Siddhārtha (as discussed in chapter 7, in his lifetime immediately prior to his final birth, he was a god in the Tuṣita or "Joyous" heaven), the perfection that the bodhisattva practiced was generosity, the most important virtue for the Buddhist laity. He was a prince, named Vessantara, who was so selfless in his giving that, in perhaps the most heartbreaking scene in all of Buddhist literature, he gave away his own small children to

an evil brahmin. He later gave away his wife. (The story has a happy ending; the family is reunited.)

Among the Buddha's prodigious powers is his ability to remember all of his past lives, as well as the past lives of all sentient beings. During the night of his enlightenment, he is said to have had a vision of all of his previous births. According to the tradition, he would often recount those past lives, explaining how in a previous life—sometimes as a human, sometimes as an animal—he had practiced one of those six or ten perfections. His recollection of those births would be collected as the *jātaka* stories. They tend to follow a simple pattern. Someone will ask the Buddha a question. He will then answer the question with a story, often quite lengthy, about the distant past. At the end of the story, he will explain who the characters in the story are in the present. In almost all cases, he is the protagonist, the hero who saves the day, often through sacrificing his life. His companions in the story are often his close disciples, especially the monks Śāriputra and Maudgalyāyana; if there are virtuous female characters, they are often the Buddha's wife and mother. If there is a villain, as there often is, he is usually the Buddha's evil cousin Devadatta, notorious for making three attempts to assassinate the Buddha. It is interesting to note, however, that the villains of the past are not always the villains of the future. For example, Hyecho alludes to the story in which five *yakṣas* (in this case, a kind of demon) eat the body of the bodhisattva. These five demons were eventually reborn as the "group of five," the five ascetics who practiced various forms of self-mortification with Prince Siddhārtha and who received his first teaching after his enlightenment. This sermon on the middle way and the four truths was delivered at the Deer Park at Sarnath, one of the "eight great stūpas" that Hyecho visited. Here, rather than consuming the bodhisattva's flesh, they consumed the body of the Buddha's dharma.

The *jātaka* collection remains one of the most important genres of Buddhist literature, with some of the stories, especially those in which the bodhisattva was an animal, in modern times translated into children's cartoons and comics. They are in many cases entertaining tales for moral edification, easily told and retold, largely bereft of doctrine, or indeed of any particularly Buddhist content. It is only at the end, when the Buddha reveals the present identity of the protagonists, that the stories become somehow "Buddhist." Indeed, research has shown that many of these stories were freely circulating folktales in ancient India—similar to *Aesop's Fables*—that were appropriated by Buddhist authors for their purposes. What would those purposes be?

The first and most obvious is that the *jātaka* stories provide a way to convey simple moral lessons to the laity. The doctrines most associated with Buddhism in the modern imagination—the four noble truths, the twelve links of dependent origination, nirvāṇa, impermanence, no self—are often technical in their presentation and their vocabulary. They were the purview of monks and nuns, and even there, the more scholarly monks and nuns. In the domain of practice, the Buddhist laity traditionally did not practice meditation. Instead, they took refuge in the three jewels (the Buddha, the dharma, and the saṃgha), they sought to live an ethical life (often by taking vows not to kill, steal, engage in illicit sex, lie, or use intoxicants), and they practiced charity, directed to the monastic community above all. These virtues did not lead immediately to liberation from rebirth and the attainment of nirvāṇa, but this was rarely the soteriological goal of the Buddhist laity. Instead they sought happiness within saṃsāra as a well-born human, or, better, as a long-lived god in one of the several Buddhist heavens. And they sought to avoid rebirth in the lower realms of animals, ghosts, and the denizens of hell. According to Buddhist karma theory, deeds of ethics lead to rebirth as a human and deeds of generosity lead to rebirth as a god.

Ethical lessons and the glories of generosity were conveyed through the *jātaka* stories, stories that could be listened to and learned without having to be read, that could be told and retold again and again, both in public settings and within the family. Thus, much more than notions of nirvāṇa, the *jātaka* stories provided the content of the Buddhist dharma for Buddhists, imparting the lessons that one needed to learn to be reborn as a wealthy human or as a god in the next lifetime.

Indeed, the *jātaka* stories provided the Buddhist laity with their own understanding of the three jewels. In the scholastic literature, there is much discussion of what it means to go for refuge. What are the Buddha, dharma, and saṃgha in whom one seeks protection from the sufferings of saṃsāra? The Buddha is not the fleshly body that grew old, died, and was cremated. It is instead the transcendent qualities of the Buddha's mind. The dharma is not the words that the Buddha spoke but the state of the cessation of suffering and rebirth called nirvāṇa. The saṃgha is not the local community of monks and nuns that the laity supports with its charity but the "noble saṃgha," those who have achieved one of the four levels of enlightenment. This scholastic version of the three jewels has remained both conceptually and physically distant from most of the Buddhists across the centuries who have recited, "I go for refuge to the Buddha. I go for refuge to the dharma. I go for refuge to the saṃgha."

The *jataka* stories provide a richer and less sterile alternative. The Buddha is a prince who left his family to achieve enlightenment under the Bodhi Tree. Of equal or sometimes greater importance, he is the protagonist in scores of stories, each with a plot, a hero, a villain, and a happy (or at least inspiring) ending. In parts of the Buddhist world (one thinks immediately of Thailand), the story of Prince Vessantara is in many ways more popular than the story of Prince Siddhārtha. The second jewel, the dharma, is democratized, becoming not nirvāṇa, but the ethical virtues that lead to a happy rebirth. And the saṃgha is the monks and nuns who appear at the door each day with their begging bowls.

But the *jataka* stories do not simply teach simple virtues; they perform a more subtle function, what might be called the Buddhafication of the imagination. As noted above, many of the stories seem to have already been present in the vast corpus of Indian folklore. These stories could easily be "Buddhafied" with the addition of the standard *jataka* frame: the Buddha introduces the story at the beginning and he identifies the characters with Buddhist figures—most importantly, himself—at the end, thereby transforming a simple folktale about a monkey or a deer into an account of a past life of the Buddha himself. Bedtime stories become sacred texts. These tales were told not only in words; they were told in stone. There are relatively few scenes from the life of the Buddha that can be represented artistically without commentary. Indeed, in Tibetan paintings that depict the life of the Buddha, the various episodes require captions to identify them. Although the biographies of the Buddha that began to appear centuries after his death added all manner of embellishments, they could never compete in scope and popularity with the *jataka* stories. Thus, at a great stūpa complex at Bharhut, for example, one finds that depictions of *jataka* stories far outnumber depictions of scenes from the (last) life of the Buddha, forty-four to seventeen.

The *jataka* collections also allowed the life of the Buddha to be extended in time and in space. Ancient India was a place where innovation, at least in the realm of religion, was regarded with skepticism. For an ascetic to claim that he had suddenly discovered a new truth carried little weight without the sanction of tradition. Thus the Vedas, the sacred scriptures of the Hindus, were understood to be eternal, existing forever as sound, appearing in time as they were heard by sages. The Buddhists required a similar pedigree. This was acquired in one way with the claim that Śākyamuni was only the latest in a long line of buddhas, extending back in time across aeons. However, at least in the early tradition, nirvāṇa was annihilation. When the

Buddha entered nirvāṇa he ceased to exist in important ways; he was not like Jesus, who sits at the right hand of God for eternity. The Buddha could therefore not persist into the future, except in the form of his words and his relics. However, with the *jātaka* stories, his life could be extended far in time into the distant past.

Hyecho's allusion to *jātaka* stories in his entry on Gandhāra suggests their importance in extending the life of the Buddha in space. Although the Buddha taught for forty-five years after his enlightenment, his geographical domain was limited to a relatively small region in northeastern India. This was therefore where the first places of pilgrimage were located. The *jātaka* stories allow for that region to be greatly expanded; the wider landscape itself becomes Buddhafied as the sites of the stories are placed all over the subcontinent. And thus Gandhāra, in what is today Afghanistan, is incorporated into the sacred geography of Buddhism and becomes a place of pilgrimage. Pilgrimage as a practice and a network thereby becomes both universalized and localized: the route of pilgrims is expanded beyond the realm of the Buddha's activities in his last lifetime, providing more sites for pilgrimage, and thus merit-making, to those unable to make the long journey to the places of the Buddha's birth, enlightenment, first teaching, and death. Gandhāra in the far northwest becomes a sacred site, a place of pilgrimage, because it was there, long ago, that the bodhisattva gave away his head.

THE ART

As discussed in the introduction, Gandhāra became a major center of Buddhist culture in its own right, the site of major contributions in art, architecture, and doctrine. As noted in chapter 6, some scholars see it as the site of the origin of the Buddha image. Given Hyecho's allusion to the *jātaka* stories, it is appropriate that our two pieces are the Buddha and a bodhisattva. Both of the images are heads that over the course of time broke off (or were broken off) from their bodies.

The head of the Buddha (fig. 20) is dated to the second century CE, the period when Gandhāra was part of the Kushan Empire and perhaps during the reign of the emperor Kaniṣka I, remembered in Buddhist legends as a great patron of the dharma. (As in the case of the emperor Aśoka, archaeological and numismatic evidence suggests that those remembered as pious Buddhist monarchs were more likely equal-opportunity patrons of the several religions of their realms.) It is made of a kind of stone called schist,

typically gray in color. A brown material was applied to the surface of this piece, however, so that gold leaf could adhere. Traces of the gold leaf that once covered this sculpture are apparent in the grooves of the Buddha's hair, the curves of his lips, and especially his eyes.

This piece is typical of the Gandhāran style, with the Buddha having Apollonian features, likely the result of circulating Greco-Roman artistic ideals. The body to which this head once belonged undoubtedly wore monastic robes, yet more in the style of a Roman toga than the robes of Indian monks. Because this head is more than twelve inches high, the full image was probably larger than life size and imposing in presence. Damage to the back of this piece suggests that a halo, long broken off, was attached to the head it once framed. Based on its significant size and robust material, the full sculpture was perhaps the object of worship in a monastic shrine. Of particular interest for the development of the Buddha image is his hair, gathered in a chignon on the top of his head and lacking the stylized tight curls of later images. Art historians speculate that this simple bun evolved over time into the fleshy (or even bone) "crown protrusion" (*uṣṇīṣa*), becoming one of the thirty-two marks of a superman (*mahāpuruṣa*) that adorn the Buddha's body. Another of these iconic characteristics is a golden complexion, here made manifest in the gold leaf applied to the face and, one might imagine, the entirety of the sculpture.

The second piece (fig. 21) is the head of a bodhisattva, dating perhaps to the fourth century of the Common Era. Although art historians have much to say about how this work was made, it is difficult to identify whom it depicts, with part of the head and the entire body missing. The head, even without the long locks and turban that it likely wore, is almost twenty-one inches tall, suggesting that it was from a colossal statue, one that either was part of a tableau (perhaps flanking an even larger Buddha image) or was itself the centerpiece at a monastery or stūpa, housed within a temple shrine. It was not possible for sculptors to carve images of this colossal scale from schist. They would therefore model the body of the figure from stucco, a mixture of lime, sand, and water, sometimes strengthened with plant or animal fibers.

They would first make a frame out of plaited straw and rope, then cover it with a mixture of clay and stucco. They would sculpt the head separately, using a more solid stucco, and attach it to the body with a wooden dowel. That would have been the process utilized for the creation of this piece. Because the head was therefore more durable than the body, heads often survived when bodies did not. Thus, this head likely lost its body through

the ravages of time rather than through some act of desecration (such acts have occurred across the Buddhist world). Traces of pigment suggest that this bodhisattva, like the gods in Greek temples, was painted.

Sadly, there is little we can say about the identity of the bodhisattva. There are a number of possibilities. In keeping with the discussion above of the *jātaka* stories, the figure could be the future Buddha, either during his years as a prince in the palace, or in one of his many past lives as a prince. It is also possible that the figure is the next buddha who will appear in our world, Maitreya, now a bodhisattva and awaiting his final birth in the Tuṣita heaven (as all buddhas do). Maitreya appears often in the Mahāyāna sūtras, such as the *Lotus Sūtra*, and developed his own cult of devotees who wished to be reborn in his entourage when he becomes a buddha, in the far distant future. Or it could be the bodhisattva Avalokiteśvara, also mentioned in the *Lotus Sūtra*; even though Gandhāra was known as a center of mainstream or "Hīnayāna" monasticism, the influence of the Mahāyāna is apparent in the visual record, where bodhisattvas prevail. Although the sculptures that these heads once surmounted were carved many centuries before Hyecho visited Gandhāra, he would have encountered images such as these still standing in the temples and monasteries of the region, still a bastion of Buddhism in the eighth century.

FURTHER READING

Kurt Behrendt and Pia Brancaccio, eds., *Gandhāran Buddhism: Archaeology, Art, Texts* (Vancouver: University of British Columbia Press, 2006).

Robert DeCaroli, *Image Problems: The Origin and Development of the Buddha's Image in Early South Asia* (Seattle: University of Washington Press, 2015).

Rhi Ju-Hyung. "From Bodhisattva to Buddha: The Beginning of Iconic Representation in Buddhist Art," *Artibus Asiae* 54, nos. 3–4 (1994): 207–225.

Wladimir Zwalf, *A Catalogue of the Gandhāra Sculpture in the British Museum*, 2 vols. (London: British Museum Press, 1996).

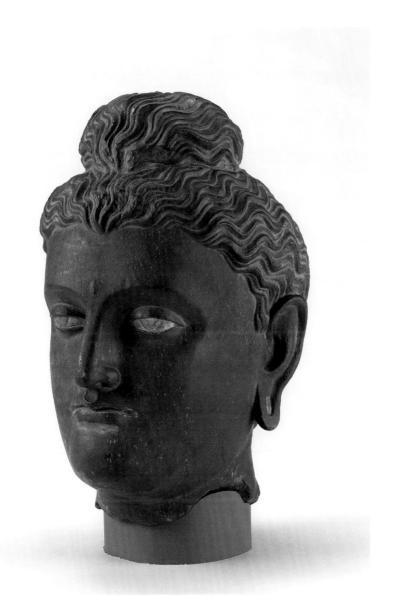

A Head of a Buddha from Gandhāra, Pakistan or Afghanistan
(second century). Schist with traces of gold leaf, 12 ⁵/₈ × 7 ⁹/₁₆
× 9 ⁷/₁₆ in. Purchase—Charles Lang Freer Endowment, Freer
Gallery of Art (F1998.299a–b).

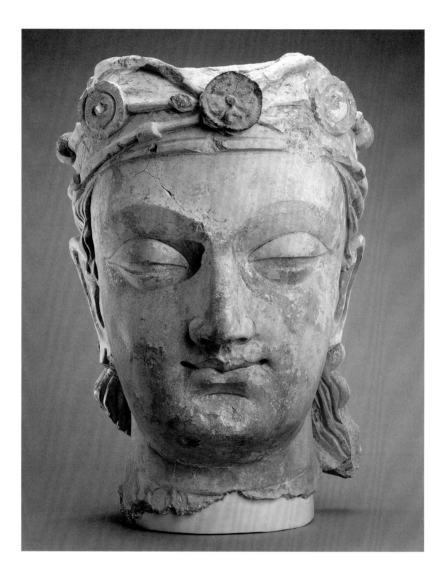

FIGURE 21

A Head of a Bodhisattva from Gandhāra, Afghanistan (third
to fifth century). Stucco with traces of pigment, 20 7/8 × 14
1/2 × 13 1/4 in. Gift of Arthur M. Sackler, Arthur M. Sackler
Gallery (S1987.951).

ARABIA

Buddhism Encounters Islam

"When eating, there is no distinction between nobles and commoners. They eat food together from the same plate using their hands, spoons, and chopsticks. They are extremely fond of hunting: what appears particularly ill bred is that they say the greatest happiness comes only when you eat what you have killed with your own hands. They serve Heaven and know nothing of the *buddhadharma*. According to the law of the land, there is no custom of doing prostrations."[51]

If Hyecho indeed traveled as far west as Arabia, he would have been perhaps the first Buddhist monk to encounter Islam in the land of its birth. Yet he says little about the religion of the Arabs, only that "they serve Heaven and know nothing of the *buddhadharma*," that is, the teachings of the Buddha. He may have been wrong about this, for during the eighth century, if not before, the story of the Buddha, or least some of the most famous elements of the story, appeared in an Arabic work (likely translated from a Persian version that has since been lost) called *Kitāb Bilawhar wa Būdāsf* (*The Book of Bilawhar and Būdāsf*). The hero of the story is a prince named Būdāsf, derived from the Sanskrit *bodhisattva*, the term commonly used to describe the Buddha in the years before his enlightenment. It is a long and somewhat complicated tale, filled with parables. We can provide only a plot summary here.

THE STORY

King Ğunaysar rules India from his capital, Šawilābaṭṭ, a place name that may be derived from Kapilavastu (also visited by Hyecho), the birthplace of the Buddha. The king is an idol worshipper who persecutes the "people of the Religion" (*dīn* in Arabic), who practice a form of asceticism. He is childless and longs to have a son.

One night, his wife has a dream that she will give birth to a son named Būdāsf. When the king instructs the court astrologers to predict his son's destiny, all but one say that the prince will attain honors and wealth. One astrologer predicts that the prince will be a leader of the ascetics, attaining glory in the next world. Fearing this fate, the king constructs a palace where the prince will be surrounded by beauty and shielded from the sorrows of the world.

When Būdāsf is a young man, he asks Ğunaysar to allow him to venture into the city. The king consents, but only after ordering that all signs of suffering be removed from the prince's route. Despite this precaution, Būdāsf encounters two beggars, one diseased and the other blind. On another

excursion, he encounters an old man and learns of the inevitability of death. He becomes discouraged with the pleasures of the world and seeks a life of asceticism.

On the island of Sarandìb (Sri Lanka), an ascetic named Bilawhar hears about the prince and decides to go to India to teach him, instructing him in "the Religion," which rejects this world in preparation for the next. Bilawhar eventually departs, leaving the prince to practice the Religion in secret.

Būdāsf and his father then engage in a series of debates. Both claim to be followers of the teachings of al-Budd, who brought the word of God to India before his death. According to the king, al-Budd taught charity and morality but not renunciation of the world. According to Būdāsf, al-Budd taught the rejection of the world and the practice of asceticism. He accuses his father of honoring al-Budd with his words but betraying him with his deeds, especially the persecution of ascetics. The king wavers, almost convinced by his son, but eventually proposes a public debate between a representative of the ascetics and the king's philosophers. The king and the prince agree that the loser will convert to the victor's religion. When the ascetics win, Ğunaysar does not convert to the Religion but he abandons his efforts to convert the prince to idolatry.

However, on the advice of an idolater priest, the king tries a different strategy to bind his son to the world. Ğunaysar removes all of the male servants from Būdāsf's palace and replaces them with four thousand beautiful women, instructing them to seduce his son. They dress in provocative ways, sing to him, speak sweetly to him, and debate with him about religion. Būdāsf is attracted by a particularly beautiful princess, who tells him that if he will become her lover for a year, she will then convert to his religion and live a life of chastity. When the prince declines, the princess proposes a month or just a single night. Būdāsf succumbs, spending a single night, during which he fathers a son, and he regrets his weakness the next day.

The king is overjoyed at the news of the pregnancy, thinking that fatherhood might persuade the prince to inherit the throne. If it does not, the grandson will ensure the royal lineage. The women remain in the palace, and the prince continues to be tormented by their beauty, spending long hours at prayer to avoid them. One night he has a vision in which Bilawhar transports him to paradise and reveals the wonders that await him there, wonders that make the world, and the women, disgusting to him. When Būdāsf tells his father about the vision, King Ğunaysar converts to the Religion and renounces his idols. His grandson is born, and the astrologers predict he will have a long life and many descendants, thus continuing the royal lineage.

An angel from God appears to Būdāsf and instructs him to abandon this world and seek the eternal kingdom. Būdāsf tells no one of the angel's visit and prepares to leave the palace under cover of darkness on horseback. A servant runs after him, begging him not to leave; the people have been waiting for him to assume the throne. Būdāsf dismounts, telling the man to take the horse back to his parents. The servant worries about the hard life that the prince has chosen. Būdāsf's horse bows to the prince and speaks, begging Būdāsf not to leave him. The prince remains firm in his resolve and gives his royal raiment, his jewels, and his horse to his servant. He travels north until he reaches a great plain where a tree is filled with birds. He ascends to heaven with four angels who reveal the secrets to him. The prince then returns to his native land to preach the Religion to the people. King Ğunaysar also receives the teachings and dies in peace.

The prince buries the king according to the custom of the ascetics. He converts his people, destroys the idols, and turns their temples into temples of God. Thirty thousand people become ascetics and go to live in the wilderness. Būdāsf appoints his uncle Samṭā to rule in his stead and then wanders through India teaching the Religion.

When he arrives in Kashmir, he knows that his own death is near. He tells the people of Kashmir, "I have taught, protected, and raised up the Church, I have put there the lamps of those who came before me, I have reassembled the dispersed flock of Islam to which I was sent. Now the moment comes when I will be raised out of this world and my spirit will be freed from its body. Observe your commandments, do not stray from the truth, adopt the ascetic life! Let Abābīd be your leader!"

Būdāsf then orders his disciple Abābīd to smooth a place on the ground. He lies down on his side, his head pointing north, and dies.

Samṭā succeeds him as ruler of the land of Šawilābatt. After his death, Šāmil, the son of Būdāsf, rules the land, following the Right Path of his father's religion.

THE COMMENTARY

The story of Bilawhar and Būdāsf was translated from Persian into Arabic, and then into Georgian by Christian monks, who turned the prince into a Christian (his father remained an idolater). From Georgian it was translated into Greek and then into Latin. From Latin, it was translated into many of the vernaculars of medieval Europe, becoming one of the most famous saint's tales of the Middle Ages, known to posterity as *Barlaam and Josaphat*. Its connection to the life of the Buddha would not be recognized by

scholars until the mid-nineteenth century.[52] However, the connection is clear, as we see a prince shielded from the sufferings of the world by his father, the king. The prince then takes chariot rides outside the city, where he encounters old age, sickness, and death. His father tries to distract him from his quest with beautiful women, but the prince goes off in search of enlightenment, eventually finding it under a tree, then going back to convert his father. All of these elements are found in various versions of the life of the Buddha. What is missing from them is the figure of the teacher, Bilawhar in the Arabic tale, Barlaam in Europe, who hears of the prince and journeys to the kingdom to teach him the true path. The Buddha famously relied on no teacher in his last lifetime.

Buddhism had largely disappeared from the Indian subcontinent by around 1300 CE, its disappearance long represented as a cause for lament by Buddhists around the world. The reasons for its demise remain a topic of scholarly investigation and debate. Almost all interpretations, however, ascribe some responsibility to Islam. Islam did play a role, but it is also important to note that what sometimes descends to the level of a condemnation of Islam must be understood as part of a larger pattern of the West's demonization of Islam and divinization of Buddhism, a religion of war destroying a religion of peace. This is, of course, a gross caricature. The relationship between Buddhism and Islam is long and complex.

After the revelation of the Qur'an in 609, Muhammad spent the remainder of his life establishing his new community among his own Quraysh tribe around Mecca and Medina in western Arabia. After his death in 632, however, his movement spread quickly; by the 650s, Muslims had extended their influence throughout the region from Yemen in the south to Armenia in the north, from Egypt in the west to eastern Iran in the east. This area was bounded on the west and the east by two large empires, the Christian Byzantine Empire, with its capital at Constantinople in the west, and the Zoroastrian Sasanian Empire of Persia, with its capital at Seleucia in the east. These two empires, long rivals, were often at war with each other over the centuries. By the time of the death of Muhammad, both were weak. Muslim armies occupied the eastern regions of the Byzantine Empire; troops under the command of the third caliph, Uthman, toppled the Sasanian Empire, bringing Persia under Muslim control by 651. It was in the eastern domains of the former Persian Empire that Muslims likely had their first encounters with Buddhists.

Scholars have debated the extent to which the rapid Muslim conquests were "religious," but it does not appear that conversion was an immediate aim. The religions that were known to the early community were the forms

of Judaism and Christianity taught in Arabia during the time of the prophet and the Zoroastrianism of the Persians. As Islam expanded eastward into central Asia and modern Afghanistan, Muslims encountered Buddhist communities. In 711, the Sindh capital of Aror (modern Rohri) fell to Muslim troops under the command of Muhammad ibn Qasim of the Umayyad Caliphate. Hyecho, in his description of "West India," likely the Sindh region of what is today southern Pakistan, writes, "Currently, half the country is destroyed, crushed by the invasions of the Arabs." Later, in his description of "Sindh-Gujarat," he writes, "Half the nation has suffered much damage due to the invasion of the Arabs." However, it is noteworthy that in each case he says that the king and his subjects revere the three jewels and that there are many monasteries and monks in the region.

This would suggest that military control, and the economic benefits that followed from it, were the primary motivations of the Muslims. For a number of Buddhist regions in Central Asia, that military control resulted from a treaty rather than a war. At least in the first centuries of Islam, its followers seemed content to leave local rulers, and their religions, in place. Indeed, an early controversy in the community was how non-Arabs should be incorporated into the Muslim community. Even after this matter was resolved, Buddhism remained largely mysterious to Muslims. Because they did not appear to pose a particular threat, Buddhists eventually received the designation of *dhimmi*, that is, "protected," a term used for those communities (originally Jews and Christians) that were allowed to maintain their own religion and their own customs but were required to pay the *jizya* tax. At the same time, the "Pact of Umar," a document of uncertain origin that eventually became part of Muslim law, prohibited Christians and Jews from building new churches and synagogues and from restoring those that had been destroyed. It is unclear to what extent these rules were applied to Hindus and Buddhists far to the east.

Further evidence that Buddhists were not subject to conversion is evident in the deployment of a famous, and to some infamous, Arabic term. During Hyecho's travels in the Gandhāra region, he stopped in Kāpiśī, today a province of northeastern Afghanistan. He describes a pious Buddhist king and a vibrant Buddhist community, with temples and monasteries, one of which houses relics of the Buddha. Under Muslim rule the regions came to be known as Kafiristan, the Lands of the Idolaters, both because of the presence of Buddha images and because *kafir* sounds like Kāpiśī. Buddhism may have made its way into the Muslim lexicon in other ways as well. Among the etymologies suggested for the word *pagoda* is the Persian term *butkada*, literally "idol house," with *but* (idol) derived from *buddha*.

Hyecho passed through a number of regions that had been brought under Muslim control just a few years before. Governors of the Umayyad Caliphate launched campaigns into Balkh in northeastern Iran. Between 705 and 713, regions of modern Uzbekistan—including the six "Hu Nations" described by Hyecho—were brought into the Umayyad Empire. Thus, it is not to be denied that vast regions where Buddhism held sway eventually became Muslim, with the Buddhists either converting or leaving. But this happened slowly. Buddhism remained active in Bāmiyān, the site of the famous Buddha statues in Afghanistan, until the eleventh century. Some Uighur communities practiced Buddhism until the sixteenth century.

In subsequent centuries, Muslim armies made their way into India proper, first into the Indus Valley of modern Pakistan, and then eastward into the Gangetic plain. Here again, their motivations seem to have been largely economic. After what is today Afghanistan had come under Muslim control, troops waited for the snows that blocked the Khyber Pass to clear each year so that they could raid northwestern India. Buddhist monks and Hindu priests were killed, monasteries and temples sacked, not because they were idolaters worshipping idols but because those idols were made of gold. In 1001, Mahmud of Ghazni defeated the Hindu king Jayapāla at the Battle of Peshawar, known in Sanskrit as Puruṣapura, the former capital of Kaniṣka, the pious Buddhist king.

THE ART

If Hyecho traveled into Persia and Arabia, he would have done so at the end of the Umayyad period, entering an Islamic world in a period of formation, where Sasanian, Byzantine, and new Muslim elements would have all been in evidence. This would have especially been the case with regard to visual culture, since the full flowering of a distinctive Islamic idiom had not yet occurred. Hyecho seems not to have traveled beyond the eastern borderlands that had only recently come under Arab rule. Here, this plurality of cultural elements would likely have been even more apparent. If the landscape was not yet marked by mosques, even of the Umayyad variety, the Persia he encountered may not have been distinguishable, especially to his untrained eye, from the way things had been in the recent past, when the Persians ruled the Arabs. Indeed, apart from noting the recent change in rulers, his descriptions of Persia and Arabia are quite similar, noting that both "worship Heaven." The two pieces presented here provide something of a "before and after."

The first piece (fig. 22) is a large silver and gilt ewer or pitcher, dating from Persia in the sixth or seventh century. Measuring almost thirteen inches high, six inches wide, and almost five inches deep, it is decorated with three female figures in diaphanous robes. Each holds a pair of attributes. The fully visible figure holds a flower and a bird; the partially visible figure on the right holds a peacock and a cylindrical box (*pyxis*); the third figure, on the back, holds a child and a bowl of fruit. There is a wide range of opinions on the identity of the female figures. Some scholars speculate that they are related to Anahita, the ancient Zoroastrian goddess of abundance and fertility; the figures may represent Anahita herself or priestesses of her cult. The figures may also be related to the cult of Dionysus, in which case they may represent *maenads* ("raving ones"), the female acolytes of the god of sensual indulgence. The women may also represent the *daena*, the female figure in Zoroastrianism who leads the soul to the afterlife; some scholars speculate that the *houris* of Islam, the maidens who delight the faithful in paradise, derive from the *daena*.

Pitchers of this kind were commonly used in elaborate drinking ceremonies during the Sasanian period. It should not be assumed that such practices immediately ended with the Arab conquest; the aesthetic asceticism associated with Islam in the popular imagination is but one of many misconceptions. Sasanian themes were copied or used as inspiration by Islamic artisans; a number of plates and bowls attributed to the Sasanian period may represent the *bazm* ritual of late Sasanian and early Islamic Iran: ceremonial drinking of wine and listening to music during courtly feasts. Indeed, the Umayyad rulers, conquerors of the Byzantines in the west and the Sasanians in the east, came to see themselves as the heirs of these high cultures, maintaining forms and motifs that derived from Late Antiquity well into the ninth century.[53]

If the first piece represents the influence of the past, the second suggests the impact of the new religious and political order of Islam, legitimated, among other means, by art and architecture that had their own visual identity. Although the Umayyads continued to allow figural motifs in secular art, they eliminated the depiction of human figures in religious architecture and in manuscripts of the Qur'an, as represented by the second piece.

It is a page from the Qur'an (fig. 23). The Qur'an is God's revelation to the Prophet Muhammad. The angel Gabriel appeared to him and instructed him to recite the words that he revealed. Muhammad received these revelations of varying lengths over the course of twenty years, orally transmitting to his disciples the message that the angel had spoken. From its beginnings,

the Qur'an was thus meant to be heard and spoken aloud; its orality is encompassed in its unique euphony and embedded in its very name, which is derived from the term *qara'a*, "to read or recite." The words of the message received by Muhammad were not recorded until after his death in 632. In 651, the third caliph Uthman instructed a group of scholars to produce what became the standard version of the Qur'an, divided into 114 chapters or *suras*. The copying of the Qur'an, like the Buddhist copying of the *Lotus Sūtra* described in chapter 5, became both an act of piety and an act of artistic creation. Indeed, the standardization of the text of the Qur'an led not only to the proliferation of the text but also to the development of Arabic calligraphy as an art form. Again, however, these forms did not appear from nowhere; the earliest parchment manuscripts of the Qur'an display affinities with Bibles in Syriac, Hebrew, and Greek.

The page here is parchment, about thirteen inches wide and nine and a half inches high, with letters in dark ink, vowel markers in red, and a gold leaf illumination. It dates from the eighth or ninth century and could have been produced in North Africa or the Near East. It is from the Abbasid period, which began in 750, with the capital of this new caliphate moving east from Damascus to Baghdad.

Like the scroll of the *Lotus Sūtra* in chapter 5, this page marks the end of one chapter and the beginning of the next, but with a much more beautiful and elaborate demarcation. Above the gold illumination are the final verses of Sura 38, called "Sad," the eighteenth letter of the Arabic alphabet. It recounts stories of previous messengers of God—including David, Solomon, and Job—and tells of the rewards of those who heeded them and the punishments suffered by those who did not. The final verses state that the Qur'an is only a reminder for the worlds of humans and *jinn*; its truth will be known soon. The title of Sura 39 is variously translated as "The Troops," "The Crowds," and "The Throngs," derived from a passage near the end of the chapter in which crowds of the unfaithful will be led into hell and crowds of the faithful will be led into paradise. The first two verses appear on the page. They read, "In the Name of God, the Compassionate, the Merciful. This Book is revealed by God, the Mighty, the Wise One. We have revealed to you the Book with the Truth: therefore serve God and worship none but Him."[54]

Some of the earliest surviving copies of the Qur'an are written in a script called "kufic," named after the city of Kufa in modern Iraq. The script, represented in the piece here, is notable for its thick lines and contours made with a reed pen. Kufic is further characterized by short vertical strokes, long horizontal strokes, red vowel markers, large blank spaces between letters,

and small gold balls stacked in a pyramid to mark the verses. In this folio, a long gold band with a leaf motif on the left separates Sura 38 and Sura 39. Within the illuminated band, the chapter heading is written in the white blank space that is outlined.[55]

As Hyecho began the long trip east back to China, he would encounter Muslims (in his words, Arabs) again and again, who brought with them not only a new religion but new forms of art and architecture intended for its expression, forms that borrowed heavily from the past to create a new visual identity.

FURTHER READING

Jamal J. Elias, *Aisha's Cushion: Religious Art, Perception, and Practice in Islam* (Cambridge, MA: Harvard University Press, 2012).

Johan Elverskog, *Buddhism and Islam on the Silk Road* (Philadelphia: University of Pennsylvania Press, 2010).

Helen C. Evans and Brandie Ratliff, eds. *Byzantium and Islam: Age of Transition, 7th–9th Century* (New York: Metropolitan Museum of Art, 2012).

Massumeh Farhad and Simon Rettig, eds. *The Art of the Qur'an: Treasures from the Museum of Turkish and Islamic Arts* (Washington, DC: Smithsonian Institution Press, 2016).

Kate Masia-Radford, "Luxury Silver Vessels of the Sasanian Period," in *The Oxford Handbook of Ancient Iran*, ed. D. T. Potts (Oxford: Oxford University Press, 2013), pp. 920–942.

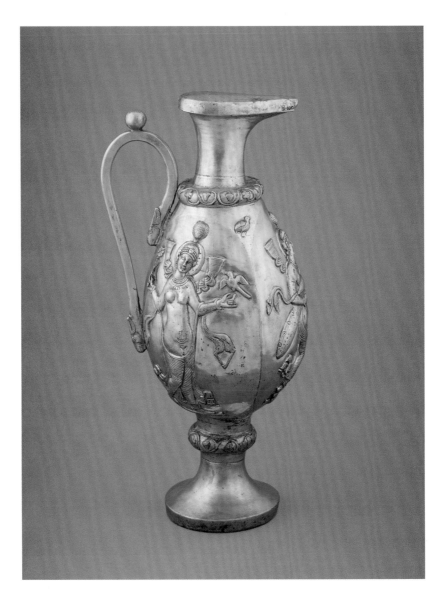

A Persian Ewer, decorated with female figures, Sasanian period, Iran (sixth to seventh century). Silver and gilt, 12 $^{13}/_{16}$ × 6 × 4 $^{13}/_{16}$ in. Gift of Arthur M. Sackler, Arthur M. Sacker Gallery (S1987.118a-b).

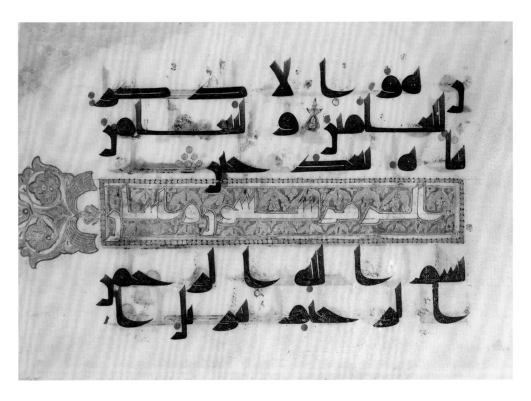

FIGURE 23

A Page from the Qur'an, Sura 39, verse 1, Abbasid period,
Northern Africa or Iraq (eighth to ninth century). Ink, color,
and gold on parchment (verso), 9 7/16 × 13 1/4 in. Purchase—
Charles Lang Freer Endowment, Freer Gallery of Art
(F1930.60).

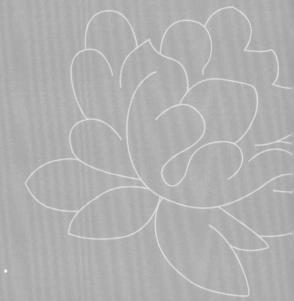

· TWELVE ·

WUTAISHAN

The Pilgrim Passes Away

As noted in the introduction, our major source for Hyecho's life after he returned to China from his pilgrimage to India is the preface to the translation of the *Sūtra of the Thousand Arm Mañjuśrī*. The preface states that in the fifth month of 780, Hyecho, likely almost eighty years old, left the Tang capital of Chang'an for Wutaishan, where he died a few years later.

Among the myriad bodhisattvas of the Mahāyāna, the two most famous are Avalokiteśvara, the bodhisattva of compassion (described in chapter 2) and Mañjuśrī, the bodhisattva of wisdom. Hyecho was his devotee. Mañjuśrī, whose name means "Gentle Glory" in Sanskrit, plays a major role in a number of Mahāyāna sūtras and in many tantras. He appears in many forms. In his most common form, he is dressed as a prince, seated in the lotus posture. In his right hand, he holds aloft the sword of wisdom with which he severs the bonds of ignorance. In his left hand, he holds the stem of a lotus flower that blossoms over his left shoulder. Atop the lotus is a text, specifically a perfection of wisdom sūtra.

Mañjuśrī plays an important role in Buddhist pilgrimage. The most famous pilgrimage in Buddhist literature occurs in the *Gaṇḍavyūha*, the final chapter of the *Avataṃsaka Sūtra*. There, the youth Sudhana sets out in search of a teacher, eventually encountering fifty-two beings, including Avalokiteśvara, the future buddha Maitreya, and the Buddha's mother, Mahāmāyā. It is Mañjuśrī who sets him on his quest.

The first translation of the *Avataṃsaka Sūtra* into Chinese, made in the fifth century, includes the following passage: "In the northeastern direction there is a place where bodhisattvas dwell known as Mount Clear-and-Cool. Over the ages past bodhisattvas have constantly inhabited its recesses. At present there is a bodhisattva dwelling there by the name of Mañjuśrī. He has [a retinue of] some ten thousand bodhisattvas who are constantly engaged in preaching the dharma."

With the growth of Buddhism during the Northern Wei Dynasty (386–534), the mythic Qingliangshan (Mount Clear-and-Cool), the earthly abode of the bodhisattva of wisdom, Mañjuśrī, came to be identified with Wutaishan ("Five-terraced Mountain"), a cluster of five peaks in northern Shanxi Province in China. With the rise of the Huayan school (which regarded the *Avataṃsaka Sūtra* as the Buddha's highest teaching) during the Tang Dynasty (618–907), Wutaishan became the site of many shrines and monasteries and an important pilgrimage destination.

In Mahāyāna Buddhism there is the notion of the sacred domain of a buddha or a bodhisattva (*daochang* in Chinese; *bodhimaṇḍa* in Sanskrit), the place where he abides and which is his field of activity. Such sites are most often associated with the buddhas, in which case the place is called a

"buddha field" (*buddhakṣetra*); the most famous of these is Sukhāvatī, the "western paradise" of the buddha Amitābha, a figure of particular devotion in China, Japan, and Hyecho's Korea. Mañjuśrī's field of activity is said to be Wutaishan, a sacred abode not in heaven but on earth, and thus accessible in this life and in this world.

Thus, the abode of an Indian bodhisattva was said to be in China. Pilgrims came not only from China, but from Korea, Japan, and later Tibet, all in search of a vision of Mañjuśrī, visions often set against the otherworldly rainbows, clouds, and supernal lights that often appear above the mountains. There are many accounts of pilgrimages to the mountain and of the visions pilgrims experienced when they arrived. There are even stories of monks from India leaving the birthplace of Buddhism (and of the texts that tell of Mañjuśrī) and going on pilgrimage to China in search of the bodhisattva of wisdom. The most famous such story is about a monk named Buddhapālita.

THE STORY

It is said that Buddhapālita reached Wutaishan in 676. Facing the mountains, he bowed down, touching the crown of his head to the ground, and said:

> After the extinction of the Tathāgata, the holy ones all hid their spirits—only on this very mountain does the great sire Mañjuśrī still draw out common beings and teach bodhisattvas. What I, Pālita, bitterly regret is that, having been born into the eight hardships [(1) birth as a denizen of the hells, (2) birth as a ghost, (3) birth as an animal, (4) birth as a god of long life, (5) birth in an uncultured region, (6) having impaired sense faculties, (7) having wrong views, and (8) being born in a world system where a buddha does not appear], I may not see the holy countenance [of the Buddha]. Long have I wandered across the flowing sands to come to pay respect and gain an audience. I submit to and beseech the all-encompassing great kindness and compassion of Mañjuśrī to allow me to gaze on his venerable form.

He finished his prayer, tears flowing down his cheeks, and once again touched his head to the ground.

When he raised his head, he saw an old man coming out of a mountain. When the man reached Buddhapālita, the man spoke to him not in Chinese

but in Sanskrit. He said, "Dharma Master, you have kept longing for the Way in your heart and searched out the remains of the holy ones; you have not feared hardship but searched far for the traces. However, many are the beings of the Han (i.e., Chinese) lands who commit sinful acts and many are those among the renunciants, as well, who break the precepts and rules (of the Buddhist order). Only the *Dhāraṇī of the Buddha's Victorious Crown* can destroy all the evil deeds of beings. I do not know, Dharma Master, if you have brought it with you or not." The monk replied, "This poor man of the Way has simply come to pay his respects and has not brought any scriptures." The old man said, "Since you have not brought the scripture you have come in vain—what benefit could there be? Even if you were to see Mañjuśrī, how would you recognize him? The Master might return to the western countries (i.e., India) and bring the scripture back and transmit it to the Han lands. Thus he would widely serve all the holy ones and vastly profit beings; he would save the dead and the living and repay the benevolence of the buddhas. Master, if you bring the scripture here I, your disciple, will show you where the bodhisattva Mañjuśrī dwells."

Hearing this, Buddhapālita was filled with joy. Holding back tears, he bowed wholeheartedly. When he raised his head, the old man was gone. He returned to the western countries and procured the *Dhāraṇī of the Buddha's Victorious Crown*.

He then returned to Chang'an, the capital of China, in 683 and reported these events to Emperor Gaozong (r. 649–683). When Buddhapālita presented the scripture to the emperor, the emperor gave him thirty bolts of silk in return and ordered his monks to translate the text into Chinese. Buddhapālita wept bitterly and petitioned the throne, saying, "This poor man of the Way has sacrificed his body and dedicated his life to bringing this scripture from afar. My dearest hope is to save all beings and rescue them from suffering and hardship. My thoughts are not of wealth; I do not nurture the desire for fame. I beseech you to return the text of the scripture to me so that I may spread its teachings so that sentient beings may benefit from them."

The emperor kept the translation but returned the Sanskrit text to the monk. Buddhapālita took it to the Ximingsi monastery, where, after making inquiries, he met the Han monk Shunzhen, who was skilled in Sanskrit. They petitioned the throne for permission to translate the scripture together, which the emperor granted. When this second translation was complete, the monk Buddhapālita took the Sanskrit text, journeyed to Wutaishan, and entered the mountains. He has never emerged.[56]

Wutaishan became one of the most potent Buddhist places of pilgrimage in China, drawing pilgrims from around the Buddhist world as well as the patronage of generations of rulers, from the Empress Wu Zhao (r. 690–705) to the Qianlong Emperor a millennium later. A painting of the famous Qing emperor in the guise of Mañjuśrī on Wutaishan is discussed below. Indeed, there is much to say about the apotheosis of various Asian rulers into various Buddhist deities.

However, here we might comment on another element of the story, the movement of holy places outside the holy land. As we have seen, in his final instructions at the time of his death, the Buddha recommended pilgrimage to four sites in northern India associated with his life. Yet, as Buddhism spread throughout Asia, these sites, so close for many in India, became more and more distant. Travel was perilous, and many pilgrims lost their lives. How could the sacred sites, and the benefits of pilgrimage to them, be brought closer? In Christianity, one of the most common solutions to this problem was the "translation of relics," that is, the transportation of the holy relics to another location; pieces of the true cross, for example, are to be found in churches all over Europe.

Christians were preceded by Buddhists in this practice. The famous Shwedagon Pagoda in Rangoon is said to contain hairs that the Buddha gave to two merchants, Bhallika and Trapuṣa, who offered him his first meal after his enlightenment. After the Buddha's death, it is said that the emperor Aśoka broke open the ten stūpas that contained the Buddha's relics, divided them further, and built 84,000 stūpas throughout his realm, a realm that, according to some legends, extended to China. And, as we shall see below, there came to be other ways of making stūpas.

However, the sacralization of Wutaishan resulted from a different strategy for bringing the holy to the homeland. Among the most influential Buddhist scriptures in China was the *Avataṃsaka Sūtra*. It served as the foundational text for the Huayan school in China (called Kegon in Japan, Hwaeom in Korea) but was studied and commented upon across the Buddhist traditions of China, Korea, and Japan. Said to be the Buddha's first discourse, offered two weeks after his enlightenment (and thus delivered prior to the sermon in the Deer Park in Sarnath), it is a massive text composed in a baroque style, an encyclopedic work on the nature of enlightenment. Although a number of its sections were freestanding works in India, there are no Sanskrit manuscripts of the entire text or even references to its title;

some scholars speculate that it is of Central Asian (specifically, Khotanese) origin. As noted above, the sūtra locates Mañjuśrī's abode not in a pure land but on Mount Clear-and-Cool, located in the northeast. Thus, the existence of the mountain, and Mañjuśrī's presence there, is sanctioned by one of the most influential of the many Mahāyāna sūtras. Once Mount Clear-and-Cool became associated with Wutaishan, it became a place of pilgrimage. Particularly important in this enterprise was Amoghavajra, himself possibly Khotanese, the tantric master who, along with his own teacher, Vajrabodhi, is credited with bringing esoteric Buddhism to China. Amoghavajra, who became Hyecho's primary teacher, was a strong devotee of Mañjuśrī and played an important role in the promotion of Wutaishan as his abode. It is important to note, however, that the association of Mañjuśrī with Wutaishan was already well established by the time of Amoghavajra's arrival in China. In 703, Empress Wu Zhao, whose family was from the region, had a statue of herself carved in jade and had it sent to Wutaishan in homage to the bodhisattva.[57]

As discussed in the introduction, Amoghavajra played a central role at the Tang court, carrying out all manner of esoteric rituals to protect the emperor and his empire. In 759, he performed a consecration ceremony that transformed the emperor into a *cakravartin*, a "universal monarch" who righteously rules through the promotion of the dharma. Through Amoghavajra's efforts, Wutaishan became closely associated with the imperial cult, an association that continued for the next millennium, as illustrated by the second of our works of art for this chapter.

However, in addition to the *Avataṃsaka Sūtra*, another text had a major role in the elevation of Wutaishan. It was the *Dhāraṇī of the Buddha's Victorious Crown* (Sanskrit: *Uṣṇīṣavijayadhāraṇī*, Chinese: *Foding zunsheng tuoluoni jing*), the very text that Mañjuśrī told Buddhapālita to retrieve from India. Like many other Mahāyāna works, that text recommends its own propagation through copying. It specifically advises copying the text on walls, mountains, and pillars, stating that anyone who stands in the shadow of such a carving will be cleansed of negative karma.[58] Thus, this text, summoned to Wutaishan by Mañjuśrī himself, became a means of disseminating sites of the sacred throughout the realm.

Yet there were more massive duplications of sacred sites. Around 636, almost a century before Hyecho's journey to India, the Korean monk Jajang (mentioned in chapter 2) made his way to Wutaishan. Upon his arrival, he worshipped an image of Mañjuśrī for seven days. One night, he had a dream in which the bodhisattva appeared to him, reciting a four-line verse

in Sanskrit, a language that Jajang could not understand. Yet he memorized the verse. The next day, an old monk approached carrying a brocade robe spangled with gold, the Buddha's begging bowl, and a relic from the Buddha's skull. At Jajang's request, he translated the Sanskrit verse that Mañjuśrī had spoken: "Comprehend all phenomena. Their own nature cannot be ascertained. Comprehend the nature of phenomena in this way and you will instantly see Vairocana."

The monk then gave Jajang the robe, the bowl, and the relic of Śākyamuni Buddha and told him that in the northeast of his native Korea there was a mountain called Odaesan (Korean for Wuitaishan), where ten thousand Mañjuśrīs resided. The monk instructed Jajang to go there. Jajang later learned from a dragon that the old monk was Mañjuśrī himself. Like Wutaishan in China, Odaesan in Korea has five peaks. And like Wutaishan, it was populated by bodhisattvas. On the eastern peak there are ten thousand Avalokiteśvaras; on the southern peak, ten thousand Kṣitigarbhas; on the western peak, ten thousand Mahāsthāmaprāptas; on the northern peak, five hundred arhats; and on the central peak, ten thousand Mañjuśrīs.[59]

Whether it was by Mañjuśrī himself or by the instruction of his teachers Vajrabodhi and Amoghavajra, Hyecho was lured to Wutaishan, the abode of the bodhisattva of wisdom.

THE ART

One of the epithets of Mañjuśrī is *kumārabhūta*, which means both "ever youthful" and "ever a prince." This is how he is depicted in a Japanese scroll (fig. 24) from the Kamakura period (1185–1333), one of the most consequential eras in the history of Japanese Buddhism. This was the time of the Zen master Dōgen, of the Pure Land master Shinran, and of Nichiren, ardent advocate of the *Lotus Sūtra*. Here, the young prince is easily identified with his standard accoutrements. He sits atop a fierce lion, a lotus blossoming under each of his paws. In the prince's right hand is the sword of wisdom, not held aloft, ready to cut, as he is often depicted in Indian art, but held at the ready by his side. In his left hand he holds the stem of a lotus, which blossoms over his left shoulder. Atop the blossom is a sūtra of the perfection of wisdom, not in the form of a scroll that it would have had in China and Japan, but in the form of a loose-leaf manuscript that it would have had in India. Indeed, Mañjuśrī's bare chest and arms, his elaborate jewelry, and his patterned pantaloons are all attempts to represent him as an Indian prince.

This particular image of Mañjuśrī is said to derive from a Chinese vision of the bodhisattva, one that Hyecho might have known. In 710, a monk

named Fayun commissioned a statue of Mañjuśrī from a sculptor, An Sheng. However, all of the statues he made had cracks. Finally, Fayun appealed to the bodhisattva, at which point seventy-two manifestations of Mañjuśrī appeared to assist him. This image is believed to be a perfect imitation of that manifestation. The image probably depicted Mañjuśrī in his bodhisattva attire, sitting on a lotus seat mounted on the back of a lion, accompanied by a lion tamer or groom (the groom is absent in the painting here). The lion is powerfully depicted: proportionally much larger than Mañjuśrī, he is roaring, with his head turned to the side.[60]

The temple where this image was housed, known thereafter as Cloister of the True Appearance (Zhenrongyuan), became a primary place of pilgrimage. Indeed, in maps of Wutaishan from Dunhuang, the temple often occupies the center of the composition.

Dating from the late thirteenth century, the image on this hanging scroll is painted on a silk panel, fifty-one inches high and about twenty-two inches wide. The commission of the scroll coincided with the period when the monk Eison (1201–1290), a major figure in the precept-reviving movement (*Shingon risshū*) in medieval Japan, promoted the worship of Mañjuśrī as the protector of criminals, beggars, and other social outcasts. As Eison was the administrator of the Saidaiji Temple in Nara, his movement is known as the Saidaiji Order; it was one of the most important religious organizations in Kamakura and Nanbokuchō Japan.

It is said that in 1245 Eison had a vision in which Mañjuśrī, sitting on a jeweled lotus flower and riding on a golden lion, appeared in the sky. The bodhisattva declared that he was conferring on Eison the mudrās and mantras of the esoteric vows (*samaya*) for those who practice the esoteric teaching during the Period of the Final Dharma. The vision is recorded in a document dated 1269, written at the time when Eison himself transmitted the precepts to his disciple.

It should be noted that, apart from this painting, the Saidaiji Order under Eison also commissioned two life-sized statues of Mañjuśrī during the Kamakura period: one completed in 1302 in the Saidaiji Temple, the other (no longer extant) in 1267 in Hannyaji Temple, a branch temple of the former, also located in Nara. The rituals associated with these images were often conducted for large audiences, who were encouraged to establish personal connections with the images (a practice known as *kechien*). As if reenacting Eison's vision, the sculptures were often described as the living body (*shōjin*) of Mañjuśrī, and were filled with various sacred objects, including sūtras, relics, Buddhist paintings, iconographic manuals, miniature statues of Mañjuśrī, and votive documents made by clergy and laity.[61] Although the

exact ritual associated with the Freer painting has yet to be determined, its connection to the Saidaiji Order's Mañjuśrī cult is well established.

The second piece (fig. 25), dating from a period long after Hyecho, nonetheless demonstrates that the international Buddhism that he witnessed in his journey would persist for a millennium. It is a Chinese painting in a Tibetan style of a Manchu emperor. There is some evidence that the Manchus, who conquered China in 1644, changed the name by which their nation was known from Jurchen to Manju in order to associate themselves with Mañjuśrī. The Kangxi emperor, who ruled from 1661 to 1722 and who visited Wutaishan five times, declared himself to be Mañjuśrī. Our painting is of his grandson, the Qianlong Emperor. Like the Tang emperor before him, he received consecration as a *cakravartin* by a foreign monk, this time a Tibetan named Jangkya Rolpé Dorjé (1717–1786).[62]

The work is a large Tibetan *thangka* or scroll painting, about forty-five inches high and twenty-five inches wide. It conforms to a particular format, in which the central figure, in this case the emperor, sits on a throne that is supported by a lotus blossom emerging from a lake, and a table in front of him is set with offerings. He is surrounded by one hundred eight figures. At the bottom of the painting are various wrathful deities, offering protection. At the top are various buddhas and bodhisattvas. Surrounding the central figure are various teachers in the lineage, with the root teacher seated directly above the central figure's head. The mountainous background of the painting suggests that the bodhisattva sits in his abode among the five peaks of Wutaishan.

The painting shows the emperor dressed in the robes of a Buddhist monk. His identity as Mañjuśrī is signaled by the presence of a flaming sword upright on a lotus blossom over his right shoulder and a volume of the perfection of wisdom on a lotus blossom over his left shoulder. He holds the stem of each in his hands. That he is also a *cakravartin*, a "wheel turning" emperor, is evident from the golden wheel that rests upright in his left hand. Both identities are confirmed by an inscription in Tibetan directly above the large lotus blossom on which he sits. It reads:

> Sharp-witted Mañjuśrī, king of the dharma,
> The lord who appears as the leader of humans.
> May you remain firmly on the diamond throne.
> May all your wishes be spontaneously achieved.

Directly above him is his teacher, Jangkya Rolpé Dorjé. The other figures include both historical figures and various transcendent beings of

the elaborate pantheon of Tibetan Buddhism; the name of each is helpfully written in gold on the base of each one's throne. Thus, the blue tantric buddha Vajradhara is in the circle at the top, surrounded by tantric yogins. Below the circle on the right are ten bodhisattvas, with Mañjuśrī at the top, flanked by a blue Vajrapāṇi and a white Avalokiteśvara. Surrounding Qianlong are important figures from the history of Tibetan Buddhism, including Milarepa and several Dalai Lamas and Panchen Lamas. Directly above Qianlong's head is Tsong kha pa. Examining the faces of the various figures, it is clear that the face of the emperor is different from all the rest; his appears more natural than the standard visage of the rest. The painting is the work of Tibetan artists (or Chinese artists trained in the Tibetan style) at the Qing court; the emperor established a Tibetan Buddhist painting academy in the Hall of Central Rectitude (Zhongzhengdian). However, the face of the emperor was reserved for his European court painter, the Jesuit Giuseppe Castiglione (1688–1766). Over the course of his long reign, Qianlong had himself portrayed as a number of figures from myth and history, including the famous lay bodhisattva Vimalakīrti. However, he seems to have considered portraits of himself as Mañjuśrī to be particularly important, having himself painted in this guise many times; eight such paintings survive.

Like many emperors before him, Qianlong understood himself to be a *cakravartin* and projected himself as such through artistic, architectural, and literary forms. Qianlong took his mandate as "universal monarch" not from a consecration like the one performed by Amoghavajra, but from an ostensible prophecy given by the Fifth Dalai Lama during the reign of the first Qing ruler. Inserted into the long legacy of consecrated Buddhist rulers, Qianlong naturally asserted his place in the imperial cult of Mañjuśrī and Wutaishan, a position occupied by emperors going back to the time of Hyecho.

FURTHER READING

Patricia Berger, *Empire of Emptiness: Buddhist Art and Political Authority in Qing China* (Honolulu: University of Hawaii Press, 2002).

Chou Wen-shing, "Imperial Apparitions: Manchu Buddhism and the Cult of Mañjuśrī," *Archives of Asian Art* 65, no. 1 (2015): 139–179.

Karl Debreczeny, "Wutai shan: Pilgrimage to Five-Peak Mountain," *Journal of the International Association of Tibetan Studies* 6 (2011): 1–133.

Lin Wei-Cheng, *Building a Sacred Mountain: The Buddhist Architecture of China's Mount Wutai* (Seattle: University of Washington Press, 2014).

Wu Pei-Jung, "Wooden Statues as Living Bodies: Deciphering the Meanings of the Deposits within Two Mañjuśrī Images of the Saidaiji Order," *Artibus Asiae* 74, no. 1 (2014): 75–93.

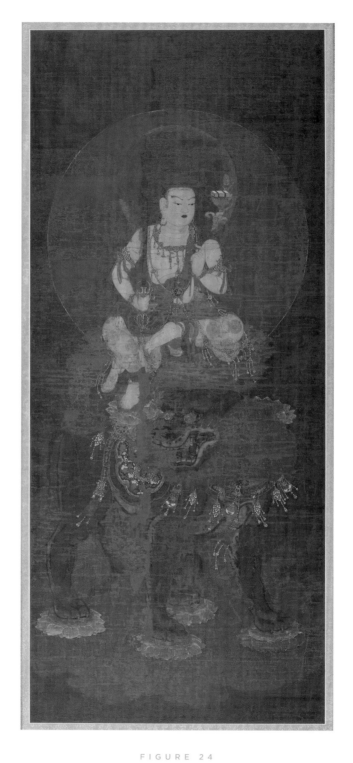

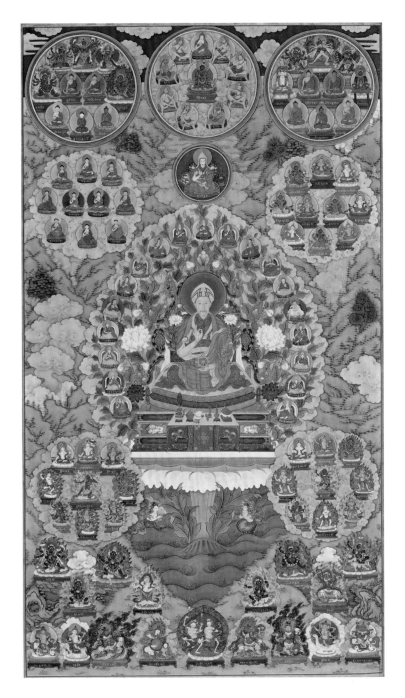

FIGURE 25

The Qianlong Emperor as Mañjuśrī, Imperial workshop;
emperor's face painted by Giuseppe Castiglione (1688–1766);
Qing Dynasty (reign of Qianlong), China (mid-eighteenth
century). Ink, color, and gold on silk, 44 ³/₄ × 25 ⁵/₁₆ in.
Purchase—Charles Lang Freer Endowment and funds provid-
ed by an anonymous donor, Freer Gallery of Art (F2000.4).

CODA

．．．

It has long been recognized that Buddhism is a religion that travels. During the long period of his teaching (traditionally said to have lasted forty-five years), the Buddha walked through many of the regions of what is today northeastern India and southern Nepal, pausing to spend the "rains retreat" at various cities (and, in one case, in the Heaven of the Thirty-Three on the summit of Mount Sumeru). After his first sixty monks had attained enlightenment, he famously instructed them to "wander forth for the good of the many, for the happiness of many, out of compassion for the world, for the good, benefit, and happiness of gods and humans. Let no two go in the same direction."

They seem to have obeyed him, for over the decades and centuries, Buddhism spread throughout the subcontinent of India; south to Sri Lanka and eventually to much of Southeast Asia, including modern Indonesia; west into what is today Pakistan, Afghanistan, and Iran; north to China, Korea, Japan, Tibet, Mongolia, and several of the modern Russian republics; and in the nineteenth century to "the West," to Europe and North America.

However, an abstract noun like "Buddhism" is incapable of travel. What travels are people and things; in the case of Buddhism, it has most often been monks and merchants and what they carry in their minds and on their backs: texts, relics, and images. Before the modern age, such travel took place on foot, on the back of an animal, or on the deck of a ship. The names of many of the travelers are known, exalted as saints and heroes in the lands where they carried the dharma.

At the same time, all manner of more magical travel occurred. It is said that at night, while his monks were sleeping, the Buddha would use his "mind-made body" to travel to distant regions of India to teach the dharma. Eventually, stories were told of the Buddha making magical journeys to faraway lands, often leaving his footprint set in stone to mark his presence. One of the most famous Mahāyāna sūtras is called the *Laṅkāvatāra* (*Descent into Laṅkā*), which describes the Buddha's teaching in Sri Lanka. The domain of the Buddha's dharma was expanded yet further with the composition of the *jātaka* stories, the accounts of the Buddha's former lives, which occurred in regions and worlds far beyond the roads that the Buddha and his first disciples traveled.

For that dharma to be understood, it required translation, a term that itself evokes travel; it literally means "carry across." The process of translation, so crucial to the spread of Buddhism around the world, seems to have begun early on. The Buddha is said to have forbidden two brahmin converts from rendering his teaching in formal verses for chanting, warning that to do so would constitute an infraction of the monastic code. Each

disciple should teach the word of the Buddha in his own dialect. But there were many dialects in Buddhist India, making it difficult for monks from one region to communicate with those from another. Eventually, in an effort to promote communication, a new vernacular was invented, combining elements from different regions of India. This language, called Pāli, might be considered the first artificial language. Still, negotiating the dialects of India was one thing; to translate books in Indic languages into Chinese was another. And so another category of Buddhist saints and heroes are the translators, those who, in many cases, traveled to foreign climes and invented entirely new vocabularies in languages like Chinese and Tibetan to make the dharma accessible to the people of new lands.

Yet another form of translation came in the domain of art. Here, a new, and in many ways strange, god—the Buddha—was introduced, his body adorned, according to tradition, with the thirty-two major marks and eighty ancillary marks of a superman. The Buddha not only had a body that needed to be depicted in ways appealing to new audiences; he also brought with him an entire pantheon of gods, saints, ghosts, and demons (and a vast collection of stories about them) to be painted on scrolls, carved in stone or wood, and cast in bronze.

This process of translation—of bodies, books, and icons across space, of words and images into new idioms—proved remarkably successful. Indeed, when the term "world religions" was first coined in the nineteenth century, the initial list contained only two, Christianity and Buddhism, because of their geographical sweep. And yet the movement of Buddhism away from the place of its origin inspired a reverse movement as Buddhists from distant lands made the often dangerous journey to the birthplace of the Buddha. Many made the pilgrimage, sometimes from the most distant reaches of the Buddhist world. Many never returned home.

This book is the story of one of those travelers, a monk distinguished by the fact that he was so undistinguished. As has been pointed out, he was not a great scholar, he was not a great translator, he was not a great artist. And he was very young at the time of his journey. Yet, for reasons that we do not know, he was inspired to undertake a great voyage, and unlike so many others who set out before and after him, he returned to tell his story. That story is preserved only in fragments, and the fragments that survive leave the reader wanting to know more. Because Hyecho very rarely says what he was thinking as he made his way along his perilous route, we are left to imagine it. This book has sought to suggest the thoughts and experiences that Hyecho might have had as he made his way from one sacred site to the

next, beginning in his homeland in Korea and ending where he ended his days, in the mystical mountains of Wutaishan.

Knowing the stories of Buddhism, as he surely did, what scenes from the life of the Buddha, what lines from a particular sūtra, would have been evoked when he saw a stūpa or a statue? Hyecho did not remain in India long enough to learn Sanskrit or, likely, any of the local vernaculars. His encounter with the Buddha would therefore have taken place in his mind and in his eyes, the thoughts triggered by a place, the stories sparked by an image.

This book has sought to tell those stories and to offer those images that Hyecho would have known and seen, connecting him to the larger Buddhist world he inhabited and traversed, as well as to the world of Buddhism that preceded and succeeded him. The book is admittedly speculative; all we really have to go on is Hyecho's map. That map, reconstructed from the fragments of Hyecho's travel journal, provides a picture of what it might mean to speak of a Buddhism beyond national and sectarian borders, an opportunity to rethink our own conceptual maps of the movement of people, objects, and ideas across that world. And so it seemed fitting to honor this young monk about whom we know so little, this young monk who traveled so far.

• ACKNOWLEDGMENTS •

This book would not have been possible without the material and spiritual support of many. For their financial support, we would like to thank the Humanities Collaboratory and the MCubed program at the University of Michigan. The project was facilitated by the renowned Asia Library at the University of Michigan, directed by Dawn Lawson. A number of colleagues in the Department of Asian Languages and Cultures gave generously of their time and expertise, including Micah Auerback, William Baxter, and Benjamin Brose. Peter Knoop and Rachel Trudell of the Information Technology office of the College of Literature, Science, and the Arts provided essential assistance in creating the maps for this book. Outside the University of Michigan, we are grateful for the insights of Robert Buswell, Charles Orzech, Jung Byung-sam, and the anonymous manuscript reviewers for the University of Chicago Press. The editorial director at the Press, Alan Thomas, made extraordinary efforts to publish the book in time for the opening of the Buddhist art exhibition at the Freer|Sackler Gallery in Washington. At Freer|Sackler, we would like to thank its Director, Julian Raby; curators Debra Diamond, Robert DeCaroli, Stephen Allee, and Jan Stuart; and photographer Neil Greentree. The Freer|Sackler very generously provided, without charge, the images of the works of art that appear in this book. The collaborative spirit of all of these friends and colleagues is deeply appreciated.

• N O T E S •

1. *Last Days of the Buddha: The Mahāparinibbāna Sutta*, translated from Pāli by Sister Vajirā and Francis Story, rev. ed. (Kandy, Sri Lanka: Buddhist Publication Society, 1998), pp. 62–63.

2. Paul Pelliot described Hyecho's prose and poetry in unflattering terms, writing in 1908, "Ce pèlerin nouveau n'a ni la valeur littéraire de Fa-hien, ni l'information minutieuse de Hiuan-tsang. J'ai connu à Ouroumtchi un Chinois qui, dans sa relation, a inséré non seulement ses nombreuses poésies, mais encore celles de son domestique. Houeitch'ao, si c'est lui, n'a pas de ces recherches. Son style est plat, et s'il a conservé peu de ses pièces de vers, il eût mieux valu qu'il n'en mît pas du tout. Ses notices sont désespérément brèves et monotones." Paul Pelliot, "Une bibliothèque médiévale retrouvée au Kan-sou," *Bulletin de l'Ecole française d'Extrême-Orient* (BEFEO) 8 (1908): 512.

For a more thorough assessment of Hyecho's language, see Tanaka Tokio, "*Echō Ō go-Tenjikukoku den* no gengo to Tonkō shahon no seikaku," in *Echō Ō go-Tenjikukoku den kenkyū*, ed. Kuwayama Shōshin, rev. 2nd ed. (Kyoto: Rinsen Shoten, 1998), pp. 204–206.

3. For a translation of Yijing's text, see Latika Lahiri, *Chinese Monks in India* (Delhi: Motilal Banarsidass, 2015). On Chinese pilgrims to Indian during a later period, see Sam van Schaik and Imre Galambos, *Manuscripts and Travellers: The Sino-Tibetan Documents of a Tenth-Century Buddhist Pilgrim* (Berlin: De Gruyter, 2011).

4. For a useful discussion of the vicissitudes of the terms "tantra" and "esoteric" in the case of East Asian Buddhism, see Robert H. Sharf, *Coming to Terms with Chinese Buddhism: A Reading of the "Treasure Store Treatise"* (Honolulu: University of Hawai'i Press, 2002), pp. 263–278.

5. See "Open Road to the World: Memoirs of a Pilgrimage to the Five Indian Kingdoms," ed. Roderick Whitfield, trans. Matty Wegehaupt, in *Collected Works of Korean Buddhism*, vol. 10, *Korean Buddhist Culture: Accounts of a Pilgrimage, Monuments, and Eminent Monks* (Seoul: Jogye Order of Korean Buddhism, 2012), p. 8.

6. Ibid., p. 8 and p. 9, n. 7. Note that although the text of "Open Road to the World" states that fifteen Korean monks traveled to India during this period, the list of monks in note 7 on page 9 has only fourteen names.

7. This poem and the other poems by Hyecho that appear here were translated by Chun Wa Chan and Kevin Carr, with the assistance of Benjamin Brose and William Baxter.

8. *A Record of the Buddhist Religion as Practised in India and the Malay Archipelago (A.D. 671–695) by I-Tsing*, trans. Junjiro Takakusu (Oxford, Clarendon Press, 1896), p. xxxii.

9. "Open Road to the World: Memoirs of a Pilgrimage to the Five Indian Kingdoms," ed. Roderick Whitfield, trans. Matty Wegehaupt, in *Collected Works of Korean Buddhism*, vol. 10, *Korean Buddhist Culture: Accounts of a Pilgrimage, Monuments, and Eminent Monks* (Seoul: Jogye Order of Korean Buddhism, 2012), p. 88.

10. The term "eight great stūpas" appears often in such works as *Lives of Eminent Monks* (*Gaoseng zhuan*, T.2059: 322c4–423a19) without specification. Wukong (d. 812), a Chinese pilgrim to India, provides a list of eight, consisting of Kapilavastu, the Mahābodhi, the Deer Park, Vulture Peak (because the *Lotus Sūtra* was taught there), Vaiśālī, Sāṃkāśya, Śrāvastī (because the *Mahāprajñāpāramitā Sūtra* was taught there), and Kuśinagara. In Tibetan Buddhism, there is yet another set of eight: Lumbinī, the Mahābodhi, the Deer Park, Śrāvastī, Sāṃkāśya, the Veṇugrāmaka Grove in Rājagṛha (commemorating the Buddha's healing of the schism caused by Devadatta), Cāpālacaitya near Vaiśālī (commemorating the Buddha's extension of his life by three months), and Kuśinagara.

11. *The Lotus Sūtra*, trans. Tsugunari Kubo and Akira Yuyama, rev. 2nd ed., BDK English Tripiṭaka Series (Berkeley, CA: Numata Center for Buddhist Translation and Research, 2007), p. 238.

12. *The Life of Hiuen-Tsiang by the Shaman Hwui Li*, trans. Samuel Beal (London: Kegan Paul/Trench, Trübner, 1914), p. 105.

13. See James Huntley Grayson, *Early Buddhism and Christianity in Korea: A Study in the Emplantation of Religion* (Leiden: E. J. Brill, 1997), pp. 34–35.

14. *The Great Tang Dynasty Record of the Western Regions*, trans. Li Rongxi, BDK English Tripiṭaka 79 (Berkeley, CA: Numata Center for Buddhist Translation and Research, 1996), p. 83.

15. On Vajrabodhi, see Charles D. Orzech, "Vajrabodhi (671–741)," in *Esoteric Buddhism and the Tantras in East Asia*, ed. Charles Orzech, Henrik Sorensen, and Richard Payne (Leiden: Brill, 2011), pp. 345–350.

16. See Jeffrey Sundberg and Rolf Giebel, "The Life of the Tang Court Monk Vajrabodhi as Chronicled by Lü Xiang (呂向): South Indian and Śrī Laṅkān Antecedents to the Arrival of Buddhist Vajrayāna in Eighth-Century Java and China," *Pacific World*, 3rd series, 13 (Fall 2011): 129–222.

17. See Charles D. Orzech, "Vajrabodhi (671–741)," in *Esoteric Buddhism and the Tantras in East Asia*, ed. Charles Orzech, Henrik Sorensen, and Richard Payne (Leiden: Brill, 2011), p. 347.

18. The rendering of the Chinese name Jin'gang here as Amoghavajra is speculative. Jin'gang, "Vajra" (or Jin'gangshi, "Teacher Vajra") is the standard rendering of Vajrabodhi's name in Chinese. However, in 742, Vajrabodhi was already dead, and it is known that Amoghavajra returned to India at that time, as explained below. Another possibility is to read Jin'gang as referring to Vajrabodhi and to assume that the author of the preface was mistaken about the date of his death; Vajrabodhi died on the twenty-ninth day of the eighth month of

the fifteenth year of the Kaiyuan era, which corresponds to September 29, 741. In this case, the passage would be read to say not that Vajrabodhi himself took the texts back to India but that he instructed that others do so.

19. *Dasheng yujia jingang xinghai Manshushili qianbi qianbo dajiaowangjing* (T.1177A:724b6–775c26) is made up of ten fascicles. The preface can be found at the beginning of the text (T.1177A:724b8–c05), but it is not certain it was originally part of the translation. The translation of the Chinese was made by Chun Wa Chan and Kevin Carr, after consulting a paraphrase and discussion of the preface in *The Hye Ch'o Diary: Memoir of the Pilgrimage to the Five Regions of India*, trans. and ed. Han-sung Yang, Yün-hua Jan, Shotaro Iida, and Laurence W. Preston (Berkeley: Asian Humanities Press, 1984), pp. 15–18. They also consulted a translation of the preface in Max Deeg, "Has Huichao Been Back to India? On a Chinese Inscription on the Back of a Pāla Bronze and the Chronology of Indian Esoteric Buddhism," in *From Turfan to Ajanta: Festschrift for Dieter Schlingloff on the Occasion of His Eightieth Birthday*, ed. Eli Franco and Monika Zin, vol. 1 (Kathmandu: Lumbini International Research Institute, 2010), pp. 207–208.

20. See Max Deeg, "Has Huichao Been Back to India? On a Chinese Inscription on the Back of a Pāla Bronze and the Chronology of Indian Esoteric Buddhism," in *From Turfan to Ajanta: Festschrift for Dieter Schlingloff on the Occasion of His Eightieth Birthday*, ed. Eli Franco and Monika Zin, vol. 1 (Kathmandu: Lumbini Research Institute, 2010), pp. 197–213.

21. See "Open Road to the World: Memoirs of a Pilgrimage to the Five Indian Kingdoms," ed. Roderick Whitfield, trans. Matty Wegehaupt, in *Collected Works of Korean Buddhism*, vol. 10, *Korean Buddhist Culture: Accounts of a Pilgrimage, Monuments, and Eminent Monks* (Seoul: Jogye Order of Korean Buddhism, 2012), pp. 10–11.

22. See Han-sung Yang, Yün-hua Jan, Shotaro Iida, and Laurence W. Preston, trans. and eds., *The Hye Ch'o Diary: A Memoir of the Pilgrimage to the Five Regions of India* (Berkeley, CA: Asian Humanities Press, 1984), p. 18.

23. *The Mahayana Mahaparinirvana-Sutra: A Complete Translation from the Classical Chinese Language in 3 Volumes*, trans. Kōshō Yamamoto, 3 vols. (Oyama, Japan: Karin Bunkō, 1975), vol. 3, p. 469.

24. For the story of Jijang, see William Powell, "Mt. Jiuhua: The Nine-Florate Realm of Dicang [*sic*] Pusa," *Asian Cultural Studies* 16 (November 1987): 55–69; and Richard D. McBride II, "Silla Buddhism and the *Hwarang segi* Manuscripts," *Korean Studies* 31, no. 1 (2007): 30–31.

25. *Garland of the Buddha's Past Lives by Āryaśūra*, trans. Justin Meiland, vol. 1 (New York: New York University Press, 2009), p. 345.

26. For a version of this famous story, see Todd T. Lewis, ed., "Story of Siṃhala, the Caravan Leader," in *Buddhism in Practice*, ed. Donald S. Lopez (Princeton, NJ: Princeton University Press, 1995), pp. 151–169.

27. For the story of Purṇa, see *Divine Stories: Divyāvadāna*, trans. Andy Rotman, part 1 (Boston: Wisdom, 2008), 71–117.

28. *The Lotus Sūtra*, trans. Tsugunari Kubo and Akira Yuyama, rev. 2nd ed., English Tripiṭaka Series (Berkeley, CA: Numata Center for Buddhist Translation and Research, 2007), p. 309.

29. See Pierre-Yves Manguin, "Early Coastal States of Southeast Asia: Funan and Śrīvijaya," in John Guy, ed., *Lost Kingdoms: Hindu-Buddhist Sculpture of Early Southeast Asia* (New York: Metropolitan Museum of Art, 2014), p. 114.

30. See Michel Jacq-Hergoualc'h, *The Malay Peninsula: Crossroads of the Maritime Silk Road (100BC–1300 AD)* (Leiden: Brill, 2002), p. 238. He is quoting Chavannes's 1894 French translation, p. 119.

31. "Open Road to the World: Memoirs of a Pilgrimage to the Five Indian Kingdoms," ed. Roderick Whitfield, trans. Matty Wegehaupt, in *Collected Works of Korean Buddhism*, vol. 10, *Korean Buddhist Culture: Accounts of a Pilgrimage, Monuments, and Eminent Monks* (Seoul: Jogye Order of Korean Buddhism, 2012), pp. 73–74.

32. For a useful study of ancient Indian funerary practices as evidenced in iconography, see Giuseppe De Marco, "The Stūpa as a Funerary Monument: New Iconographical Evidence," *East and West* 37, nos. 1–4 (December 1987): 191–246.

33. Louis de la Vallée Poussin, French trans., *Abhidharmakośabhāṣyam*, vol. 2, English trans. by Leo M. Pruden (Berkeley, CA: Asian Humanities Press, 1988), p. 382.

34. On prohibitions against damage to stūpas, see Peter Skilling, "Ideology and Law: The Three Seals Code on Crimes Related to Relics, Images, and Bodhi-trees," *Buddhism, Law, and Society* 1 (2015–2016): 69–103.

35. *The Lotus Sūtra*, trans. Tsugunari Kubo and Akira Yuyama, rev. 2nd ed., English Tri-piṭaka Series (Berkeley, CA: Numata Center for Buddhist Translation and Research, 2007), p. 238.

36. G. P. Malalasekhara, *Dictionary of Pāli Proper Names*, 2 vols. (Delhi: Munshiram Manoharlal, 1998), vol. 1, pp. 294–305.

37. For a discussion of this passage, see Robert DeCaroli, *Image Problems: The Origin and Development of the Buddha's Image in Early South Asia* (Seattle: University of Washington Press, 2015), pp. 31–34 and 173–174.

38. "Open Road to the World: Memoirs of a Pilgrimage to the Five Indian Kingdoms," ed. Roderick Whitfield, trans. Matty Wegehaupt, in *Collected Works of Korean Buddhism*, vol. 10, *Korean Buddhist Culture: Accounts of a Pilgrimage, Monuments, and Eminent Monks* (Seoul: Jogye Order of Korean Buddhism, 2012), pp. 94–95.

39. *A Record of the Buddhist Religion as Practised in India and the Malay Archipelago (A.D. 671–695) by I-Tsing*, trans. Junjirō Takakusu (Oxford: Clarendon Press, 1896), pp. 147–148.

40. Julia K. Murray, "The Evolution of Pictorial Hagiography in Chinese Art: Common Themes and Forms," *Arts Asiatiques* 55, no. 1 (2000): 84.

41. The story of the miracle at Śrāvastī is drawn from the *Prātiharya Sūtra* of the *Divyāvadāna*. For a translation, see *Divine Stories: Divyāvadāna*, trans. Andy Rotman (Boston: Wisdom, 2008), part 1, pp. 252–287.

42. Louis de la Vallée Poussin, French trans., *Abhidharmakośabhāṣyam*, English trans. by Leo M. Pruden, vol. 4 (Berkeley, CA: Asian Humanities Press, 1988), p. 1167.

43. Eugène Burnouf, *Introduction to the History of Indian Buddhism*, trans. Katia Buffetrille and Donald S. Lopez Jr. (Chicago: University of Chicago Press, 2009), p. 191.

44. We are grateful to Keith Wilson for sharing his research on the collection of Kizil fragments on long-term loan to the Freer|Sackler, especially his work on reconstructing the location of the fragments in Cave 224.

45. "Open Road to the World: Memoirs of a Pilgrimage to the Five Indian Kingdoms," ed. Roderick Whitfield, trans. Matty Wegehaupt, in *Collected Works of Korean Buddhism*, vol. 10, *Korean Buddhist Culture: Accounts of a Pilgrimage, Monuments, and Eminent Monks* (Seoul: Jogye Order of Korean Buddhism, 2012), pp. 95–96.

46. *The Great Tang Dynasty Record of the Western Regions*, trans. Li Rongxi, BDK English Tripiṭaka 79 (Berkeley, CA: Numata Center for Buddhist Translation and Research, 1996), p. 160.

47. Ibid., p. 386.

48. On the Gupta style, see Joanna Gottfried Williams, *The Art of Gupta India: Empire and Province* (Princeton, NJ: Princeton University Press, 1982).

49. "Open Road to the World: Memoirs of a Pilgrimage to the Five Indian Kingdoms," ed. Roderick Whitfield, trans. Matty Wegehaupt, in *Collected Works of Korean Buddhism*, vol. 10, *Korean Buddhist Culture: Accounts of a Pilgrimage, Monuments, and Eminent Monks* (Seoul: Jogye Order of Korean Buddhism, 2012), pp. 129–131.

50. Candraprabhāvadāna, *Divyāvadāna* 22, trans. Reiko Ohnuma from *The Divyāvadāna: A Collection of Early Buddhist Legends*, ed. Edward B. Cowell and Robert A. Neil (Amsterdam: Oriental Press, 1970; orig. pub. Cambridge, 1886), pp. 314–328, in *Buddhist Scriptures*, ed. Donald S. Lopez Jr. (New York: Penguin Classics, 2004), pp. 142–158.

51. "Open Road to the World: Memoirs of a Pilgrimage to the Five Indian Kingdoms," ed. Roderick Whitfield, trans. Matty Wegehaupt, in *Collected Works of Korean Buddhism*, vol. 10, *Korean Buddhist Culture: Accounts of a Pilgrimage, Monuments, and Eminent Monks* (Seoul: Jogye Order of Korean Buddhism, 2012), p. 148.

52. For a study of *Barlaam and Josaphat* (including a fuller version of the Arabic tale), see Donald S. Lopez Jr. and Peggy McCracken, *In Search of the Christian Buddha: How an Asian Sage Became a Medieval Saint* (New York: W. W. Norton, 2014).

53. Information on the Sasanian ewer is drawn from the Freer|Sackler object fact sheet by Massumeh Farhad and from Kate Masia-Radford, "Luxury Silver Vessels of the Sasanian Period," in *The Oxford Handbook of Ancient Iran*, ed. D. T. Potts (Oxford: Oxford University Press, 2013), pp. 920–942.

54. *The Koran*, trans. N. J. Dawood (New York: Penguin Classics, 2000), p. 457.

55. Information on the page from the Abbasid Qur'an is drawn from the Freer|Sackler object fact sheet by Massumeh Farhad; from Maryam D. Ekhtiar, "Art of the Early Caliphates (7th to 10th Centuries)," in *Masterpieces from the Department of Islamic Art in the Metropolitan Museum of Art*, ed. Maryam D. Ekhtiar, Priscilla P. Soucek, Sheila R. Canby, and Navina Najat Haidar (New York: Metropolitan Museum of Art, 2011), pp. 20–52; and from Massumeh Farhad, introduction to *The Art of the Qur'an: Treasures from the Museum of Turkish and Islamic Arts*, ed. Massumeh Farhad and Simon Rettig (Washington, DC: The Freer Gallery of Art and the Arthur M. Sackler Gallery of Art, 2016), pp. 19–39.

56. The story is recounted in the preface of *Foding zunsheng tuoluoni jing xu* (*Sūtra of the Superlative Dhāraṇī of the Buddha's Crown*), written by monk Zhijing (T.967: 349b3–349c7). Translation of the preface is adopted from Paul Copp, "Voice, Dust, Shadow, Stone: The Makings of Spells in Medieval Chinese Buddhism" (PhD diss., Princeton University, 2005), pp. 45–47. The account of Buddhapālita can also be found in *Song gaoseng zhuan*, T.2061: 717c15–718b7 and *Guang Qingliang zhuan*, T.2099: 1111a19–b23.

57. Antonino Forte, *Political Propaganda and Ideology in China at the End of the Seventh Century*, 2nd ed. (Kyoto: Scuola Italiana di Studi sull' Asia Orientale, 2005), p. 134.

58. T. H. Barrett, "Stūpa, Sūtra, and Śarīra in China, c. 656–706 CE," in *Buddhism: Critical Concepts in Religious Studies*, vol. 8, *Buddhism in China, East Asia, and Japan*, ed. Paul Williams (London: Routledge, 2005), p. 26.

59. See Robert E. Buswell Jr., "Korean Buddhist Journeys to Lands Worldly and Other-

worldly," *Journal of Asian Studies* 68, no. 4 (November 2009): 1067–1068.

60. See Lin Wei-Cheng, *Building a Sacred Mountain: The Buddhist Architecture of China's Mount Wutai* (Seattle: University of Washington Press, 2014), pp. 96–97.

61. Wu Pei-Jung, "Wooden Statues as Living Bodies: Deciphering the Meanings of the Deposits within Two Mañjuśrī Images of the Saidaiji Order," *Artibus Asiae* 74, no. 1 (2014): 76.

62. For a useful study of the various roles played by Tibetan Buddhists at Wutaishan, see Karl Debreczeny, "Wutai shan: Pilgrimage to Five-Peak Mountain," *Journal of the International Association of Tibetan Studies* 6 (2011): 9–43.

From 1906 to 1909, the famed Orientalist Paul Pelliot (1878–1945), traveled from Kashgar to Xi'an. From February to May of 1908, his team stayed at the Dunhuang Mogao caves in China. Among the many objects he took from Cave 17 ("The Library Cave") was the only extant manuscript of Hyecho's work. The text was damaged, and what remains is a manuscript of 227 lines and 5,893 Chinese characters, measuring 28.8 cm high and 358.6 cm long. It is now in the collection of the Bibliothèque Nationale de France. Detailed photographs of the entire manuscript can be found by searching for "Pelliot chinois 3532" on the International Dunhuang Project website (http://idp.bl.uk/). Although scholars generally agree that the text is not in Hyecho's hand, Pelliot was the first to identify Hyecho as the author, in his report, "Une bibliothèque médiévale retrouvée au Kan-sou," *Bulletin de l'Ecole française d'Extrême-Orient* (*BEFEO*) 8 (1908): 501–529. The text does not appear on its own in the Taishō canon but is included as part of the compilation *Youfangji chao* (T 2089).

The great Dunhuang scholar Luo Zhenyu (1866–1940) was the first to publish in Chinese on Hyecho's text: "*Wu Tianzhuguo ji*" [The record of the countries of the five Indian kingdoms], in *Dunhuang shishi yishu* (Beijing, 1909). Luo argued, based on comparison with the contents of a later work (Huilin, *Yiqiejing yinyi*, T 2128) that the extant manuscript is a portion of what was originally three fascicles. Dunhuang studies in Japan also began in 1909. It was at this time that Luo Zhenyu sent a letter to Naitō Torajirō (1866–1934), a professor at Kyōto University, describing the Dunhuang

manuscripts brought to Beijing by Pelliot. In 1910 Fujita Toyohachi (1869–1929), who was working at Beijing University, published in Beijing a study of the biography of "Huichao," which was the first monograph written by a Japanese scholar on any Dunhuang manuscript. In 1915 the Japanese scholar Takakusu Junjirō (1866–1945) identified Hyecho as a Buddhist monk from the Silla kingdom. See Takakusu Junjirō, "Echō 'Ō go Tenjikukoku den' ni tsuite'" [Concerning Hyecho's "Memoirs of a pilgrimage to the five Indian kingdoms"], *Shūkyōkai* 11, no. 7 (July 1915).

In 1938 the German philologist Walter Fuchs (1902–1979) completed the first translation of Hyecho's text into a Western language: "Huei-ch'ao's Pilgerreise durch Nordwest-Indien und Zentral-Asien um 726," in *Sitzungsberichten der Preußischen Akademie der Wissenschaften, Philosophisch-historische Klasse* 30 (Berlin: Verlag der Akademie der Wissenschaften, 1939), 426–469. There are two main translations into English: *The Hye Ch'o Diary: Memoir of the Pilgrimage to the Five Regions of India*, ed. Laurence Preston, trans. Yang Han-Sung, Jan Yun-hua, and Iida Shotaro (Berkeley, CA: Asian Humanities Press, 1984); and "Open Road to the World: Memoirs of a Pilgrimage to the Five Indian Kingdoms," ed. Roderick Whitfield, trans. Matty Wegehaupt, in *Collected Works of Korean Buddhism*, vol. 10, *Korean Buddhist Culture: Accounts of a Pilgrimage, Monuments, and Eminent Monks* (Seoul: Jogye Order of Korean Buddhism, 2012), pp. 5–174. While both offer valuable scholarly analysis, the latter includes the original text in Chinese and draws heavily on Korean and Japanese scholarship. In Korean, Jeong Suil's *Hyecho ui Wang o Cheonchukguk jeon* [Hyecho's "Memoirs of a pilgrimage to the five Indian kingdoms"] (Seoul: Hakgojae, 2004) is a massive annotated translation of Hyecho's memoir that particularly analyzes places that Hyecho mentions in his diary and the historical material available on those regions. It also includes comparative analysis with previous East Asian pilgrims' records. In Japanese, the most useful and authoritative edition of this text is Kuwayama Shōshin's *Echō Ō go Tenjikukoku-den kenkyū* [Study of Hyecho's "Memoirs of a pilgrimage to the five Indian kingdoms'], rev. 2nd ed. (Kyōto: Rinsen Shoten, 1998). There are also translations of the text into Chinese and Italian: *Wang Wu Tianzhuguo zhuan jianshi* [Notes and interpretations of "Memoirs of a pilgrimage to the five Indian kingdoms"], trans. Zhang Yi (Beijing: Zhonghua shuju, 2000); and Hyecho, *Pellegrinaggio alle cinque regioni dell'India* (Milan: O Barra O, 2010).

The best single English-language review of Hyecho scholarship is Koh Byong-ik's "Historiographical Contributions by Hyecho, the 8th Century Korean Pilgrim to India," *Altorientalische Forschungen* 19, no. 1 (January 1, 1992): 127–132. As one might expect, Hyecho scholarship is dominated by

scholars from Korea. Notable among the many studies are Jeong Suil, "Hyecho ui seoyeok gihaeng gua 'Wang o Cheonchukguk jeon'" [Hyecho's travel to the western regions and the memoir of the pilgrimage to the five regions of India], *Hanguk munhak yeongu* 27 (2004): 26–50; Yi Yongjae, "'Daedang seoyeokgi' wa 'Wang o Cheonchukguk jeon' ui munhakjeok bigyo yeongu" [A comparative literature study of the record of travels to western lands and the Hye Cho diary: Memoir of the pilgrimage to the five regions of India], *Jungguk eo munhak non jip* 56 (2009): 369–407; Yi Jeongsu, "Milgyoseung Hyecho ui jaegochal" [The Esoteric Buddhist monk Hyecho reconsidered], *Bulgyo Hakbo* 55 (2010): 315–334; and Nam Dongshin, "Hyecho 'Wang o Cheonchukguk jeon' ui balgyeon gwa pal daetap" [The discovery of Hyecho's "Memoirs of a pilgrimage to the five Indian kingdoms" and the eight great stupas], *Dongyangsahak Yeongu* 111 (2010): 1–32.

From the 1960s to the 1980s, Yang Han-sung published the most on Hyecho in English, starting with "Eighth Century Asia and Hyech'o's Travel Account," *Korea Journal* 9, no. 9 (September 1969): 35–39. Scholarly interest in Hyecho seems to have been rekindled in recent years, and significant progress has been made, with studies including Robert E. Buswell, "Korean Buddhist Journeys to Lands Worldly and Otherworldly," *Journal of Asian Studies* 68, no. 4 (November 2009): 1055–1075; and Max Deeg, "Has Huichao Been Back to India? On a Chinese Inscription on the Back of a Pāla Bronze and the Chronology of Indian Esoteric Buddhism," in *From Turfan to Ajanta: Festschrift for Dieter Schlingloff on the Occasion of His Eightieth Birthday*, ed. Eli Franco and Monika Zin, vol. 1 (Kathmandu: Lumbini International Research Institute, 2010), pp. 197–213.

Starting with the work of Fujita Toyohachi, scholars writing in Japanese (including Korean nationals) have been publishing on Hyecho and his context for more than a century. In addition to Kuwayama's work, two studies exemplify the fruits of this work in literature and religious history: Ogasawara Senshū, "Nyūjiku-sō Echō no shisō" [The poetic thought of Hyecho who entered India], in *Bukkyō bungaku kenkyū*, ed. Bukkyō bungaku kenkyūkai, vol. 3 (Kyōto: Hōzōkan, 1965), pp. 7–24; and Yi Jeongsu, "Mikkyō-sō Echō no saikōsatsu" [A reassessment of the esoteric monk Hyecho], *Indogaku Bukkyōgaku kenkyū* 48, no. 1 (December 1999): 242–329.

Finally, Hyecho has rarely been studied from the perspective of art history and material culture, but the catalog of the exhibition organized by the National Museum of Korea is a good starting point: *Silkeurodeu wa Dunhwang 'Hyecho wa hamgge ha'neun seoyeok gihaeng* [Silk Road and Dunhuang: Journey to the western regions with Hyecho] (Seoul: Gungnip Jungang Bakmulgwan, 2010).